Peter Lamborn Wilson

Angels

Pantheon Books, New York

Dedicated

to my friends and colleagues at the now-defunct Imperial Iranian Academy of Philosophy, especially to the late Henry Corbin, Angelologist; also to Seyyed Hossein Nasr, William C. Chittick, T. Izutsu, and the others.

Acknowledgments

to all the friends who helped me with this book, including (in no particular order) Marco Pallis, William Stoddart, Carmen Blacker, Kathleen Raine, John and Caitlin Matthews, Jill Purce, Sarah Nichols, Charles B. Potter, J. Peter Hobson, John Lindsay Opie, Cecil Collins, Elémire Zolla, Huston Smith, Richard Temple (Temple Gallery, Ltd.), and many others who drew my attention to various texts and pictures. Needless to say, the errors and inadequacies are my own, not theirs.

Picture Editor: Jill Purce

FIRST AMERICAN EDITION

Copyright © 1980 Thames and Hudson Ltd., London

Library of Congress Cataloging in Publication Data

Wilson, Peter Lamborn.
 Angels.

 Bibliography: p.
 Includes index.
 1. Angels in art. 2. Art and religion.
3. Title.
17793.A53W54 1980 704.9'4864 80-14161
ISBN 0-394-51355-X

Manufactured in Italy by
AMILCARE PIZZI ARTI GRAFICHE S.p.A.
CINISELLO B. (MILANO - ITALIA) - 1980

Contents

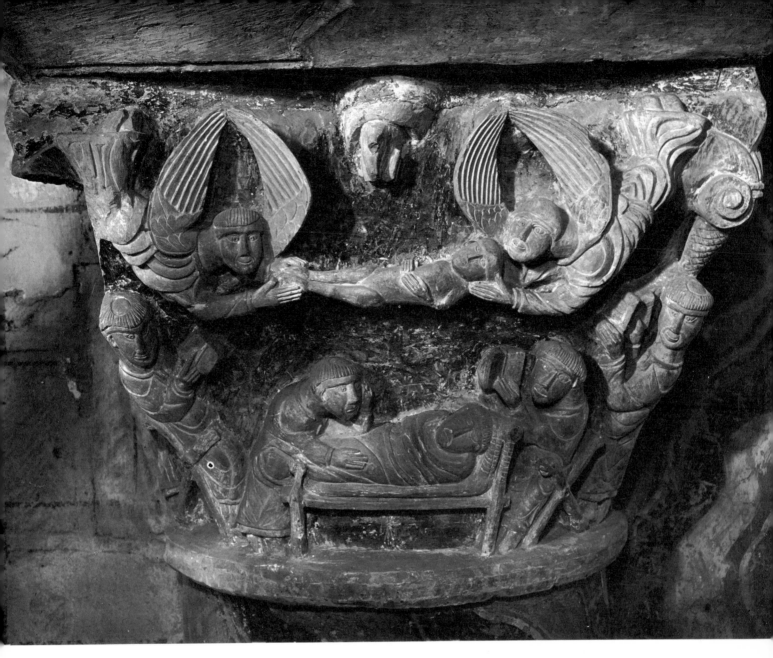

*Angels raising up the soul
of a dead man. Capital
from the Church of Saint-
Hilaire, Poitiers*

The function of the wing is to take what is
heavy and raise it up into the region above,
where the gods dwell; of all things connected
with the body, it has the greatest affinity with
the divine.

(PLATO, *Phaedrus*)

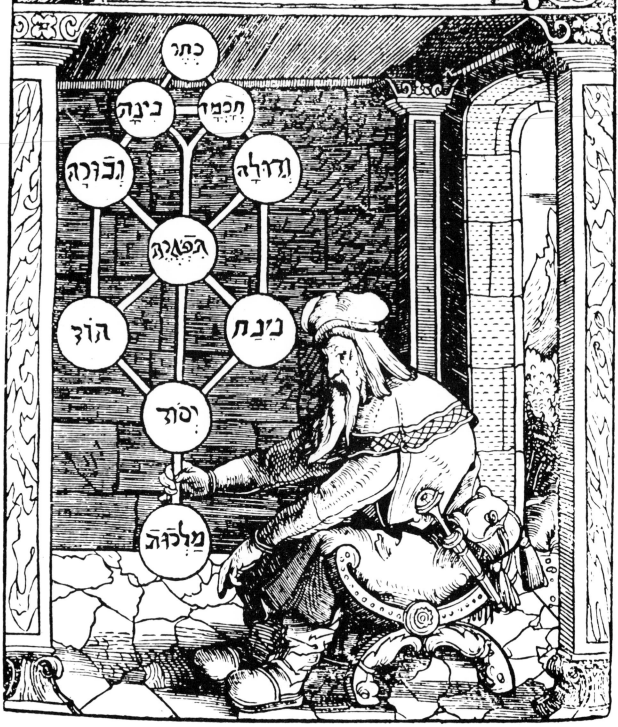

Prelude

The Kabbalist

(Opposite) Each of the stations of the Kabbalistic Tree is governed by an Angel (see p. 10); from Paulus Ricius, Porta Lucis, *Augsburg 1516*

Imagine an icon as it might have existed in the mind of a Kabbalist scholar of fifteenth-century Toledo. A beam of light streams from the window onto his lectern and he looks up in reverie from his books to picture to himself the great Tree of the Angelic World.

First he recreates the bare abstract scheme of the ten Sefiroth, the ten Divine Attributes which govern and shape the universe both seen and unseen. They arrange themselves in a shape like a rose-bush on which ten measureless blossoms of light appear.

Now each of the roses of light will unfold its petals and reveal a winged figure. At the crown of the Tree appears the great Metatron, he who is closest to the Divine Throne. This Angel was once the prophet Enoch 'who was not, for God had taken him up'. God set His own coronet on Enoch's head and gave him seventy-two wings and innumerable eyes. His flesh was transformed into flame, his sinews into fire, his bones into embers, and he is surrounded by storm, whirlwind, thunder and lightning.

The highest of all Angels, Metatron is a prophet, ancient, bearded, inspired; yet at the same time an eternal and celestial adolescent, radiantly beautiful. Isaiah saw him 'sitting upon a throne, high and lifted up, and his train filled the temple. Above him stood the Seraphim: each one had six wings; with twain he covered his face, and with twain he covered his feet, and with twain he did fly.' (Isaiah 6, 1–2)

Around Metatron stand the Kerubim:

Sefirothic Tree; from Robert Fludd, Philosophia Sacra, *1626*

. . . every one had four wings. And their feet were straight feet; and the sole of their feet was like the sole of a calf's foot; and they sparkled like the colour of burnished brass. And they had the hands of a man under their wings on their four sides . . . Their wings were joined one to another . . . As for the likeness of their faces, they

9

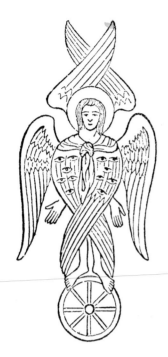

four had the face of a man, and the face of a lion, on the right side; and they four had the face of an ox on the left side; they four also had the face of an eagle. (Ezekiel 1, 4–10)

From these creatures pour streams of fiery sweat like rivers of lightning, and from the drops of this are produced multitudes of Angels (Daniel 7, 10).

The Three Angels on the left of the Tree are Zaphkiel, Angel of Contemplation; Samael, Angel of Evil, and Raphael, Angel of Healing. Samael is also called Satan, Lucifer, the Morning Star. If surprised to see him here, our Kabbalist recalls that Angels may possess many forms simultaneously. If Satan – in one decayed, gargantuan manifestation – occupies the frozen pit of Dante's lowest hell, he may also appear as the strangely elegant and sardonic adversary in the *Book of Job* who strolls about Heaven to play a game of chance with the Lord. On the Tree the Kabbalist envisions him in his original glory, blazing with jewels.

As for Raphael, he is the Divine Physician and also the patron of travellers: he wears a pilgrim's hat, carries a staff and water-gourd, or perhaps a vial of healing ointment.

The trunk of the Tree, beneath Metatron, displays three more figures of our Kabbalist's icon: Michael, Gabriel and Sandalphon. No words can do justice to the glory of Michael, who is patron of Israel, chief of the heavenly hosts, and, like his counterpart the Persian god Mithra, the sun in splendour. He may be pictured as a radiant winged warrior dressed in shining armour, piercing with his spear the writhing form of a serpent or dragon beneath his feet.

Gabriel, who commands Spiritual Wisdom, takes the form of a beautiful youth dressed in green embroidered silk, holding to his lips a golden horn.

Lastly, Sandalphon (whose name suggests the sound of approaching footsteps) is the Guardian Spirit, at once the chief and prototype of all guardian Angels. He stands at the foot of the Tree, upon the created world, but his height extends upwards throughout all the universe, and he is taller than any other 'by a journey of five hundred years'.

A six-winged Seraph standing on one of the 'Wheels' (Ophanim), which are also Angels; from Christian Iconography *by Adolphe Napoléon Didron, 1886, vol. II*

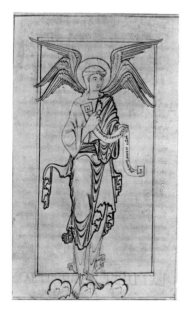

A Seraph with a message-scroll. Bodleian Library, Oxford

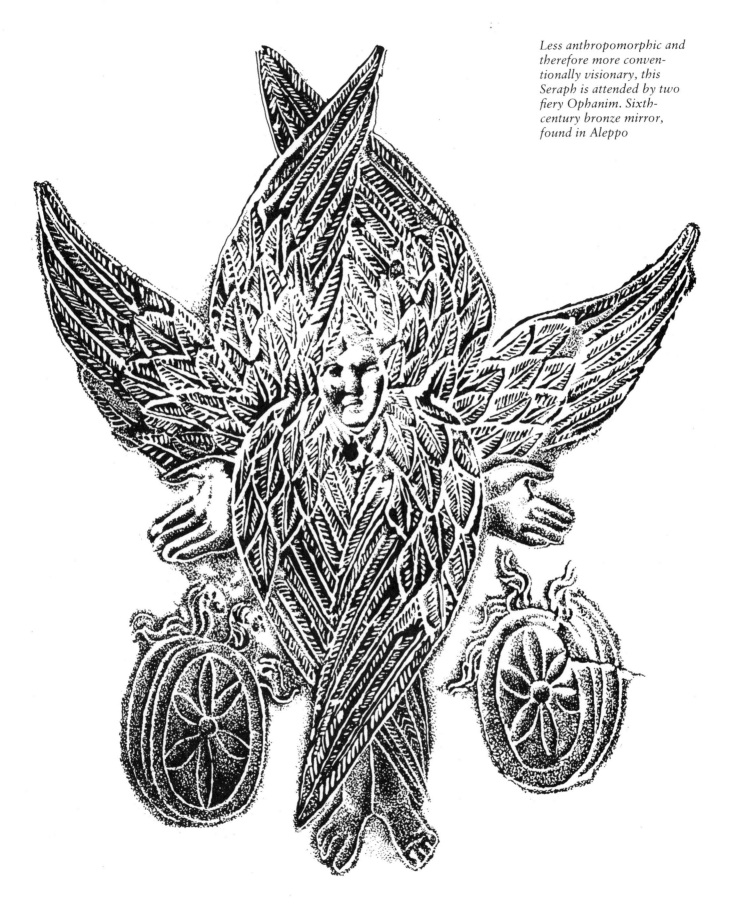

'Love's Luck' – 'shoeless and weatherbeaten', Eros makes his own fortune in the world – and thereby moves the world itself. From Peter Vischer the Younger, Fortuna Amoris; Erlangen, Graphische Sammlung der Universität

The philosopher

Plato in the *Phaedrus* implies that both the gods and the souls of men are winged. But the being who above all others must be winged is the one who is neither god nor man, but an intermediary between the two, a messenger – in Hebrew, *malakh*, in Greek, *angelos*. According to Socrates, Eros is not, as others would have it, the beautiful beloved; rather he is the Spirit who inspires the lover, who gives the lover his divine madness. Eros is neither mortal nor immortal. He is a spirit

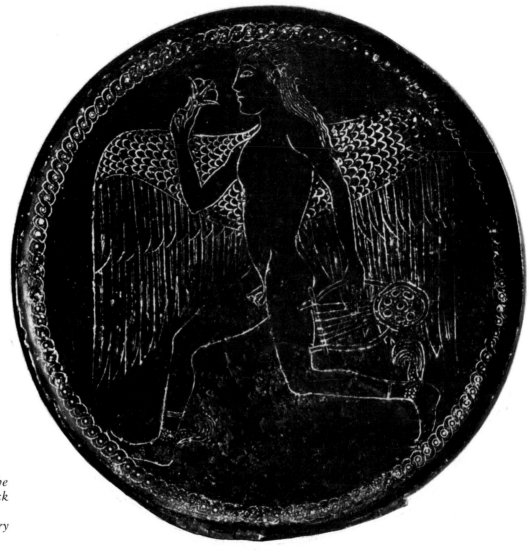

Eros as described by Agathon in Plato's Symposium: *a beautiful boy with rose and lyre, the image of the beloved. Back of an incised mirror, Etruscan, early 5th century BC; British Museum*

who interprets and conveys messages back and forth between men and gods. 'God does not deal directly with man; it is by means of spirits that all the intercourse and communication of gods with men, both in waking life and in sleep, is carried on.'

Socrates relates the priestess Diotima's account of Love's origins. On Aphrodite's birthday, Contrivance, the son of Invention, grew drunk on nectar, and Poverty took advantage of this to seduce him and bear his child, who was Eros.

The power of Venus is love – thus her 'son' Cupid hovers over her head like a nimbus or aura or 'Glory'. Hellenistic terracotta statuette; Taranto, Museo Nazionale

The apotheosis of young male beauty, appropriately enough dredged from beneath the sea like an image from the well-spring of consciousness. Eros, from the Mahdra wreck

Dionysius, god of intoxication and liberating vision, attended by Love, who beats out the trance-rhythm of divine madness. Interior of a cup by the Meleager Painter, Greek, early 4th century BC; British Museum

14

He is always poor, and, far from being sensitive and beautiful, as most people imagine, he is hard and weather-beaten, shoeless and homeless, always sleeping out for want of a bed, on the ground, on doorsteps, and in the street . . . But, being also his father's son, he schemes to get for himself whatever is beautiful and good; he is bold and forward and strenuous, always devising tricks like a cunning huntsman; he yearns after knowledge and is full of resource and is a lover of wisdom all his life, a skilful magician, an alchemist.

Like the Angels of the Kabbala, Eros is a messenger, a spirit; he is winged; he is both Ancient of Days and a graceful boy. In other contexts, we shall see that Eros also acts as guide of the soul, the guardian or spiritual double of man, and that he represents both the spiritual master and the beloved, and that this synthesis gives him a claim to be regarded as a manifestation of the highest of all Angels.

But he also plays tricks and is something of a magician. Nothing in our angelic icon prepared us for this. Can an Angel be a trickster? In order to answer, we must extend our view beyond the Holy Land and Greece, where the word 'Angel' is known, and discover whether Plato's archetype of the winged man or spirit can be found elsewhere; and if so, under what disguises.

Another 'angelic' god, Hermes the messenger, becomes the Mercurius of the alchemists. He presides over the 'war' of duality and the 'marriage' of perfect union. From Musaeum Hermeticum Reformatum et Amplificatum . . . *Frankfurt 1678*

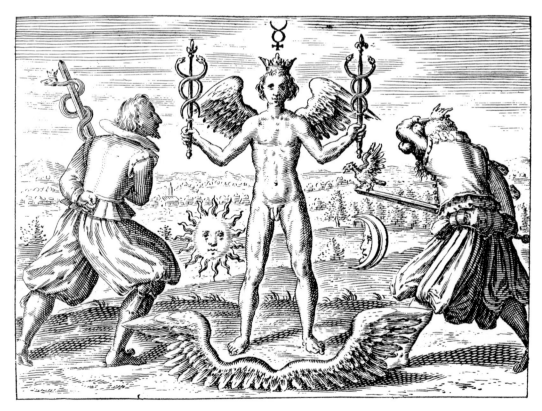

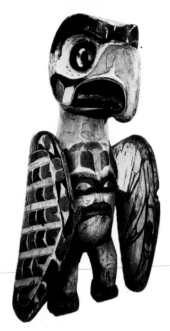

A man's face in the belly of an eagle, symbolizing the ascendant and victorious mode of consciousness. Kwakiutl, Vancouver Island, Canada

The shaman

The Campu shaman of eastern Peru sings with an eerie, distant voice which causes even his clothing to vibrate. The good spirits appear to him alone; they take human forms and dance. The hawk Koakiti appears as a winged man:

> Tobacco, tobacco, pure tobacco
> It comes from the River's Beginning.
> Koakiti the hawk brings it to you.
> Its flowers are flying, tobacco.
> It comes to your aid . . .
> Koakiti the hawk is its owner.

Tobacco smoke is the magic bridge by which the soul of the shaman can ascend into the spirit-world; hence its value. The hummingbird spirits also appear as Angels:

> Hummingbirds, hummingbirds, they come running
> Hummingbirds, hummingbirds, dark appearance
> Hummingbirds, hummingbirds, all our brothers
> Hummingbirds, hummingbirds, they all hover
> Hummingbirds, hummingbirds, group without blemish.

Lame Deer, a contemporary Sioux medicine man, gives in his autobiography this description of the Four Thunderbirds, who are also winged men:

. . . There are four large, old thunderbirds. The great *wakinyan* of the west is the first and foremost among them. He is clothed in clouds. His body has no form, but he has huge, four-jointed wings. He has no feet, but he has claws, enormous claws. He has no head, but he has a huge beak with rows of sharp teeth. His colour is black. The second thunderbird is red. He has wings with eight joints. The third thunderbird is yellow. The fourth thunderbird is blue. This one has neither eyes nor ears.

Thus, then, are the 'Kerubim', the 'four living creatures' of the Sioux.

He who has a vision of these beings must become a clown, a contrary-man or *heyoka*. He does everything backwards, to the amusement and often the horror of the tribe; like a medieval jester he has licence to turn the world topsy-turvy, to be a perpetual Lord of Misrule. The *heyoka* is also a prophet, a holy man: a sacred fool.

Raven (Qaq), the demiurge or agent of Chaos and Creation of the Tlingit of northwestern America, is another winged creature, a black,

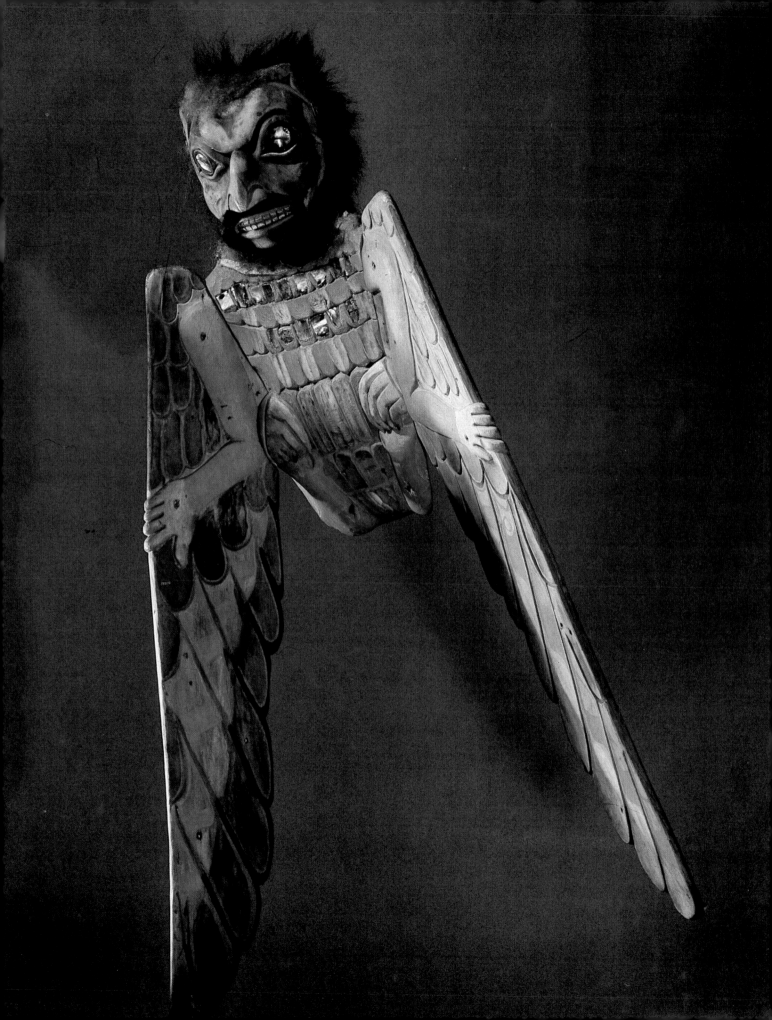

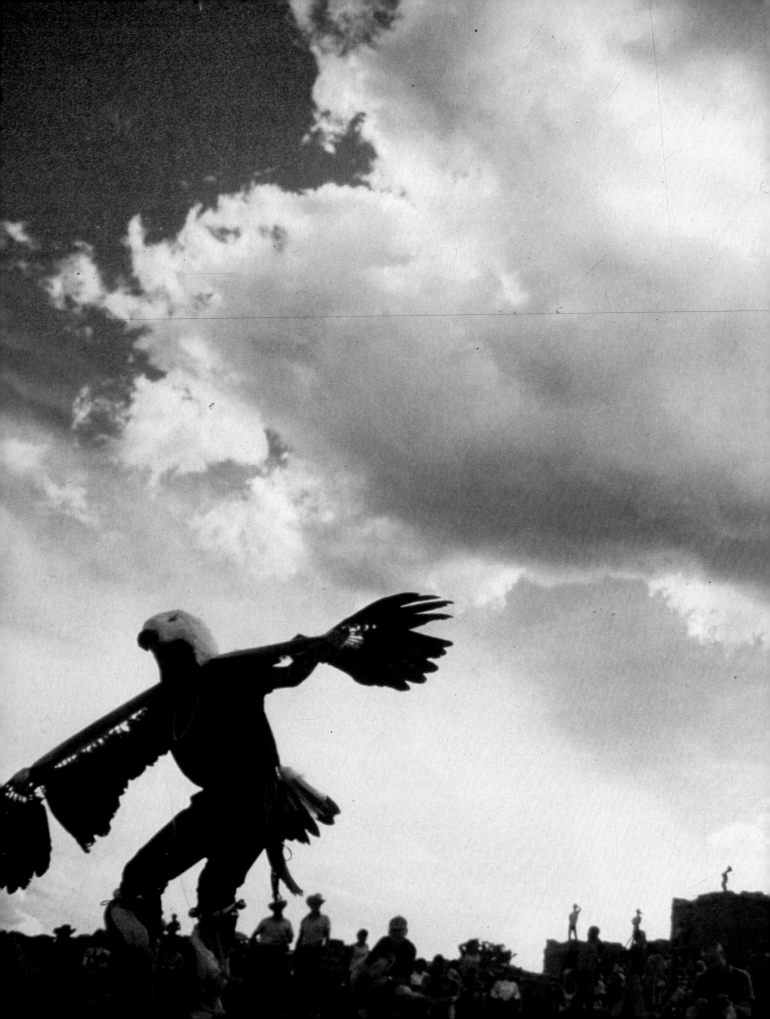

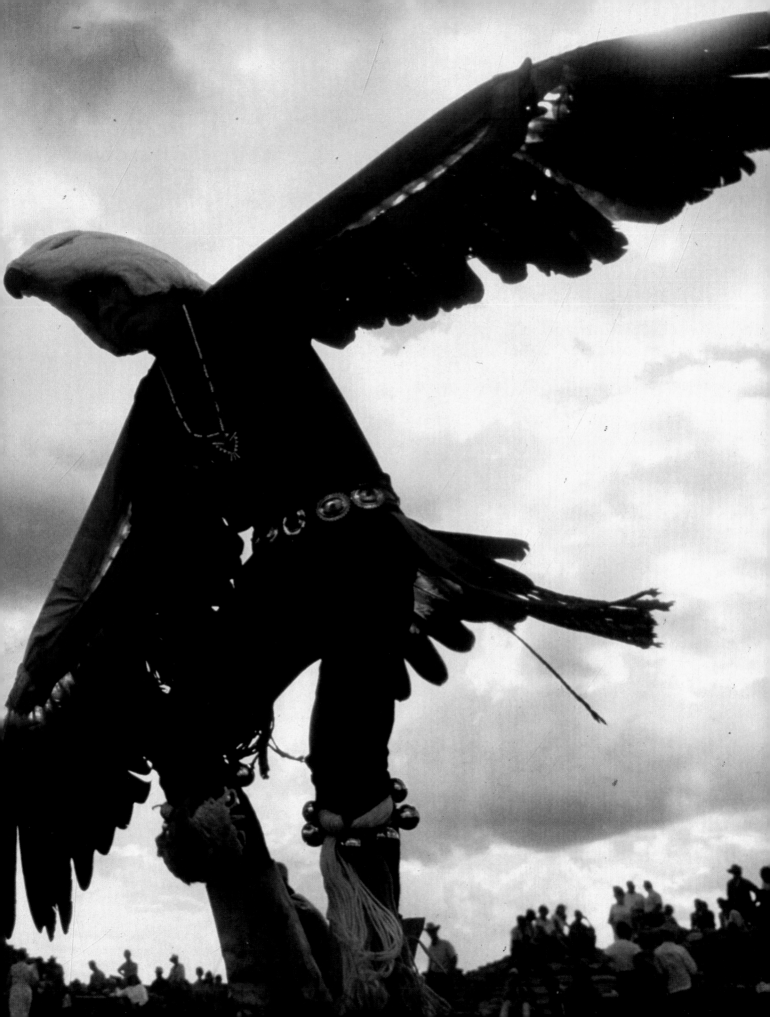

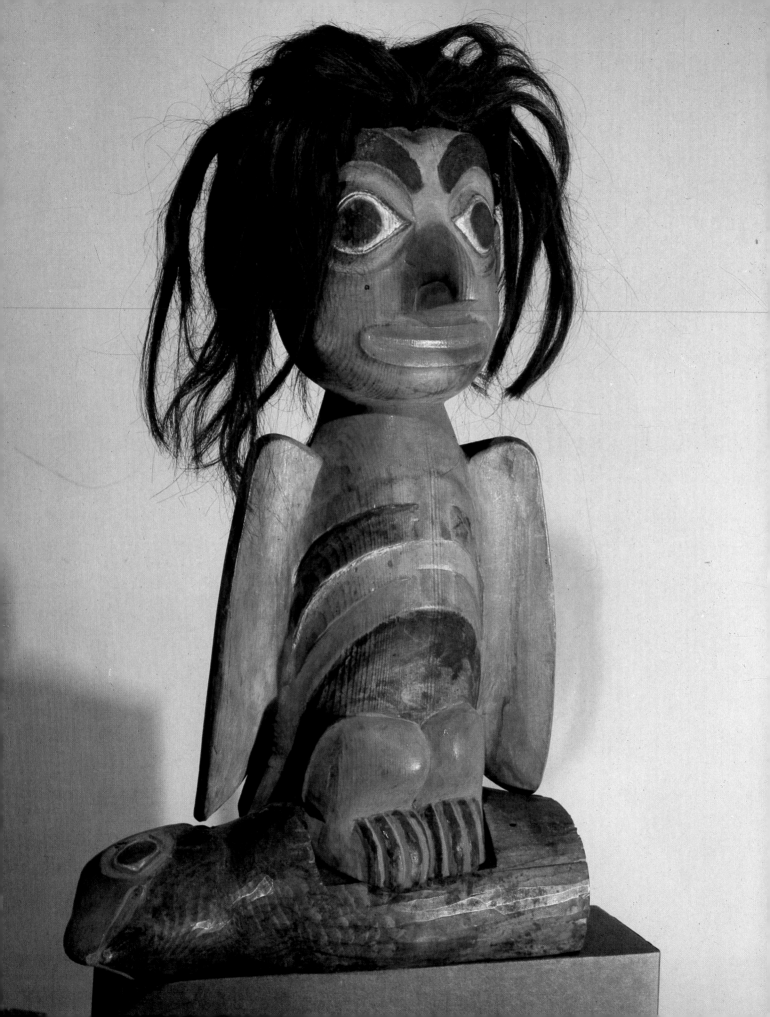

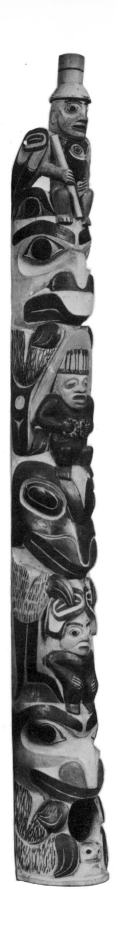

foul-mouthed, greedy, lecherous trickster who also brings light into the world by stealing the moon.

He knows who owns the moon: an old fisherman, sculling across the seas of utter darkness of 'olden times', keeps the source of light hidden inside ten boxes, like a Chinese puzzle, high on a shelf in his cabin.

Raven changes himself into a pine-needle and floats on the surface of a spring. The fisherman's daughter drinks the water, conceives and gives birth to a child. The fisherman dotes on his new grandchild and spoils him. The baby cries; the man offers him toy after toy, but only the moon-box pleases him. He opens all the boxes and plays with the bright ball. The fisherman suspects nothing and leaves the cabin.

At once Raven resumes his bird-form, utters the raven cry – 'Gaa!' – and flies up out of the smoke-hole, the moon in his beak. He breaks off bits of it and creates the sun and stars.

Raven is Logos (born of a virgin); he is Lucifer and Prometheus, Light-bearers; Maya, the Hindu goddess of nature and illusion; and Proteus, the Greek god who assumes many shapes, the very soul of matter. He manifests as a bird, a beautiful boy, a terrifying old man with a beard of moss, an old woman with a beak-shaped nose. He is the first and greatest shaman, the man who penetrates the secrets, becomes a spirit-bird and flies up the tree after the light, cawing with wild laughter. He carves the first totem-pole, symbol of the World-Tree or Angelic Ladder, the hierarchy of the cosmos, record of his journey and heraldic emblem of his people. He is Metatron, the prophet who becomes an Angel, and Hermes the trickster with angelic features, messenger of the gods who steals the cattle of the sun and invents the lyre; also Mercurius of the alchemists, the winged and naked youth.

The totem pole divides reality into a vertical hierarchy of earths and heavens – lorded over by the trickster-Angel, Raven, in a top hat. American Northwest Coast model house with totem pole; British Museum

COLOUR PLATE

Owl, hunter of night, who dives like thought out of blackness on his prey, whose vast eyes suggest piercing intellect – owl is the natural guardian of the shaman, who often works

for good ends through sinister and dramatic means. To be a shaman, in many societies, is to be an owl, an owl-man, an Angel of the dark. Mythical painted owl-man, Tlingit

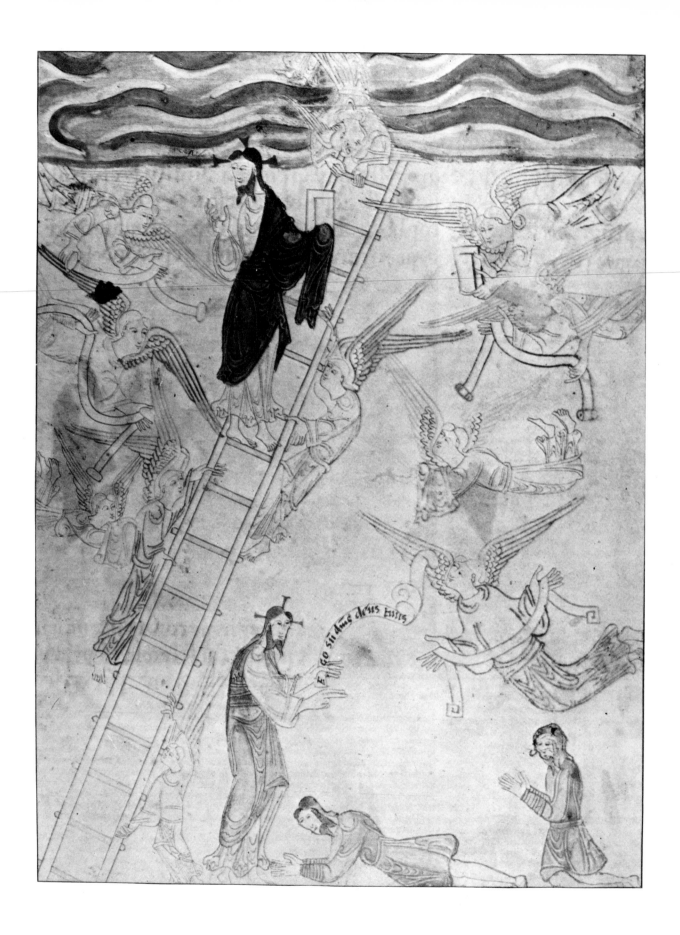

I The image of the Angel

Garuda, who kills the snake of the ego and bears the contemplative soul on his wings; and a dakini, a Buddhist being who 'flies between heaven and earth'. Illustrations from the 'Three Hundred Icons', a Tibetan xylograph printed in Peking with a Tibeto-Mongol preface and Chinese ideograph; 18th-century preface by Rölpä Dorje (1717–78)

(Opposite) 'Heaven' belongs to God, and earth to man, but the ladder of the spiritual imagination which links them is ruled by, or made of, Angels. Abraham is shown here lying on the ground while God, descending from Heaven on the ladder, promises that he will make him 'the father of a multitude of nations'. From an 11th-century Anglo-Saxon manuscript; British Museum

Most westerners, when they hear the word 'Angel', think of Christianity; many assume that only Christianity and Judaism demand belief in such creatures, and that only Christian artists have depicted them since Jewish law forbids all such representations. This is simply not so. Already we have seen Angels in classical myth and philosophy, and in shamanistic visions, and we shall also encounter them in Zoroastrianism, Hinduism, Buddhism, Taoism and Islam.

Angels have played rather an ambiguous role in Christianity. St Paul bitterly attacked 'the worship of Angels which some enter into blindly, puffed up by their mere human minds' – which suggests the existence in his time of a cult of Angels. The Council of Nicaea in 325 declared belief in Angels a part of dogma, and apparently this caused an explosive renewal of the cult: in 343 the Synod Laodicaea condemned the worship of Angels as 'idolatry'. Finally in 787 the Seventh Ecumenical Synod reinstated a carefully defined and limited cult of the Archangels which took root in the Eastern Church; in the West, however, the distrust of Angels remained stronger.

As in the case of the Virgin Mary, there is very little in the New Testament to justify a cult of any great proportions. And as with 'Mariolatry', the impulses of 'angelolatry' surged up from beneath the Church, from the peasantry, the people whose voice is *vox Dei*. Unfortunately, theologians and doctors of law and morality often fail to respond to either the popular or the mystic imagination.

Artists, however, do respond to both. Where Angels are concerned, the art of Christianity is far richer and more prolific than its theology. The lack of any Jewish religious art, and the paucity and vagueness of New Testament descriptions, presented no barrier to the Christian artist. First, he might have gone for inspiration to such writings as the

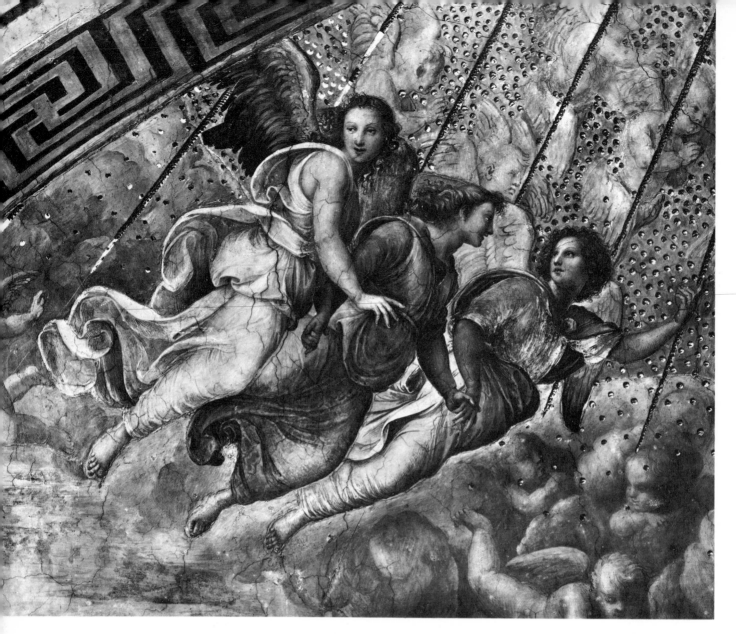

Celestial Hierarchies of Dionysius the Areopagite, and to other Neoplatonic authorities. Here he would have learned how to 'Christianize' the ancient gods and goddesses. Or he might have studied the 'idols', now broken and greyed with time, still to be seen in Rome and Byzantium. Perhaps the visions of mystics sustained his intuition – for it seems that the creatures seen by such ecstatics looked very much like the winged Victories, the Zephyrs, the Erotes and zoomorphic deities of the ancient pagans. In the earliest Eastern icons, Angels are given robes of imperial purple, despite St Matthew's description of their robes as 'white as snow'; and there are naked Angels on the model of Eros and Mercury, a motif which was not to re-emerge until the Renaissance, and then only in the debased *putti* or so-called cherubs.

24

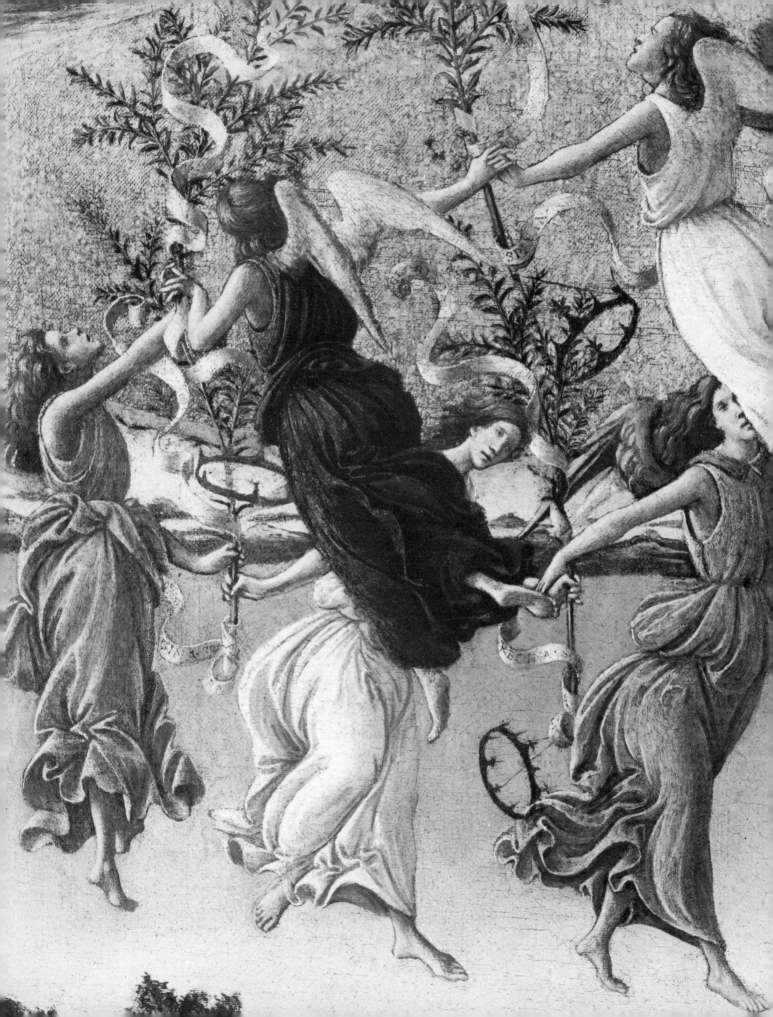

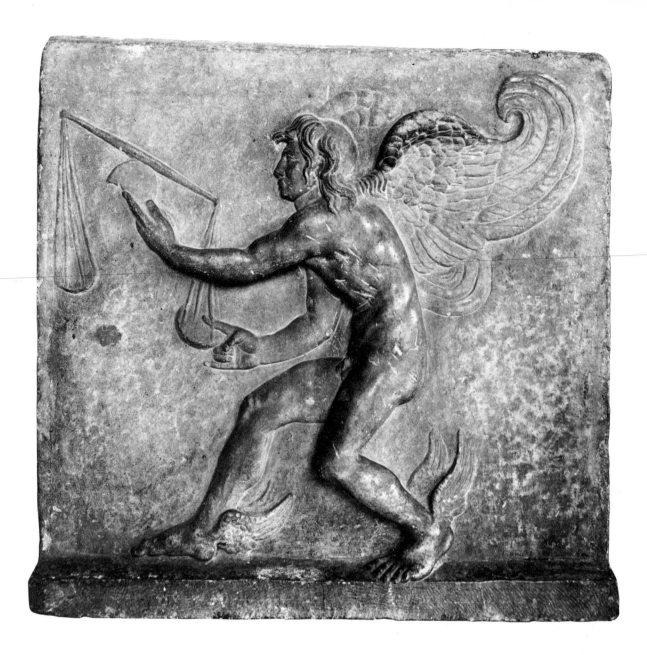

Fate is a messenger of the gods and hence winged. Roman copy after a Greek original; Turin, Museo Lapidario

Nike, or Victory (opposite), served as a model for Christian Angels; only he who meditates on truth is truly victorious. Antique stucco found in the Farnesina gardens; Rome, Museo Nazionale

26

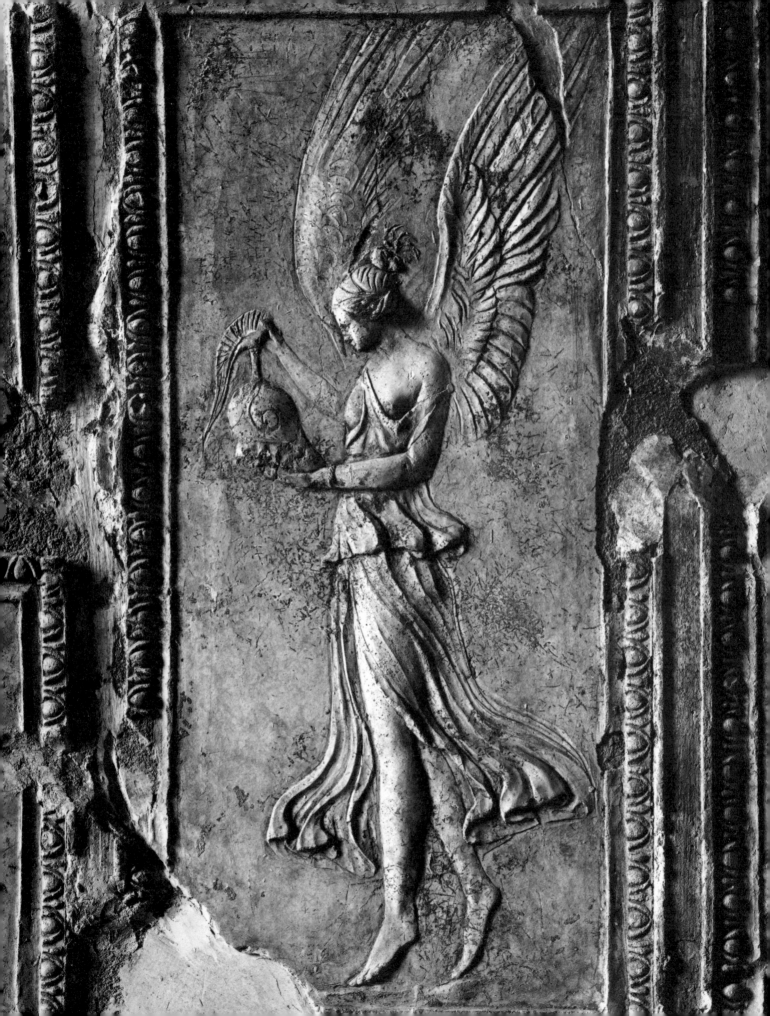

Ophanim, 'Wheels' or 'Thrones': one of the Orders of Angels. From Christian Iconography *by Adolphe Napoléon Didron, 1886, vol. II*

COLOUR PLATES

Even this small icon suggests a cosmic hugeness: Gabriel, principle of the Divine Word, holds in his hand a disc or globe of crystal which seems to represent both the world – the outer display of God's magnitude, and the womb – the secret innerness of God's mercy

For Blake, Satan is only accidentally the cause of evil (since evil has no being in itself, but only as a deprivation of good). For the soul freed of illusion, the devil resumes his original Archangelic glory, his solar and energizing power

Hildegarde and her nuns are cradled in the arms of an Angel tall as a mountain, whose crown brushes Heaven and whose wings beat like the vast slow movements of clouds, whose face reposes in the infinite mercy of granite, whose breath is the exhilaration of a high plateau. Illumination from a German manuscript, 12th century

The image of the Angel in art emerges from a creative interplay between traditional canons – based on Scripture – and the personal vision of the artist. To say that a visionary sees what Scriptures and sacred art have prepared him to see is not to accuse him of inauthenticity; vision is real, but it is also influenced by culture. In the resonances created by this paradox, the Angel unveils itself.

Basing themselves on the Old Testament and Apocrypha, artists depicted certain Angels in the form of Wheels, which Ezekiel first described: '. . . and their appearance and their work was as it were a wheel in the middle of a wheel.' (1, 16) They move through a firmament which is the colour of a 'terrible crystal', and around a throne like sapphire, on which sits Metatron, suffused in the radiance of the rainbow. The Wheels are often called 'Thrones', but are sometimes seen simply as the 'mounts' of the Kerubim or Seraphim.

Some of this imagery, to be seen in the sculpture of Chartres Cathedral, is drawn from the *Hierarchies* of Dionysius, which gives us descriptions of the nine Orders of the Angels. The biblical accounts of the first three, Seraphim, Kerubim and Wheels or Thrones, have already been mentioned. The next three Orders, Dominions, Virtues and Powers, are described by Dionysius as wearing long albs, golden

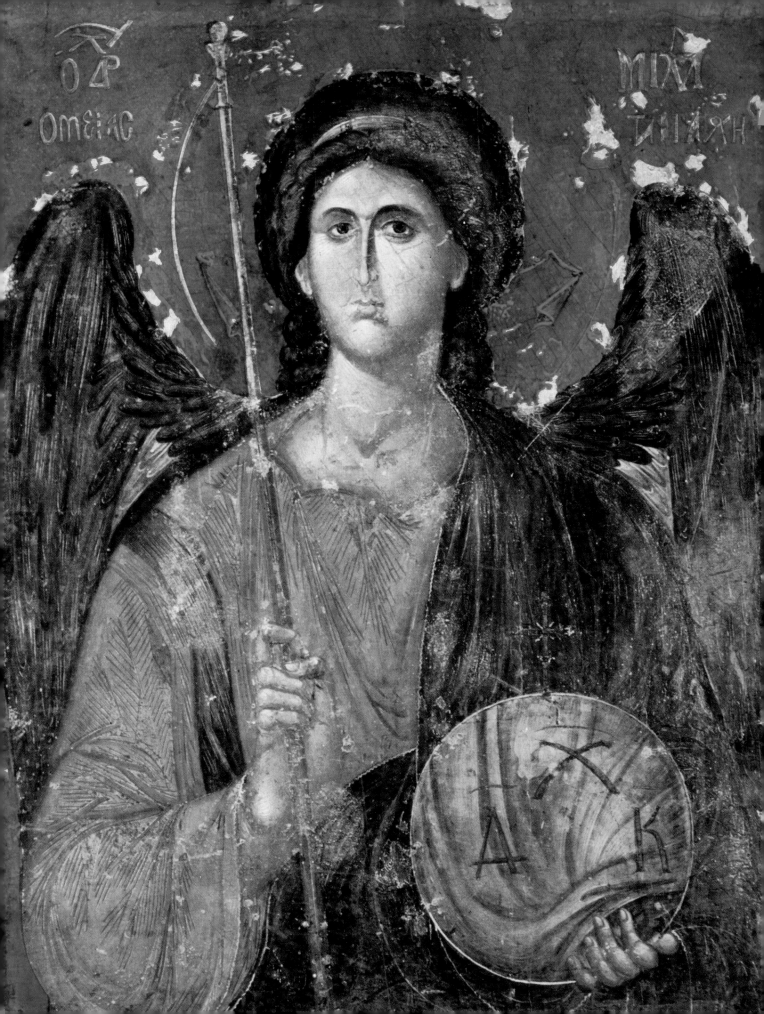

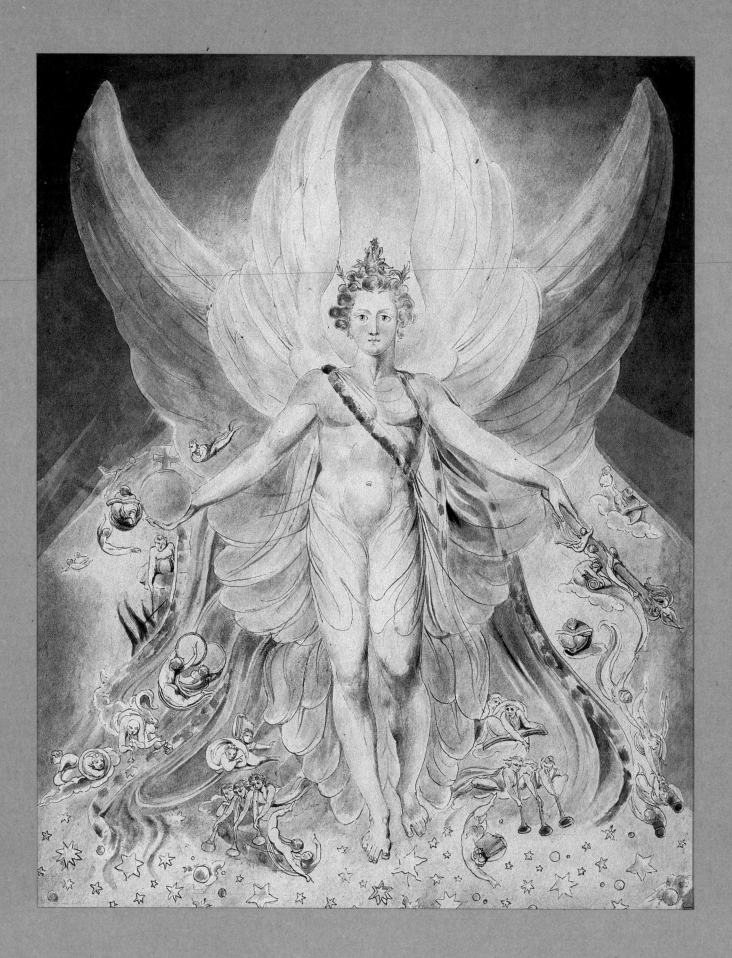

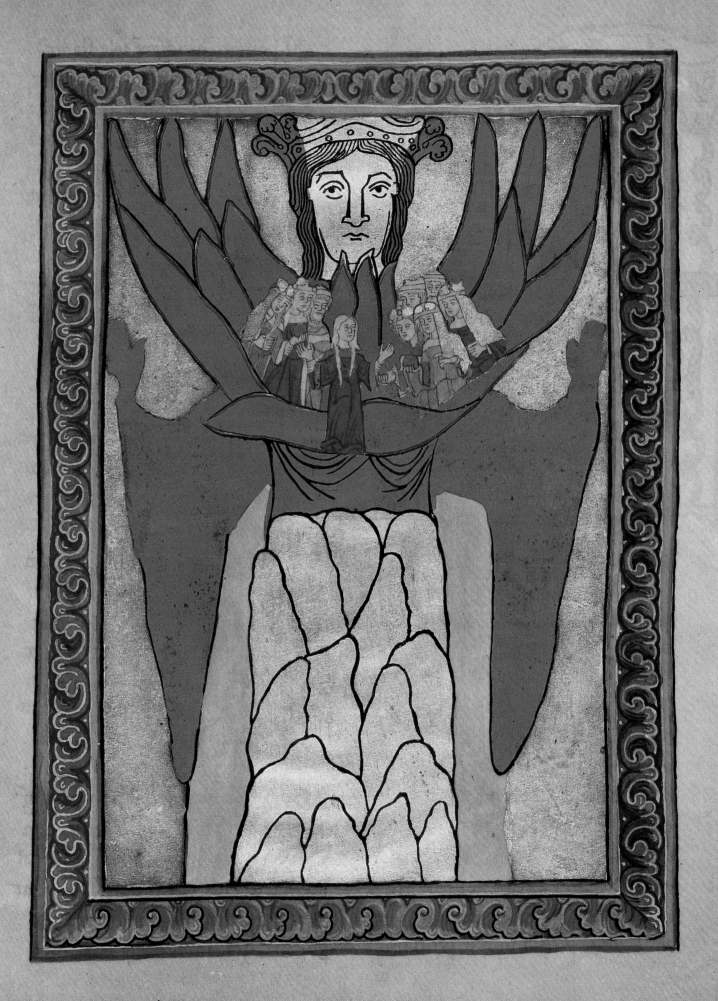

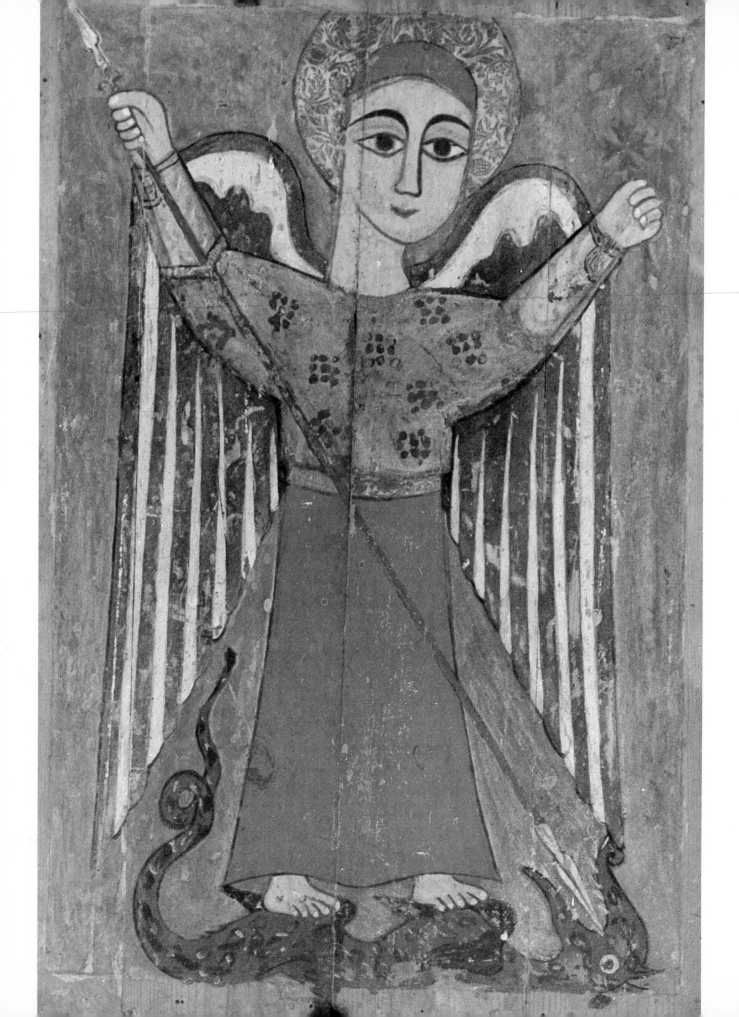

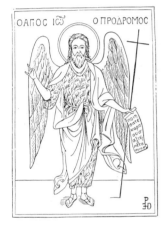

girdles and green stoles. They carry golden staves in their right hands
and the seal of God in their left. The lowest Orders, Principalities,
Archangels and Angels, dress in soldier's garb with golden belts and
carry lance-headed javelins and hatchets. At Mount Athos, in the
frescoes and inscriptions of the convent of Iviron, we discover more
detail:

The *Seraphim* inflame mortals towards Divine love. They are red,
and their three pairs of wings are red; their swords are red as flame.
The *Kerubim*, possessors of wisdom, pour it forth in floods. They
have a single pair of blue wings, and are richly garbed as Orthodox
bishops.

Above all limit are set the high *Thrones* around the Most High.
They are fiery Wheels with eyes and a haloed Angel's head. The
Virgin is linked to this Order: 'True Throne of God she exalts the
Thrones of God'.

The *Dominions* direct their will in accordance with the truly
supreme power of the absolute Master. They have two wings, robe,
mantle, shoes. In the right hand they hold a seal with a monogram of
Jesus, in the left a staff surmounted by a cross. St John the Baptist is
depicted as one of this Order, but barefoot and clad in skins; for he
was the messenger and Angel of Jesus.

Few realistic depictions, however, are able to do justice to the radiance of these creatures as experienced in personal vision. Père Lamy (1853–1931), a pious and simple French curé who regularly conversed with Angels, describes them thus:

Their garments are white, but with an unearthly whiteness. I cannot describe it, because it cannot be compared to earthly whiteness; it is much softer to the eye. These bright Angels are enveloped in a light so different from ours that by comparison everything else seems dark. When you see a band of fifty you are lost in amazement. They seem clothed with golden plates, constantly moving, like so many suns.

In all Marian apparitions of the nineteenth and twentieth centuries, the Virgin has been preceded and accompanied by Angels of this kind, who are described, too, by the children of Lourdes, Fatima and Garabandel.

Contrary to popular opinion, Islam does not prohibit images. Theologians may frown, but Moslem artists, like Sufi mystics, have imbibed a rich iconography of Angels from all the streams and sources which nourish the Islamic 'mythos': Jewish, Christian, Zoroastrian and Mesopotamian, Hermetic, Classical, pagan, Gnostic and Manichaean, Buddhist and shamanist. The following is an 'angel-ography', culled from various Islamic sources:

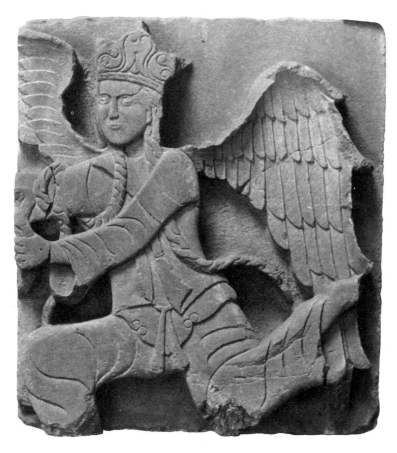

This 'Islamic' Angel displays Buddhist, Manichaean, Christian and Hellenistic influences. One of pair of winged figures originally above the main entrance to the Citadel in Konya, 1220; Konya, Ince Minaret Museum

34

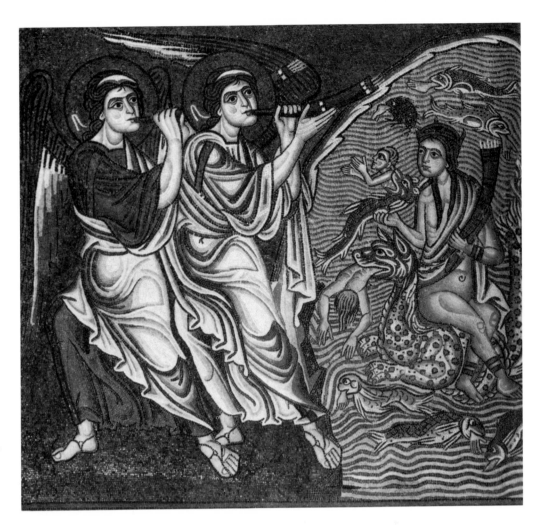

Death is a deep-sea goddess; the music of the Angels summons forth the souls of the dead like forgotten dreams. 12th-century mosaic in the Duomo, Torcello, Venice

From the soles of his feet to his head, Israfil, the Angel of the Day of Judgment, has hairs and tongues over which are stretched veils. He glorifies Allah with each tongue in a thousand languages, and Allah creates from his breath a million Angels who glorify Him. Israfil looks each day and each night towards Hell, approaches without being seen and weeps; he grows thin as a bowstring and weeps bitter tears. His trumpet or horn has the form of a beast's horn and contains dwellings like the cells of a bee's honeycomb; in these the souls of the dead repose.

Mika'il (Michael) was created by Allah 5,000 years after Israfil. He has hairs of saffron from his head to his feet, and his wings are of green topaz. On each hair he has a million faces and in each face a million eyes and a million tongues. Each tongue speaks a million languages and from each eye fall 70,000 tears. These become the Kerubim who lean down over the rain and the flowers and the trees and the fruit.

Jibra'il (Gabriel) was created five hundred years after Mika'il. He has 1600 wings and hair of saffron. The sun is between his eyes and each hair has the brightness of the moon and stars. Each day he enters the Ocean of Light 360 times. When he comes forth, a million drops fall from each wing to become Angels who glorify Allah. When he appeared to the Prophet to reveal the Koran, his wings stretched from the East to the West. His feet were yellow, his wings green, and he wore a necklace of rubies or coral. His brow was light, his face luminous; his teeth were of a radiant brightness. Between his two eyes were written the words: There is no god but God, and Mohammed is the Prophet of God.

The Angel of Death, Azrael, is veiled before the creatures of God with a million veils. His immensity is vaster than the Heavens, and the East and West are between his hands like a dish on which all things have been set, or like a man who has been put between his hands that he might eat him, and he eats of him what he wishes; and thus the Angel of Death turns the world this way and that, just as men turn their money in their hands. He sits on a throne in the sixth Heaven. He has four faces, one before him, one on his head, one behind him and one beneath his feet. He has four wings, and his body is covered with innumerable eyes. When one of these eyes closes, a creature dies.

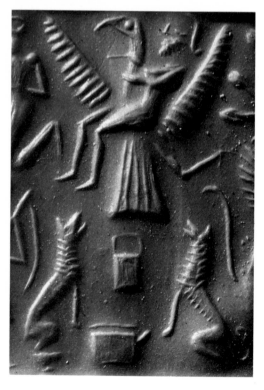

The archetype of flight, or of the Winged Man, can be traced back to the very beginnings of art. Bowl from Susa, Iran, and Babylonian cylinder seal of Sargonid Age, dynasty of Akkad; both in British Museum

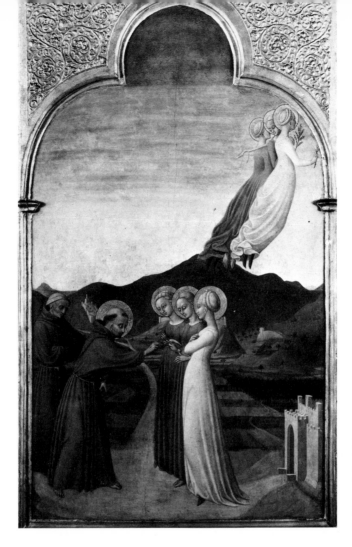

Marriage of St Francis to Lady Poverty, *painting by Sassetta (c. 1392–1451); Chantilly, Musée Condé. After the 'marriage', the three winged Virtues fly towards Heaven*

What do these and all Angels have in common? In both monotheistic and polytheistic traditions, Angels serve as messengers of God (or of the gods). We are dealing with the inhabitants of an intermediate world, and the function of messenger is *par excellence* that of intermediary. According to the Prophet Mohammed, Angels are sent by God to earth to search out those places where individuals or groups are engaged in remembering or invoking the Deity. They listen with joy, hovering over the roofs of these humans who are fulfilling the task for which they were created: to know God, Who loves to be known. Then they fly back to the Divine Throne and repeat what they have heard (though God already knows it better than they) and are entrusted with blessings to bestow on earth.

This is what characterizes Angels in all traditions: they move between earth and heaven, like the figures seen in Jacob's vision of the ladder.

Like a sudden inspiration, unlocked by prayer, an Angel whispers in the ear of the Duchess Alice. Tomb of the Duchess of Suffolk, Alice de la Pole; Ewelme, Oxon., 1473

God 'speaks' through the Angels, who descend to earth like a cascade of glittering sparks. William Blake, God Answering Job out of the Whirlwind; *National Gallery of Scotland*

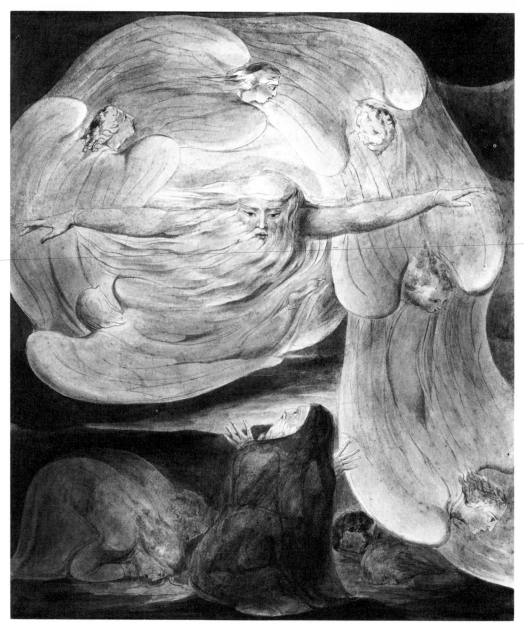

St Teresa said that 'God alone suffices', which is true enough in one sense. In another sense, however, every 'appearance of God' is in fact an appearance of the Angel – or so we shall try to demonstrate in many cultures – and, following this interpretation, man experiences a relationship with God through a relationship with the Angel.

Virtually nothing can occur without the intervention of the Angels. Mohammed said that every raindrop that falls is accompanied by an Angel – for even a raindrop is a manifestation of being. The Angelic World is a *place* inhabited by *living creatures* – but more than that, it constitutes the very relationship between the world and God.

The Angel as messenger
in three traditions:
Hellenistic, Islamic and
Christian. Detail of Hebe
from an antique vase
painting; detail of a
Mughal miniature; detail
from The Annunciation
by Melozzo da Forlì

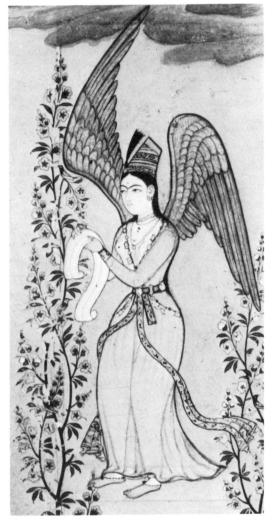

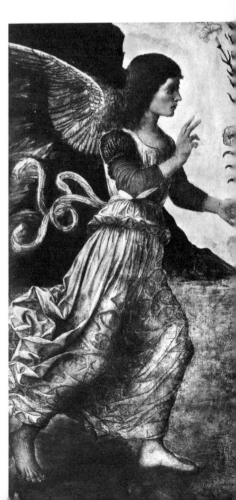

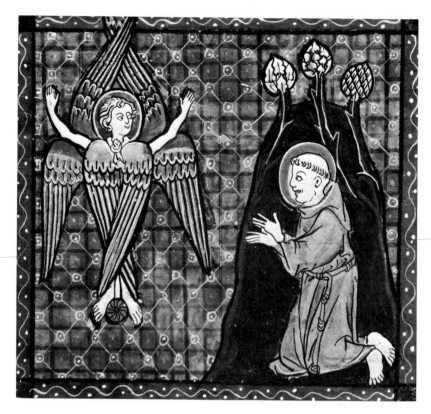

St Francis is called
'seraphic'; his followers
believe that he became an
Angel after his death. In
this miniature from a
manuscript of the Golden
Legend, compiled c. 1300
by Jacobus de Voragine,
he is seen receiving the
stigmata from a Seraph

Angels of Revelation
possess the ambiguous
symbolic power of that
book: they are multivalent,
impenetrably awesome,
violent and profound

COLOUR PLATES

God the Great Architect,
compass in hand, begins
the work of creation. The
whole substance of reality,
the air out of which He
shapes His poetry, is made
up of Angels, so many rays
from His crown. From a
15th-century French
manuscript

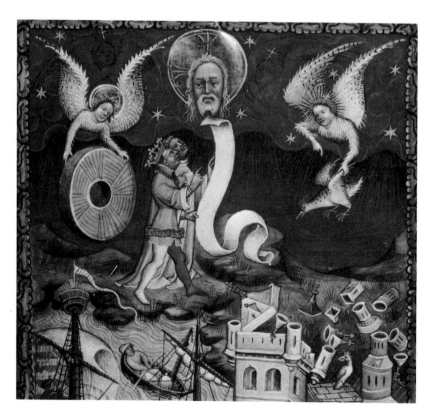

Not Christ on the cross –
He is risen – but the four
Angels of space, of
totality, dumbfounding
the saints with horn-blasts
heard from pre-eternity till
beyond Time's end. The
Second Coming; from an
Armenian Gospel

All things are Light, rays
of the supernal sun. The
Angels stand between us
and God, but they are
translucent, even trans-
parent, and they beckon us
to penetrate their lumino-
sity. West window of
Salisbury Cathedral, 16th
century

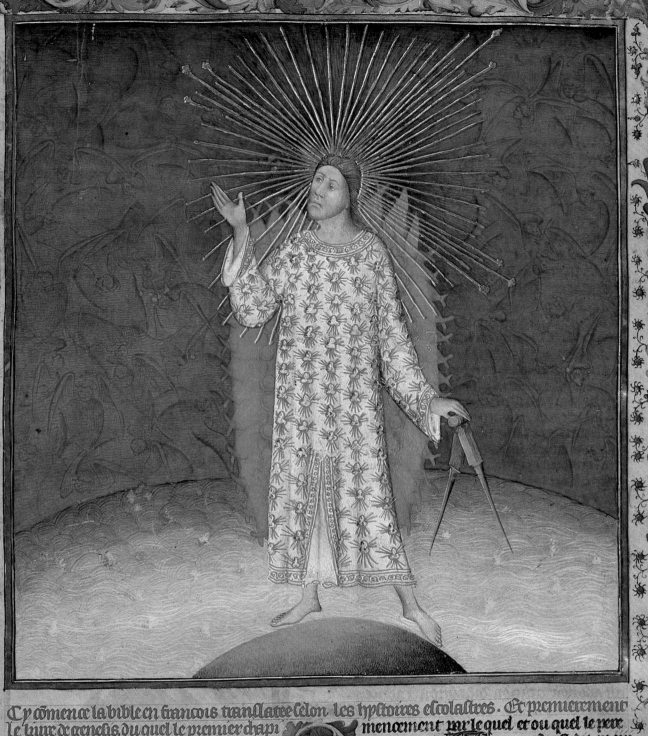

Cy cõmence la bible en francois tranflatee felon les hyſtoires eſcolaſtres. Et premierement le liure de geneſis. du quel le premier chapitre parle de la creacion du monde. Et pmie rement de la creacion du ciel. et de la terre.

Au cõmencement crea dieu le ciel et la terre. Si eſtoit la terre vaine et vuide. et tenebres eſtoient ſur la face de labiſme. et leſperit de noſtre ſeigneur ſe tranſportoit ceſt adire regardoit ſur les yaues. hyſtoire ſur ceſte partie deuantdicte de geneſis. Au cõmencement fu le filz. Et le filz eſtoit le cõ

mencement par le quel et ou quel le pere crea le monde. Le monde eſt dit en maintes manieres. Aucune fois eſt le monde appelez le ciel empiree. gloſe. Les theologiens dient que en la region du ciel ceſt en paradis ſont trois cieulx de diuerſes couleurs. Dont le premier eſt de couleur de criſtal. Le ſecond eſt de blanche couleur cõme noif. Et le tiers de rou ge couleur cõme feu. auſſi cõme ſe il fuſt tout en feu non ardant ne mal faiſant. Et ceſtui ciel de rouge couleur eſt le ciel empiree. et ſi eſt le plus hault. Et dient les theologiens que

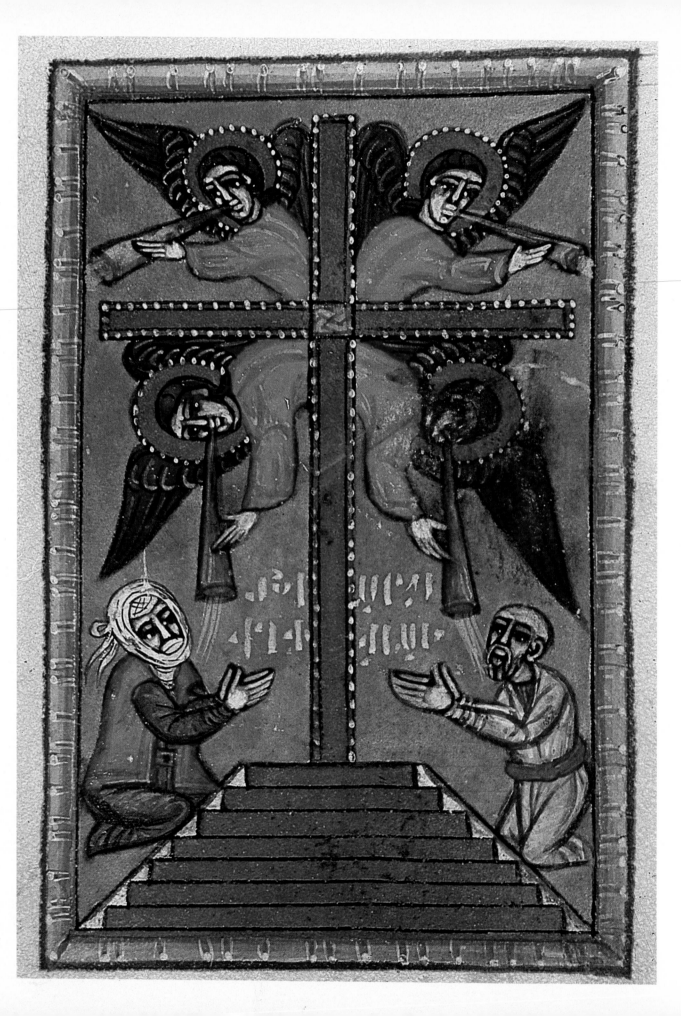

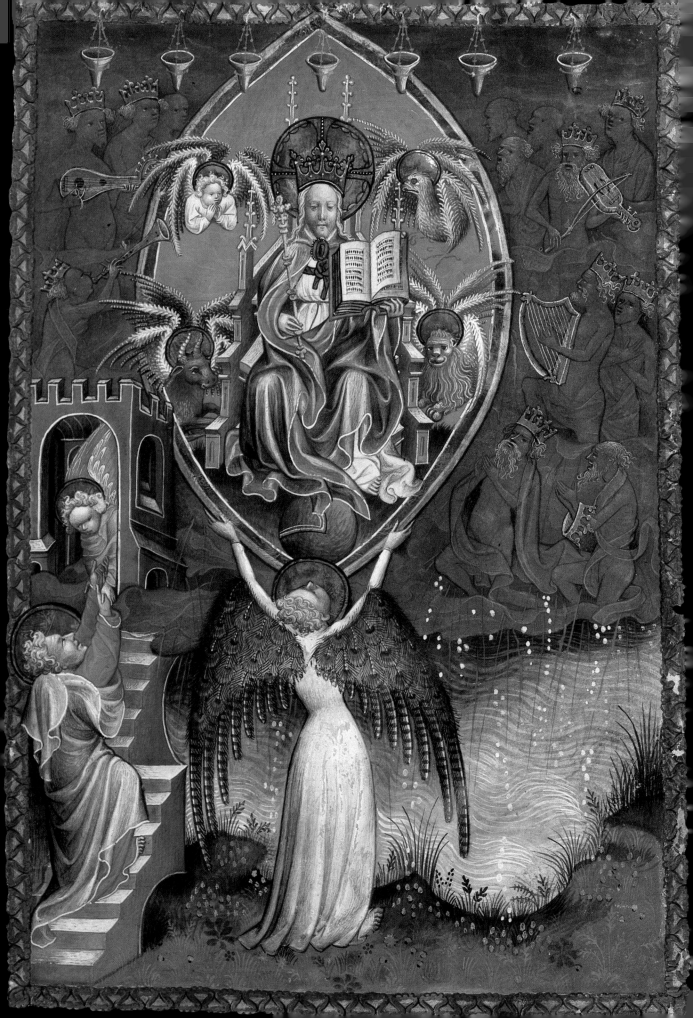

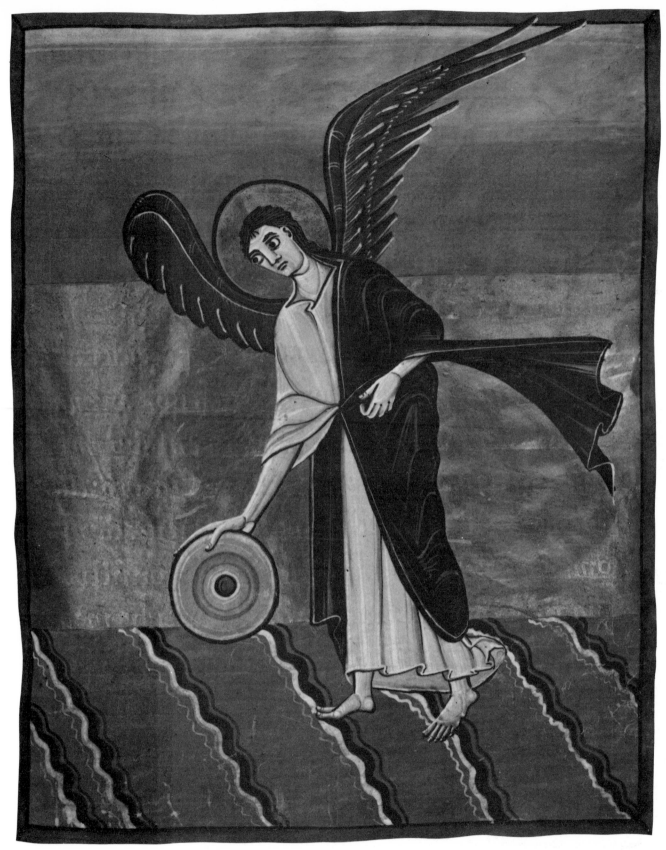

COLOUR PLATE

The empyrean of Apoca-
lypse swarms with music;
a peacock-Angel opens a
mandorla in the sky, in
which Christ and the
Angels of the four Gospels

are displayed. On this
night of nights, the one
who wakes might easily
out-do Jacob, and climb
to heaven on a ladder of
light. From the Bamberg
Apocalypse, 15th century

The mills of the gods
grind slow: the apocalyptic
circle reduces every grain
of separative existence to
the dust of Divine union –
the end of time. Bamberg
Apocalypse; Angel with
millstone

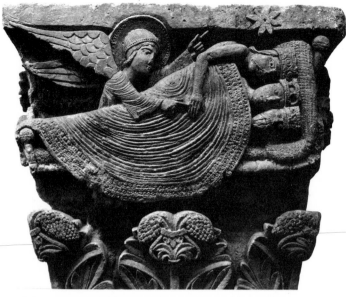

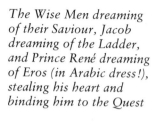

*The Wise Men dreaming
of their Saviour, Jacob
dreaming of the Ladder,
and Prince René dreaming
of Eros (in Arabic dress!),
stealing his heart and
binding him to the Quest*

*Gislebertus, capital from the Church of St Lazare at
Autun: dream of the Magi*

Illustration from Le Livre du Cueur d'Amours Espris

Ferdinand Bol (1616–80), Jacob's Dream

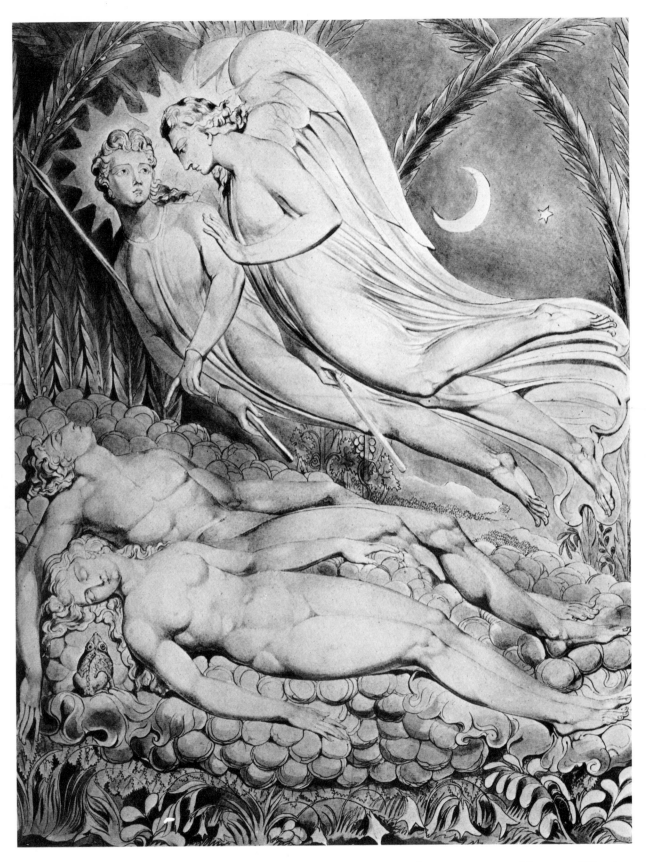

William Blake, Adam and Eve Sleeping, *watercolour, 1808; Boston Museum of Fine Arts*

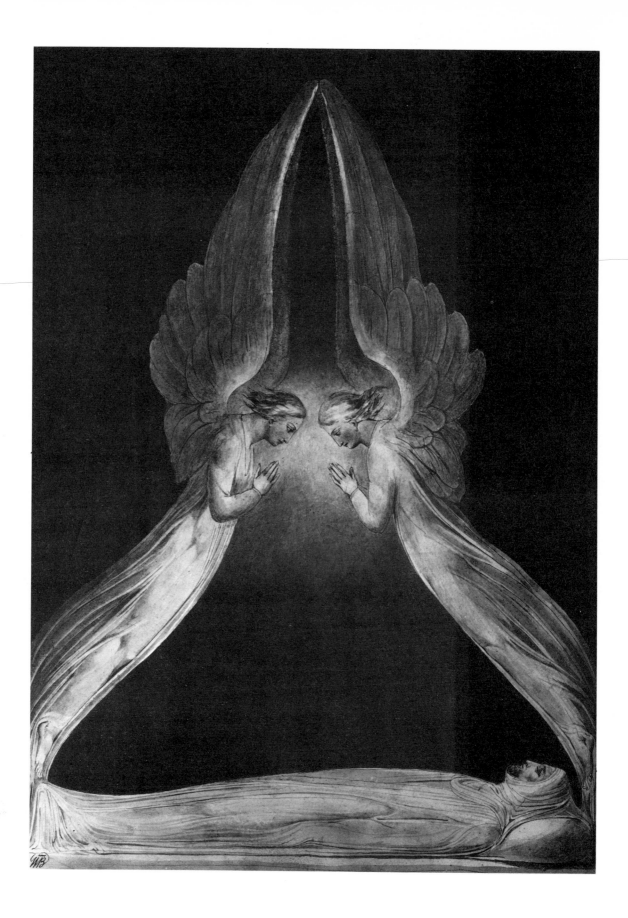

II Angel's work

Leonardo da Vinci, Study for a Kneeling Angel, pen and ink; British Museum, London

Definitions

In the Bible, the Angel of the Lord obviously possesses a spiritual nature, but it also assumes physical characteristics as a voice or a vision. To the reader of myth, to the poet, this apparent contradiction presents no problem. But over the centuries certain theologians have furiously debated the question of how something lacking a material nature can take on a shape. The medieval Jewish philosopher Maimonides reduced all apparitions recorded in Scripture to mere 'figurative expressions', or allegories. Other theologians insisted that the 'incorporeality' of Angels did not rule out their being created of some kind of subtle or ideal matter, so that they are bodiless but numerical. Aquinas called them 'powers' and 'immaterial spirits'. If Scripture refers to their manifestation, he maintained, we must think of it as 'a succession of contacts of power at diverse places' in time but not in location.

Theologians, philosophers and mystics all have the right to define the Angel however they choose, and all such insights can be valuable. But precisely because there are so many different definitions, it will be simpler and more profitable to begin by asking not 'What is an Angel?' but 'What does an Angel do?' Myth and Scripture more often yield stories than definitions and are more concerned with function than philosophy.

The Angel of the Lord

(Opposite) William Blake, Angels Watching over the Tomb of Christ, watercolour; c. 1806; Victoria and Albert Museum, London

Certain Angels remain forever immersed in the contemplation of divine beauty, unaware even that God created Adam. Although these are the highest Angels, they remain outside the hierarchy; they occupy no branch on the Tree. The highest Angel actually belonging to the

49

hierarchy is called the Angel of the Lord – or sometimes simply 'the Lord'.

In the Old Testament he is mentioned many times. It is he who speaks from the burning bush, saves Shadrach, Meshach and Abednego from the fiery furnace, appears as the god of Beth-el in Jacob's dream and stands in the way of Balaam's ass. The three Angels entertained by Abraham at Mamre appear as a triple manifestation of this 'Lord' and are thus identified by Christians as 'the Old Testament trinity', a prefiguration of Father, Son and Holy Ghost.

We have already met this Angel under his Kabbalistic description and name: Metatron, 'Closest to the Throne'. Another Kabbalistic name is Phanuel, 'Divine Face'. 'My face shall go before thee', as God promises Moses in *Exodus*.

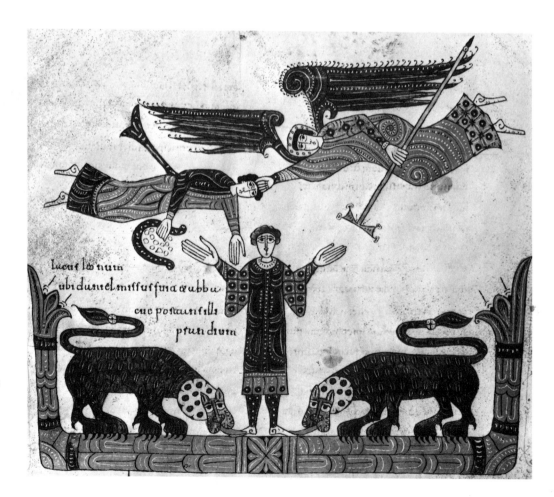

Daniel in the lion's den is protected by Guardian Angels. From a commentary on the Book of Revelation *by a Spanish monk Beatus (d. 798); BM Ms. Add. 11695*

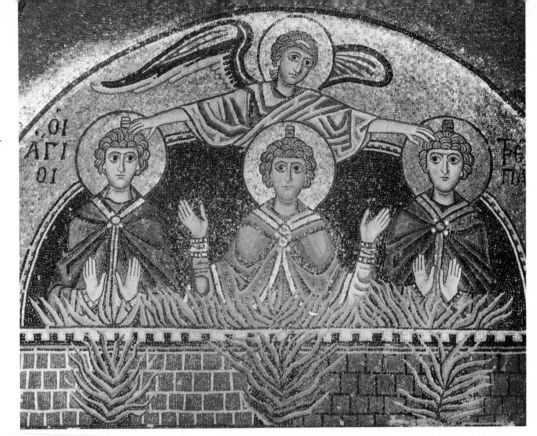

Angels in the Old Testament: the three young men saved from the fiery furnace by the Angel of the Lord; Balaam's ass baulks at the apparition of an Angel; and Abraham plays host to three Angels at Mamre (here portrayed as a three-headed figure symbolizing the Christian Trinity).

Shadrach, Meshach and Abednego; 11th-century mosaic in Hosios Lukas, Greece

Balaam and his Ass; from a Psalter of St Louis (1252–70)

Abraham and the Angels; from a Psalter in St John's College, Cambridge

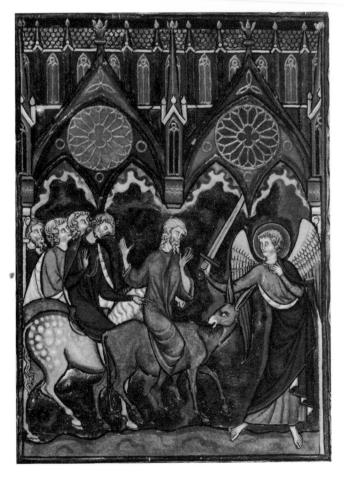

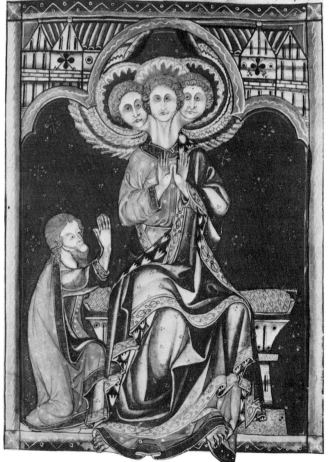

The philosopher Philo Judaeus, in explaining the confusion between 'Lord' and 'Angel of the Lord', says that to embodied souls God shows Himself as an Angel. Not that He changes in Himself, but each soul receives the impression of His presence in a different form.

As St Augustine puts it, the Lord (as God) is 'in' the Angel, who is therefore rightly called 'Lord'. 'It is the name of the indweller, not the temple.' But in truth, as Gabriel told Mohammed, God is veiled by 70,000 veils of light and darkness, and if these were suddenly swept aside, 'even I would be utterly consumed.' The absolute in its absoluteness cannot be contemplated. Therefore every manifestation of God, every epiphany, must take the form suited to the heart which beholds it.

In the Sufi system of Abdul Karim Jili, the highest Angel is identified with 'The Spirit' mentioned in the Koran. He is made from God's light, and 'from him God created the world and made him His organ of vision in the world.' He is the Divine Command, chief of the Kerubim, axis of creation. He has eight major forms, great Angels who bear the Throne, and all other Angels are created from him 'like drops from the ocean'. He is also the eternal 'prophetic light' from which all prophets derive their inner being; the breath or spirit sent to Mary to conceive Jesus; and Mohammed in his perfect manifestation.

Without pressing the comparison too far, one might say that this 'spirit' resembles the Hindu deity, Vishnu, the aspect of God incarnate in the various avatars, such as Krishna, and 'preserver' of all creation.

Jili, in describing the Angel as the 'Mohammedan light', says that God creates from his faculties the Archangels and Angels, who in turn preside over the principles of the universe. From His heart comes Israfil, the mightiest of the Angels, from His intelligence Gabriel, treasurer of Divine knowledge. From His judgment comes Azrael, Angel of Death. From his *himma* (spiritual aspiration) comes Michael, who metes out the fate of all things. From his Thoughts come all the celestial and terrestrial Angels (i.e., the 'souls of the spheres and of mankind'). From his Imagination comes the very stuff of the universe itself, which is 'Imagination within Imagination within Imagination'. From his Soul or Ego come both the sublime and contemplative Angels, the Satan and his hosts.

Remember that Metatron is (or 'was') the prophet Enoch. The most important aspect of the highest Angel will be found in just this unexpected fact: that a man can be raised to such an exalted station.

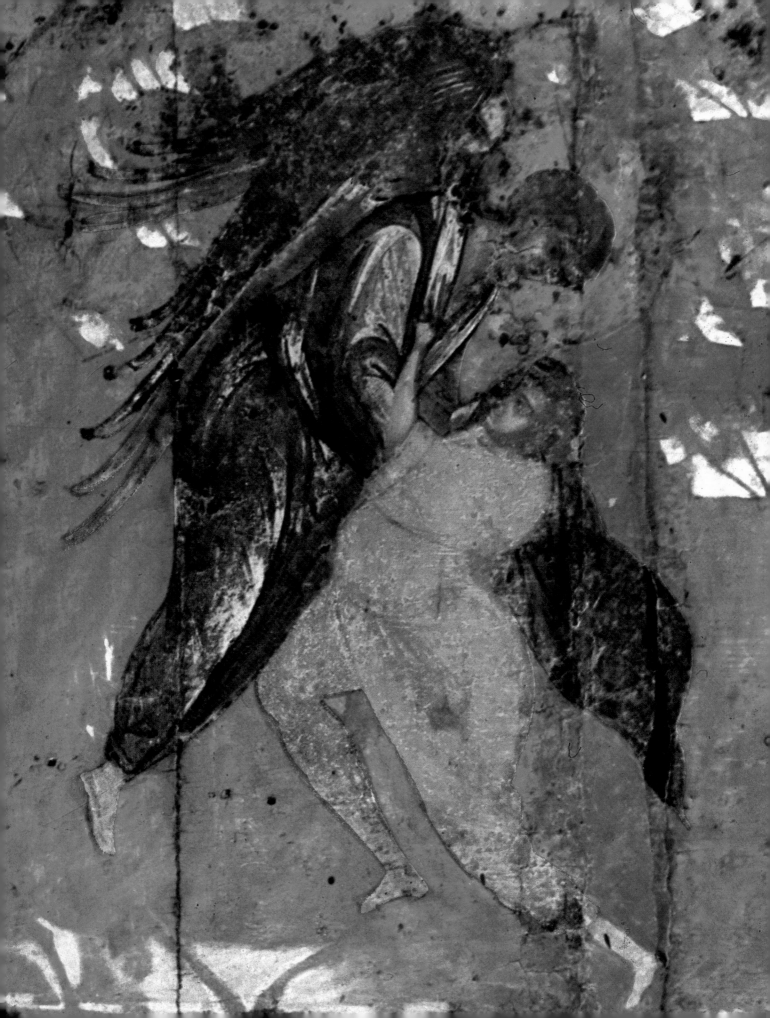

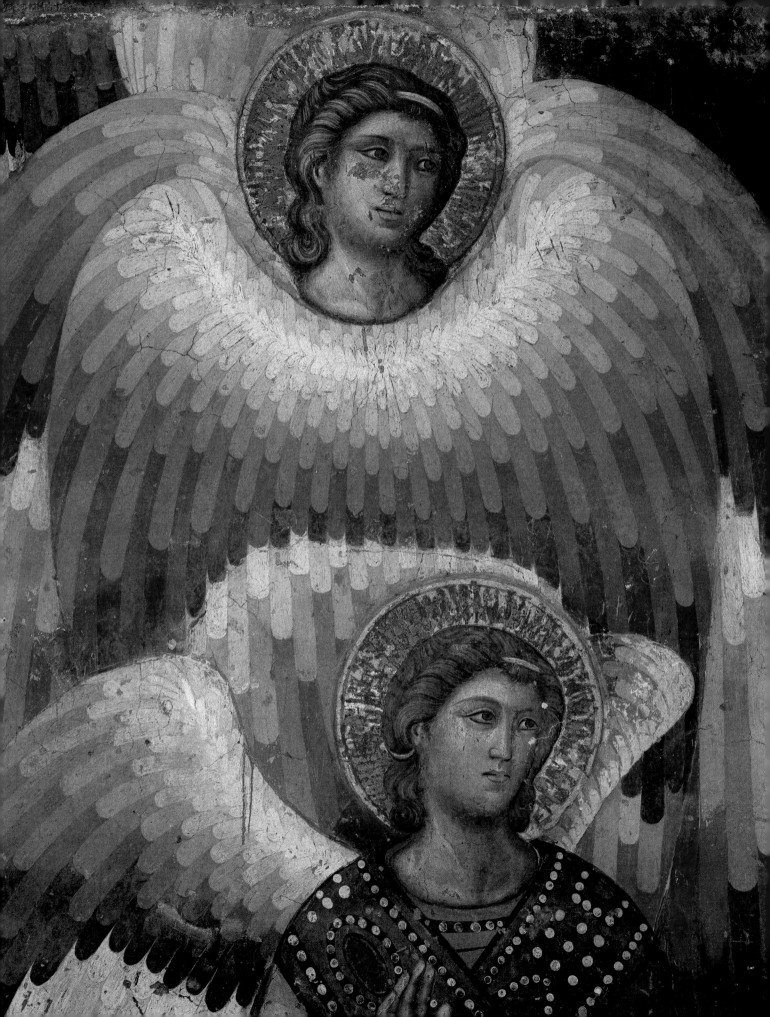

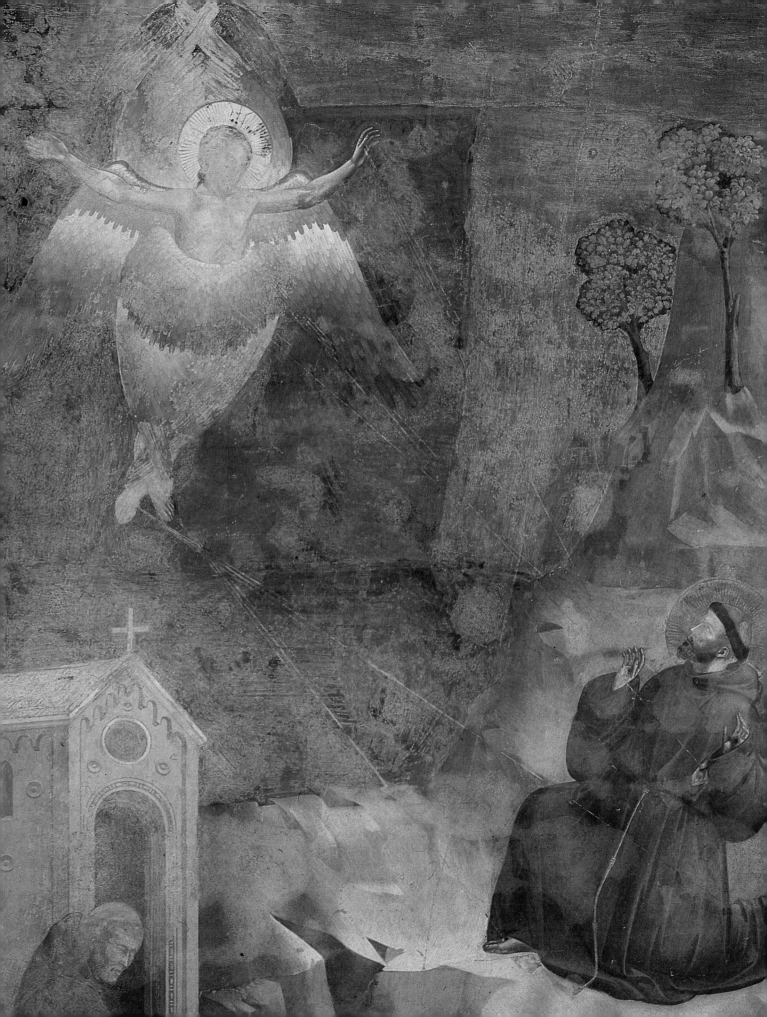

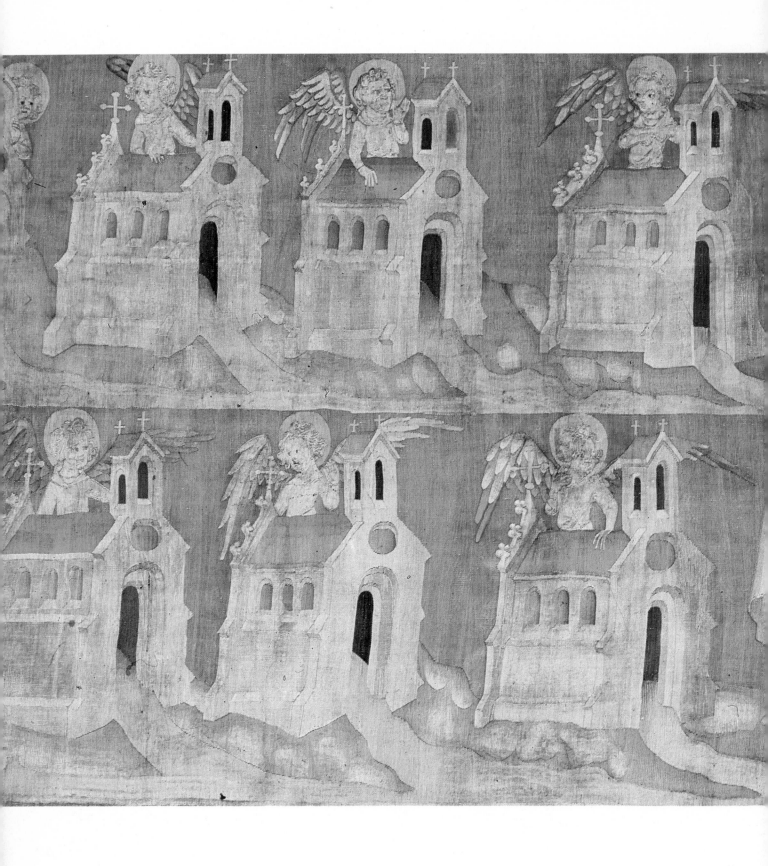

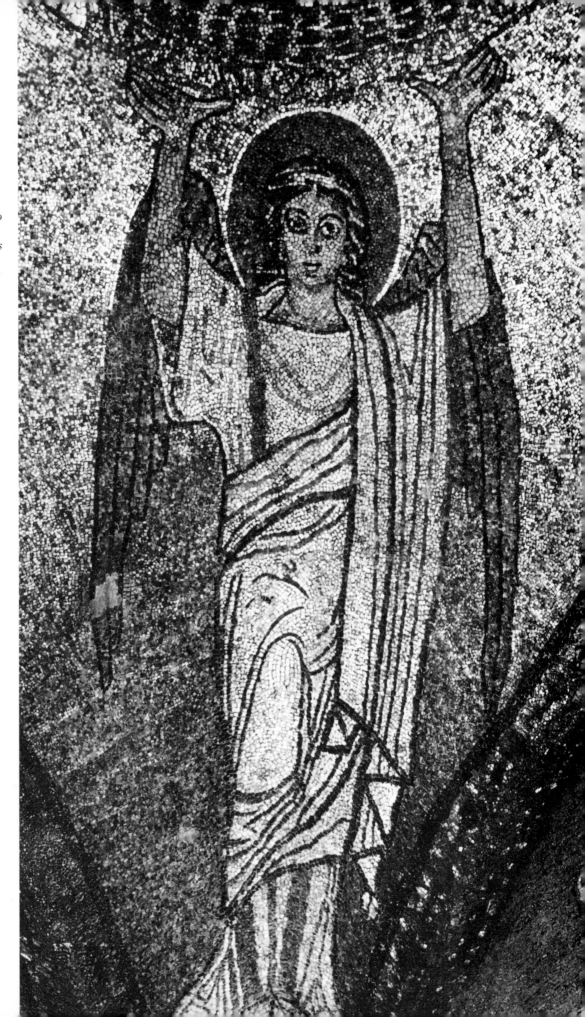

COLOUR PLATE

*Each 'church' has its
Angel; every nation of the
world receives its truth,
its Avatar or manifesta-
tion of God, in the form
of an Angelic teaching. No
rooftop, no soul is un-
visited; for those with eyes
to see, every dustmote
sparkles like a Kerub. The
Seven Churches of Asia
Minor; from the Angers
Tapestry*

*The Angel as Preserver, or
Axis Mundi, Pole of the
World; the very earth
would not remain in
place without the
intervention of that
cosmic force which is
Love. From the Church of
Santa Prasseda, Rome;
9th-century mosaic*

The Logos

The Eastern Church Fathers solve the problem of the Lord/Angel of the Lord in a different way. God is three Persons, and the Person or aspect of God which manifests itself, which appears on the level of creation, is neither the Father nor the Holy Spirit, but the Son. 'In the beginning was the Word,' the Logos, the Christic Principle. All Old Testament appearances of the Lord/Angel of the Lord are considered by the Eastern theologians to have been partial manifestations, limited theophanies of the Logos. Jesus is the final and perfect incarnation of the Logos; He is the Living Word, the Word made flesh.

If the Logos has a special Angel, however, it must surely be Gabriel. It is he who announces to Mary the descent of the spirit; it is he who brings to Mohammed the words of the Koran. He has several forms: in his 'cosmic' manifestations to Mohammed he is awe-inspiring, his body blots out half the sky, which resounds with the rushing of his wings. In icons and late medieval paintings, however, he takes his more usual shape, that of a delicate and uncannily beautiful youth, in which he often appeared to Mohammed. The Sufi Ruzbehan Baqli describes him: 'In the first rank I saw Gabriel, like a maiden, or like the moon amongst the stars. His hair was like a woman's, falling in long tresses. He wore a red robe embroidered in green. . . . He is the most beautiful of Angels. . . . His face is like a red rose.'

According to many Islamic thinkers, Gabriel is the tenth and last of the great chain of Archangel intellects which emanate from God. He rules the sphere of the moon and all that lies below it; hence he is the Angel of Humanity. All 'terrestrial Angels' – human souls – derive from him. In a sense he is father, in another sense beloved. Gabriel is the archon of all Guardian Angels. When an Angel appears to man, he is Gabriel, or is sent by Gabriel.

All this the thirteenth-century Persian poet Rumi sums up in the *Mathnawi*, in his description of the Annunciation:

> Before the apparition of a superhuman beauty,
> before this Form which flowers from the ground like a rose before her,
> like an Image raising its head from the secrecy of the heart . . .

(Opposite) Mohammed, visiting Heaven, is awe-struck by the cosmic form of the Archangel Gabriel (who has previously appeared to him only as a disembodied voice, or as a human youth). Miniature by Mi'raj-nameh, 15th century, British Museum, London

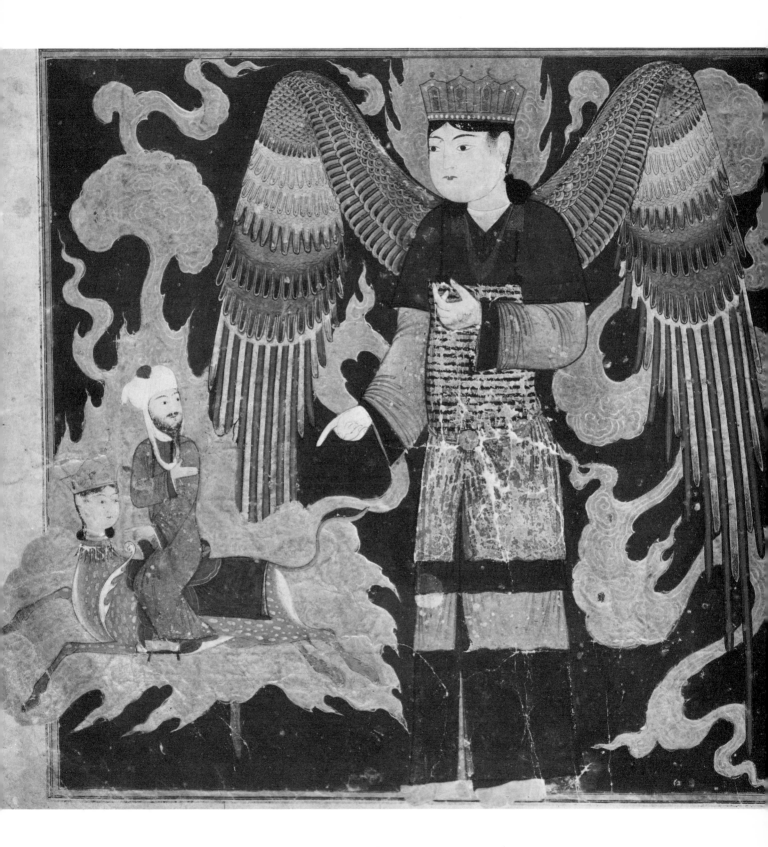

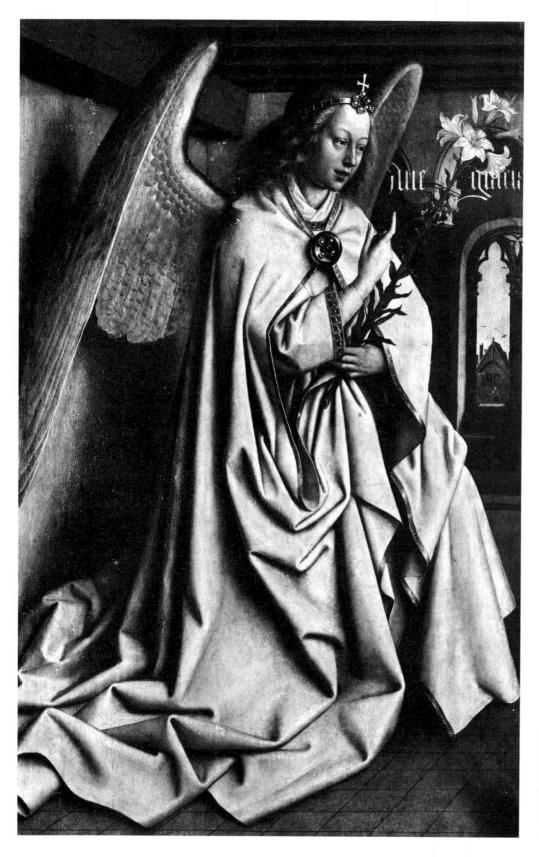

In every tradition Gabriel possesses a feminine beauty, symbolic of the perfection and bliss which are the very essence of his 'message'. Detail of the Ghent altarpiece by Jan and Hubert van Eyck

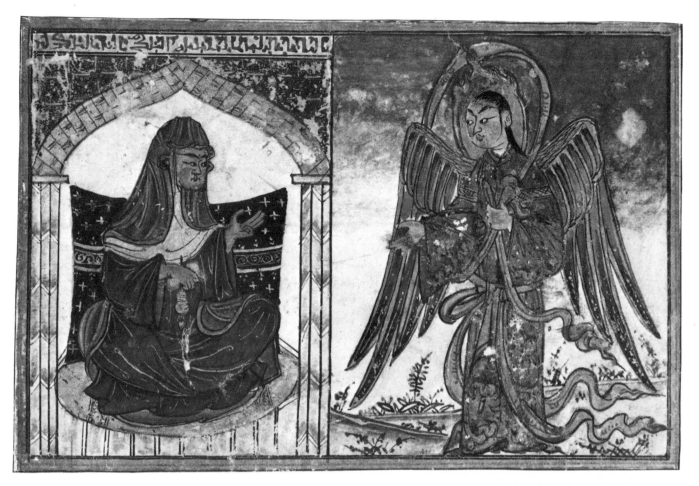

The Islamic version of the Annunciation differs from the Christian one only in dress; the Koran is quite specific on the subject of the Virgin Birth and Mary's preeminence. Illumination from an Islamic treatise on different systems of chronology, 1307

In the shade of Jesse's Tree, where David plays his harp, the dove seems almost conjured out of Heaven, as if Gabriel were a benign sorcerer. Detail from the Westphalia Passion Altar, c. 1400

Mary is afraid, and exclaims, 'I take refuge in God.' But Gabriel chides her:

> O Mary! Look well, for I am a Form difficult to discern.
> I am a new moon, I am an Image in the heart.
> When an Image enters your heart and establishes itself,
> you flee in vain: the Image will remain within you –
> unless it is a vain fancy without substance,
> sinking and vanishing like a false dawn.
> But I am like the true dawn, I am the Light of your Lord . . .

(Nicholson's trans.)

If the Angel is a 'messenger', moving between heaven and earth 'with a lightly rushing motion' (as Plato says), he is not merely a *nuncio*, a character out of the prologue of a Greek play. He *is* the Message, as the Message manifests itself to man.

Thus Philo calls all Angels *logoi*. In interpreting the story of Balaam's ass, he names the Angel '*Conviction*, the divine logos, the Angel who guides our feet and removes the obstacles before them, that we may walk without stumbling along the high road.'

The recording Angels, searching endlessly through their scrolls of human deeds. From the Wonders of Creation *of al-Qazwini, 1208*

So the logos-Angel appears often bearing a book, or somehow he *is* a book or a letter. The Gnostics named him 'the Call', the summons from beyond the spheres which awakens the soul from her profitless slumber, her demonic dream, and beckons her upwards to her true home. According to the Hebrew *Testament of Naphtali*, the Angels taught the nations of man their various languages; and for the Sufi each of the twenty-eight letters of the Arabic alphabet is ruled by an Angel (and is related to a phase of the moon, Gabriel's sphere).

Sophia

For the most part, Angels are either male – since they represent the Active Intellect in relation to the human soul seen as passive and feminine – or androgynous, since they represent perfection, completion, *coincidentia oppositorum*. But the feminine cannot be excluded from the realm of the 'Most High'. In the Kabbala, the second of the Sefiroth (or 'universal Divine principles'), *Binah* or Wisdom, is feminine. If Western monotheism has a 'goddess', then this is she.

She is often called by her Greek name, Sophia, Wisdom – that which the philosophers love. In Orthodox Christianity she occupies an exalted position, related but not equivalent to that of the Virgin. The iconographers paint her as a winged Angel seated upon a throne. She is crimson, the colour of alchemical stone, or of twilight, the time which opens a crack in time, a gateway between worlds.

In Tantrik Hinduism, every god has a *shakti* or feminine 'power'. In our texts, Sophia seems to be the shakti of God Himself. The Tantrik Buddhist idea of the feminine is in some ways even closer to the Hebrew Sophilogy. In Buddhism she is also called 'Wisdom', but she is passive ('. . . the unspotted mirror of God . . . a cloud . . .'). The intercourse which the gods and bodhisattvas enjoy with their shaktis represents their perfect harmoniousness. (Incidentally the Buddhist shaktis are often described as 'dakinis' or Angels.) The yogi, like Solomon, must attain 'immortality' (liberation, *moksha*) by a similar union with the feminine principle of Wisdom. In Hindu Tantra he attains this through *being enjoyed* by Shakti as goddess; in Buddhism through *enjoying* her as consort. In either case, the goal of the mystic is given a feminine personification, and comparisons (if not precise analogies) can be made with Western Sophilogy.

In the grandiose cosmic speculations of early Christian gnosis, the theme of Sophia is amplified and distorted in strange and revealing

ways. True dualistic gnosis, like that of the second-century philosopher Valentinus, is based on the idea of a complete separation of Good and Evil. Good lies entirely *outside* the cosmos; creation is totally evil, ruled by diabolical powers. The God of religion is often depicted as one of these demons; the gnostics particularly detested the Jehovah of the Old Testament, and taught that Christ came to release man from bondage imposed by this false god of the Jews.

Thus the values of the Old Testament are reversed as in a carnival mirror, and Sophia is revealed as the spirit responsible, through her *folly*, for the creation of the world, an error of cataclysmic proportions.

The Archangels and Satan

The gnostic 'shadows' of the Archangels are seven planetary demons. This numeration occurs for perhaps the first time in the ancient religion of Babylonia where the winged bull-man carved over and over again in monolithic grandeur by Mesopotamian and Persian artists exhibits the archaic and totemic countenance of the Angel.

Nebo, the Minister of Merodach, is the Angel of the Lord. The moon-god Athar stands at the head of a heavenly host, the Igigi,

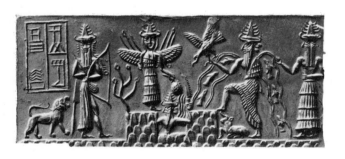

Carved seal and palace relief of winged men from ancient Mesopotamia

(Opposite) Ahura Mazda, the winged sun-disc, is the 'Angel-as-God'. Relief at Persepolis, Iran

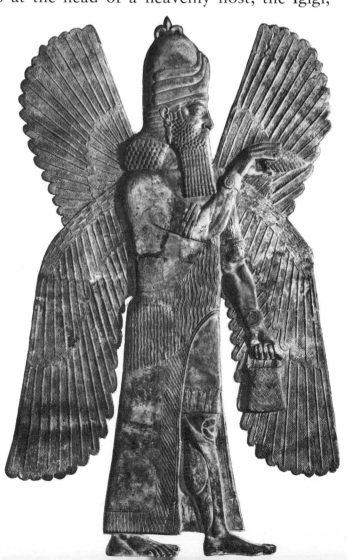

whose champion is Ninip. The Angel-messengers are called Sukalli, sons of the deity whose vicegerents they are. These and other names written on clay tablets long buried in dust, and crumbling slowly back into the element from which they were moulded, call up for us the magic 'sidereal piety' of the Chaldeans, the Harranians, the Sabeans, the star worshippers, our own past selves. Only one tiny Gnostic sect still survives today, the Mandaeans of the Mesopotamian marshes, followers of an unrecognizable John the Baptist who was betrayed by Jesus. Their books are incised on metal. Everything else, all starry wisdom and occult Angelic names, is vanished.

Zoroaster transformed these ancient gods into Archangels. By the time the Jews came in their exile to the East, his religion held sway, and much of the Jewish and Christian lore of Angels dates from Israel's contact with 'Babylonian' wisdom.

The seven Zoroastrian Amesh-spentas include God the Most High seen as a winged sun-disc, a supreme Angel of Pure Light: Ahura-Mazda. Beneath him:

Vohu-mana (Bahman in modern Persian): Good knowledge; protector of the sacred bulls.

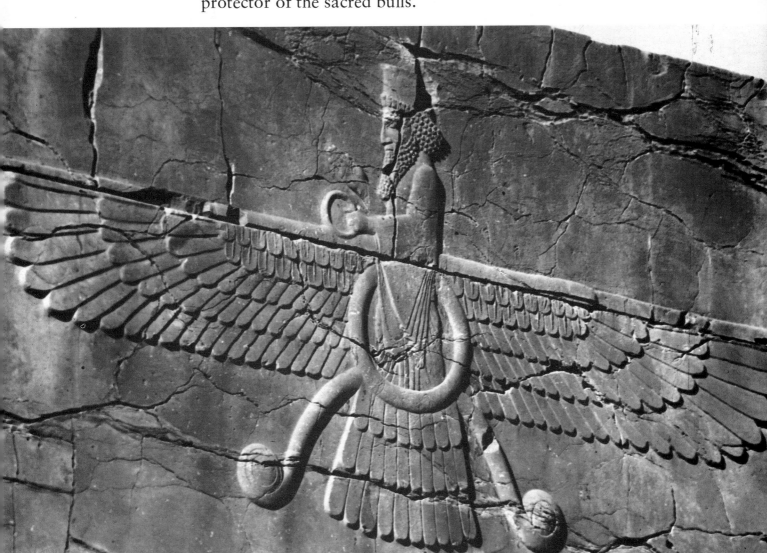

Asha-vahista (Ardibahisht): Truth or the Way; Protector of Fire.

Kshathra-vairya (Shahrivar): Power or the Kingdom; Protector of Metal.

Armati (Isfendarmad): Wisdom; Protector of Earth.

Haurvatat (Khordad): Wealth; Protector of the Waters.

Ameretat (Amerdad): Delight in Beauty or Immortality; Protector of Plants.

Beneath these Archangels are ranked the Yazatas or Angels, including Sraosha the Messenger, Psychopomp and Lord of the material plane; Vata the Air and Winds; Aban the Water; Mithra the Sun-warrior with ten thousand eyes (who later becomes the High God of his own religion); Atar the Fire; Beharam who flies like a bird; etc.

In the post-Exilic *Book of Enoch* we discover the hidden names and functions of those Archangels described so vaguely in earlier scripture, where most of them are not given any name or individuality:

Uriel, who rules the world and Tartarus

Raphael, who rules the spirits of men

Raguel, who takes vengeance on the world of the luminaries

Michael, who is set over the best part of mankind and over Chaos

Saraqael, who is set over the spirits

Gabriel, ruler of paradise, the serpents and the Kerubim

Remiel, whom God set over those who rise.

Enoch also describes a scheme of four Archangels (surrounding God's throne with their hosts): 'The first is Michael, the merciful and long-suffering; the second, who is set over all the diseases and all the wounds of the children of men, is Raphael; the third, who is set over all the powers, is Gabriel; and the fourth, who is set over the repentance unto hope of those who inherit eternal life, is named Phanuel.'

Here we may consider the most colourful if sinister Archangel, the Fallen One, Lucifer. Like the Gnostic Sophia, he is a shadow which must be faced and understood, and – according to certain mystics – 'saved'. If Sophia represents both the wisdom and the folly of the soul, Satan may represent the self, the ego, both 'fallen' and capable of being 'raised up' again.

One can easily see how a dualistic religion such as Valentinianism can admit the reality of a 'devil'. But how can a non-dualistic religion ever conceive the separate existence of Evil? Yet every religion possesses a myth of evil, and how could they not, seeing that evil is often so much more palpable than good?

Only some mystics have solved this theological problem without degrading the myth by admitting that Satan was an Angel, indeed the chief of the Angels.

The story of Lucifer's fall is related in the Apocryphal *Book of Adam and Eve*, and in the Koran. When God created Adam He ordered the Angels to bow before this new creature. But Satan refused, and for this he was banished from the Divine presence.

Man also is both at one with God and at the same time somehow separate from Him, 'fallen'. The myth of Satan is the myth of man's separate identity, his ego. But this separate identity is not *in itself* a bad thing. According to the saying of Mohammed, 'God was a hidden treasure, and desired to be known; so he created the world that He might be known.' God needs Adam to be something other-than-God, so that Adam may come to know God and thus fulfil God's purpose in creating the world. Adam's knowledge closes the circle and returns the Many to the One. And Satan presides over the beginning and end of this drama.

The fall of Satan, like creation itself, is a separation from God which must be; some mystics have gone so far as to identify themselves with Satan, calling him 'the true lover of God's unity'

The Archangel Uriel with the falling Satan; John Milton's Paradise Lost, *III, from* The Poetical Works of John Milton . . . *by W. Hayley, engravings after Westall, London, 3 vols, 1794–97*

Satan consigned to Hell; 17th-century illustration of Revelation 20

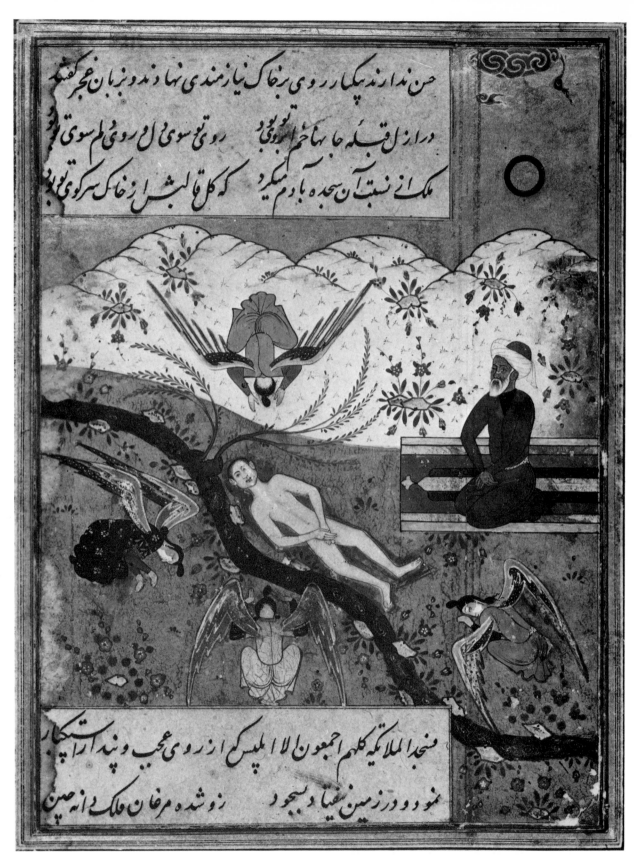

God orders the Angels to worship the newly-created Adam, but Iblis (Satan) kneels stonily and refuses to bow to a creature of clay. From a 17th-century Persian manuscript

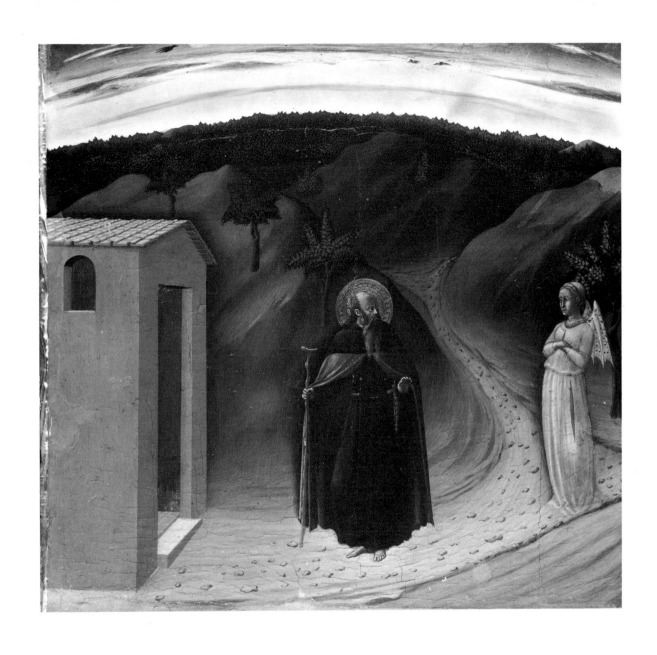

Sassetta (c. 1392–1451), St Anthony Tempted by the Devil, 1423–26; Yale University Art Gallery, New Haven, Connecticut

Dwellers in Paradise

In Hinduism, Heaven or Swarga is the domain of the devas, such as Indra, the chief of the gods (Zeus, Thunder); Agni, the god of fire; Varuna (space and infinity); Yama (death); Kama (Eros) and his consort Rati (passion); Soma (the moon, intoxication); Surya (the sun); and so on. But the Great Gods, the 'trinity' of Brahma, Vishnu and Shiva, do not reside in heaven; for Indra and his realm are not eternal. At the end of time their paradisal life will come to a close, and even the gods will have to seek liberation from the wheel of life. (This ephemerality of Heaven is particularly stressed in southern Buddhism, which emphasizes Nirvana; in Japanese Buddhism, however, the figure of Amitabha presides over a special Western paradise where dwell the souls of those who have invoked him in life.)

Swarga is thus an Intermediate World, and the gods are like the Platonic Archetypes or Archangels. Corresponding to the Angels, the lesser inhabitants of Swarga are called Gandharvas and Kinnaras (the latter are part animal or part bird) and Apsaras, celestial maidens. Gandharvas are musicians, Apsaras dancers; thus the males are melody, the females rhythm, and the two together create the 'harmony of the spheres'. The Apsaras remind us of fairies, for like the Irish Sidhe they sometimes fall in love with human beings (or are sent by the gods to seduce men who are disturbing the peace of the universe). The Apsaras disport themselves in the supremely sensuous sculpture of Hindu temples to remind us of the joys of paradise; and the mystic's enjoyment of paradise-in-this-world is symbolized by his ecstatic marriage with one of these creatures.

The Islamic paradise is watered by crystal streams, and golden pavilions line the banks in the green thought of a green shade. Martyrs inhabit the forms of emerald birds, each with its own emerald pulpit-nest; others of the faithful recline at ease, drinking wine which never causes heaviness, enjoying the embraces of their celestial spouses. Christians are not the only ones to have found this imagery shocking: various Moslems have tried to allegorize and explain it away (and even certain gnostically-inclined sufis express disdain for the eschatology of joy). Again, theologians have stressed that these pleasures are a reward *after death* for those who have refused them in life. The Persian poet Hafiz replied by quoting the Prophet: 'Life is a dream; when we die, we wake.' Over this awakening the Angel presides.

(Opposite) Apsaras – Hindu Angels – sport in paradise. Western Angels are usually male or androgynous, but these are unabashedly feminine. Rock sculpture from a temple, India

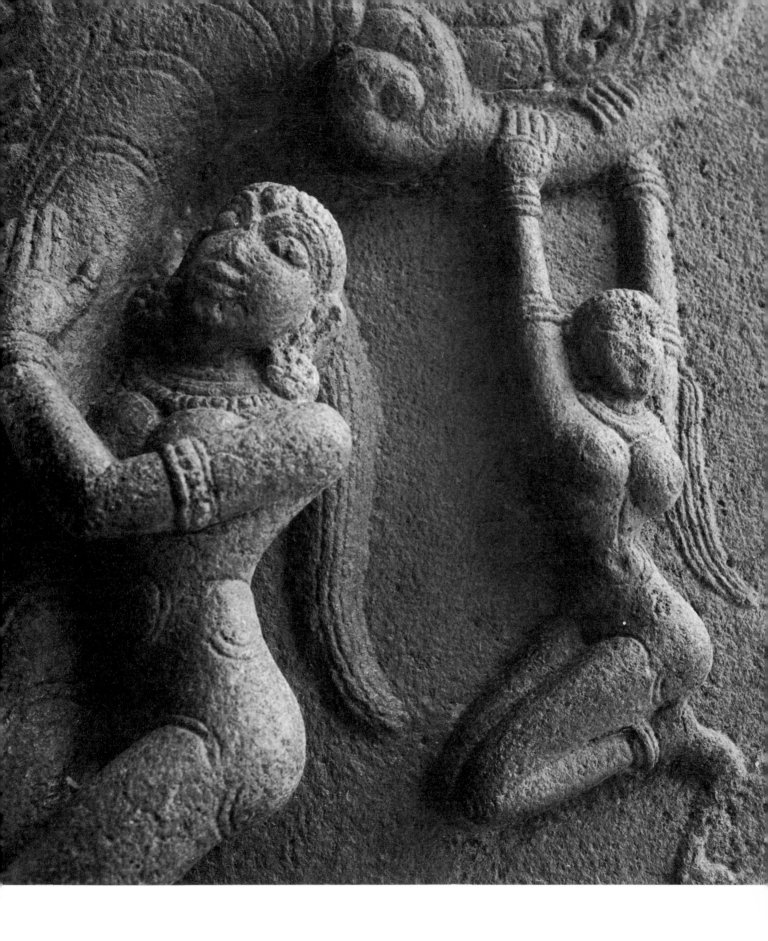

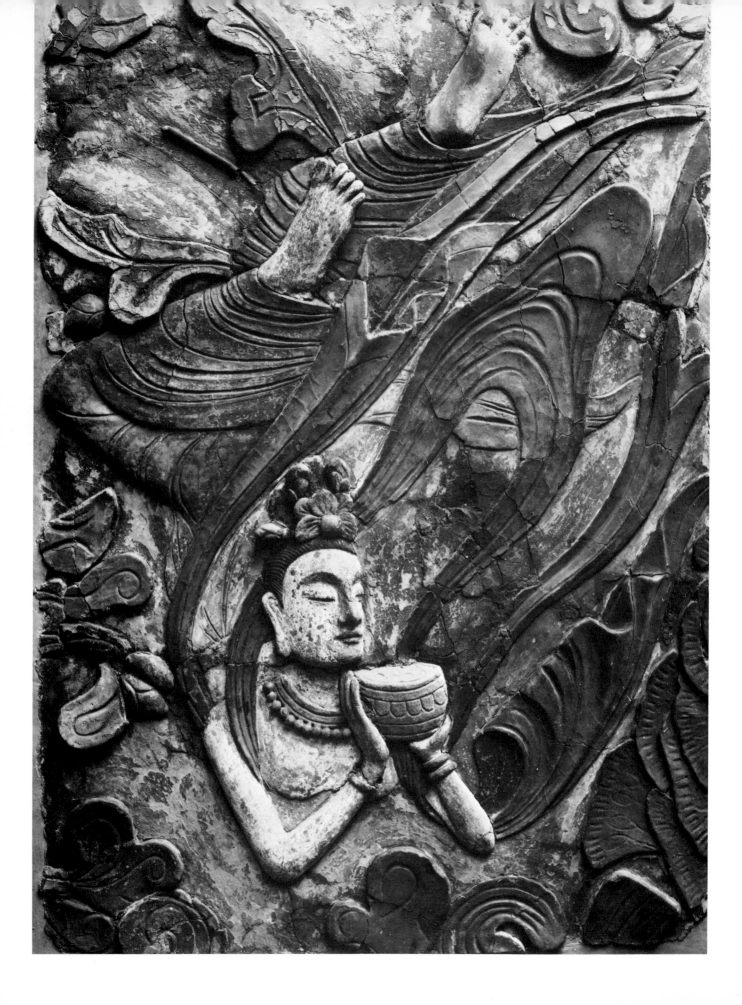

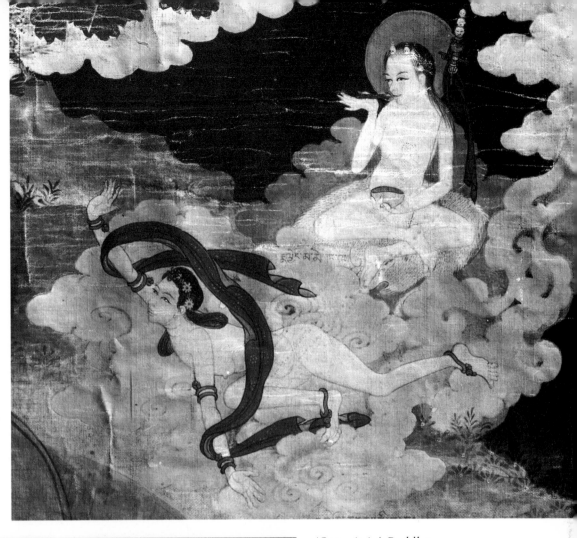

(Opposite) A Buddha Apsaras brings the divine nectar; for intoxication is itself a 'mediating experience' between earth and Heaven, and thus the proper work of Angels. All cup-bearers in all traditions are guardians of the threshold. Chinese flying figure; Victoria and Albert Museum, London

A Mahasiddha, or Great Magus, enjoys the delights of spiritual flight with his companion dakini-Angel. Tibetan tanka; Musée Guimet, Paris

A celestial attendant making music. Indian carving; Victoria and Albert Museum, London

The nature of Heaven

In the Western tradition, Heaven usually consists of seven spheres to correspond with the seven planets. Under the influence of Gnosticism (which sometimes spoke of 360 heavens, all evil), some cosmographers removed the spiritual world outside the 'heavenly' spheres. Planetary symbolism was used with power and precision as late as Dante. Modern man, however, is accustomed to think of the planets as dead shells.

A few years ago when news of the moon landings reached northern Canada, one of the older Indians was heard to say, 'Oh, that's nothing: my uncle went to the moon plenty of times!' To shamanic consciousness – as to 'sacred' consciousness in any culture – the planets are not dried husks floating in a vacuum, but states of sacred consciousness.

The lowest Jewish heaven contains clouds, winds, the 'Upper Waters' (symbolic of the gateway to the Imaginal World), two hundred Angels of the stars, storehouses of snow, ice and dew with their guardian Angels. The second is dark and full of sinners awaiting Judgment. The third contains Eden, with three hundred Angels of Light, and Gehenna or Hell (which is depicted as subterranean usually only when the earth is thought of as flat, although Dante combined the two symbolic systems in a brilliant tour de force of cosmography). In the fourth heaven are the chariots of Sun, Moon and Stars, and great Winds in the shapes of a phoenix and a brazen serpent with lions' heads (reminiscent of the Mithraic Aeons). In the fifth the fallen Angels languish in silence and despair. In the sixth reside seven Kerubim with hosts of radiant Angels who control the influences of the stars, along with the Angels of Time, the seas, rivers, crops and the souls of mankind. The seventh contains ineffable Light, Archangels, Kerubim, Seraphim and Ophanim (Thrones or Wheels).

Corresponding to the seven heavens are seven earths, the highest of which is our own world; and each of these fourteen levels is hooked like a chain-link to the ones above and below it. God presides over all; every day He mounts a Kerub and visits each of the planes, receiving homage; at dusk He returns on high on the wings of the wind.

The elements of this myth receive further amplification from Moslem visionaries such as Jili. His first heaven is that of the Moon. The Holy Spirit is here, 'so that this heaven might have the same

74

*De Macrocosmi structuræ, ejusque creaturarum originis
historia in libros VII. divisa.*

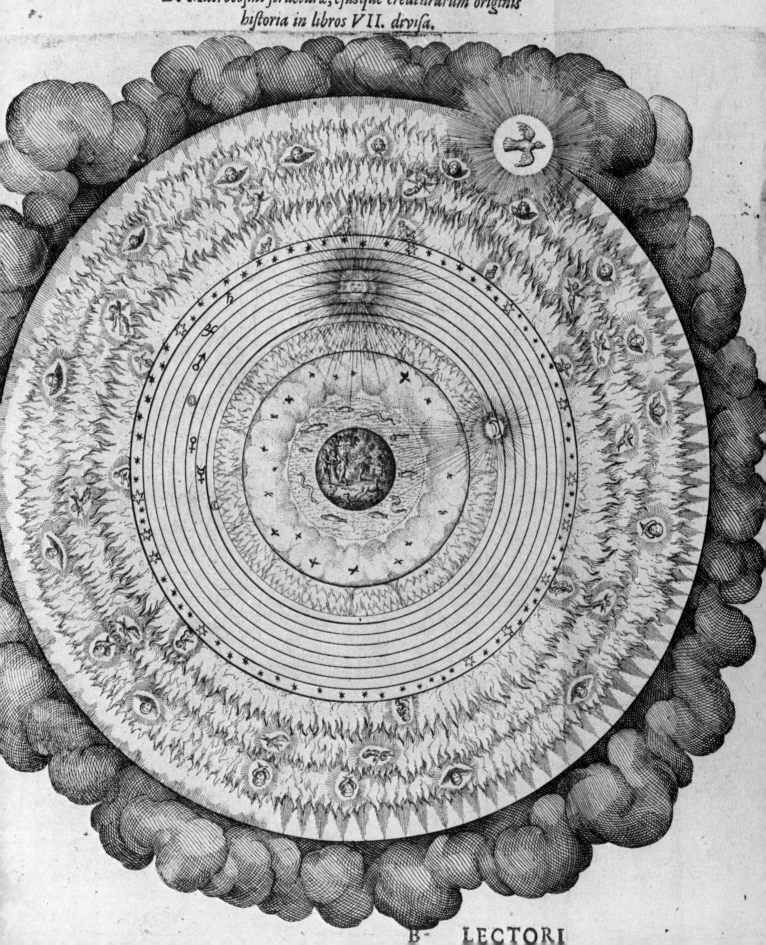

B LECTORI

relation to earth as Spirit to body.' Adam dwells here in silvery-white light. The second heaven is that of Mercury (identified by the sufis with the Egyptian Hermes, the prophets Idris and Enoch). Here the Angels of the arts and crafts reside bathed in a grey luminousness. The third heaven, that of Venus, is created from the Imagination and is the locale of the World of Similitudes, the subtle forms of all earthly things, the source of dreams and visions. The prophet Joseph lives here in yellow light. The heaven of the Sun is created from the Light of the Heart; Israfil presides over the host of prophets in a golden glow. The heaven of Mars, of the death-Angel Azrael, is blood-red with the Light of Judgment. That of Jupiter is blue with the Light of Spiritual Power (*himma*) and is lorded over by Michael. Here reside

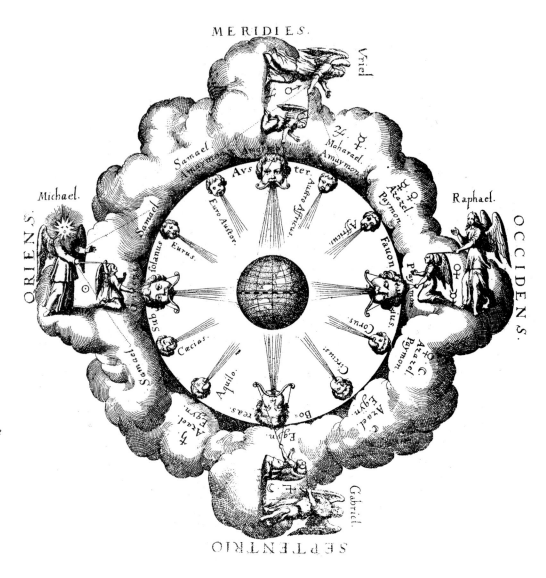

Space itself is both material and spiritual; the Archangels who preside over the directions also rule the 'winds', the breath of the Spirit. The Four Archangels and the Twelve Winds from Robert Fludd, Medicina Catholica, *1629*

the Angels of mercy and blessing, shaped as animals, birds and men; others appear, in Jili's words, 'as substances and accidents which bring health to the sick, or as solids and liquids which supply created things with food and drink. Some are made half of fire and half of ice. Here resides Moses, drunk on the wine of the revelation of Lordship.' The seventh heaven is that of Saturn, the first to be created – from the substance of the First Intelligence – and it consists of Black Light (symbolic of *fana*', Annihilation in the Divine Oneness).

Jili also speaks of seven earths or 'climes' inhabited by men, djinn and devils. The seventh is a Hyperborean paradise beyond Mount Qaf (the *axis mundi*) untouched by the Fall and ruled by Khezr, the Green Man or Hidden Prophet.

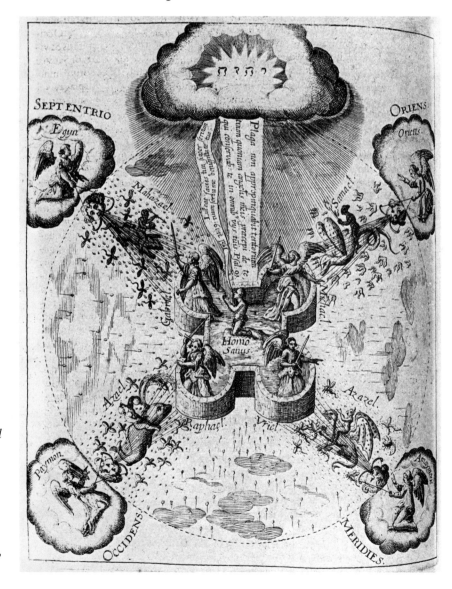

The Macrocosm has its 'evil' double or twin, a hierarchy of forces inimical to man; against this onslaught the human microcosm is protected by Angels who are seen as rays or extensions of the Divine Light. The Fortress of Health from Robert Fludd, Medicina Catholica, *1629*

From one point of view the nine Orders of
Angels surround God in worship; from another,
they encircle the earth as in the tiers of an arena
through which the soul must climb in a series of
initiations. Miniature from the Breviary of St
Hildegarde, 12th century

The Cosmos is a mirror in which each facet
reflects the face of Divine reality; each of the
planets, zodiacal houses and spatial directions
is thus presided over or identical with an Angel
which represents some aspect of God's plenitude
of being. Mirror of Life; Topkapi Saray Museum,
Istanbul

Space and time

They, all together, singing in harmony and moving round the heaven in their measured dance, unite in one harmony whose cause is one and whose end is one: it is this harmony which entitles the All to be called 'order' and not disorder.

(*De Mundo*, Anon., first century)

The Old Testament mentions Angels of Nations; some Biblical commentators say that there are seventy, others as many as the tribes or even the cities of men. 'When the Most High gave nations their homes and set the divisions of men, He fixed the borders of peoples according to the numbers of divine beings' (Qumran fragment). Like the tutelary deities of paganism, the *genii loci*, the river-gods, mountain sprites and wood-nymphs of Ovid's *Metamorphoses*, these Angels protect their places – but in a deeper sense they *are* these places. They are the inspiration, the aesthetic shock, sensed by visionary, poet, artist, hermit or traveller.

The Christian theologian Origen, writing in the third century, explains that the Angels of Nations are sometimes perceived as gods, and are responsible for the fact that each religion possesses Truth: 'The secret and occult philosophy of the Egyptians, the astrology of the Chaldeans, the Hindu claims pertaining to the science of the Most High God. . . . Each of these princes has a separate science and a special doctrine to teach.' Other Christian theologians claim that the missions of these Angels have been superseded by that of Christ; but one might seize on Origen's ideas as a justification for a more universal approach to comparative religion.

Of all the higher Archangels, Michael seems to have most often 'condescended' to play the role of an Angel of place. Not only does he rule Heaven, he also protects Israel and battles against the Angels of Israel's enemies. In Egypt he is the patron of the Nile, and his feast is celebrated on the day the river rises. In Germany the newly-converted pagans recognized Michael as the god Woden, and transformed his mountain shrines into churches of the Archangel. He is the Patron of Brittany and Cornwall, where Mont-Saint-Michel and Michael's Mount bear witness to the Angel's taste for imposing scenery and exquisite architecture.

St Michael receiving the soul of a dying man. Turkish dish, 18th century; Victoria and Albert Museum, London

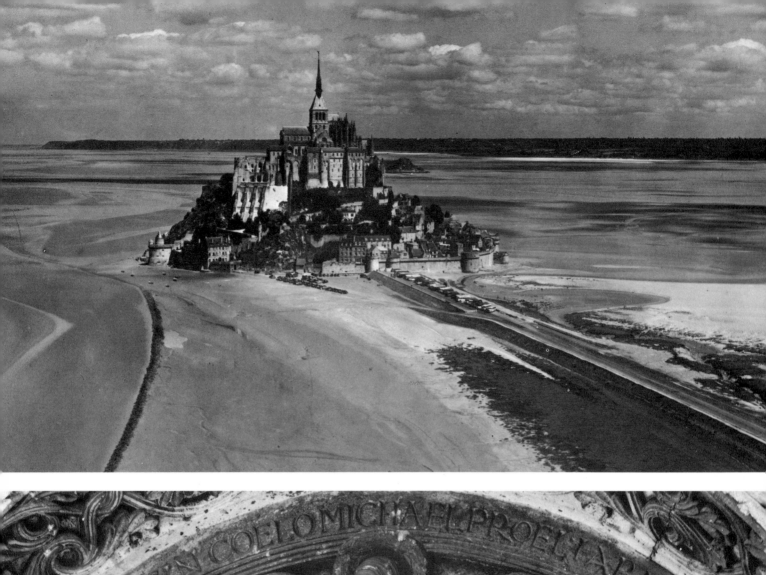

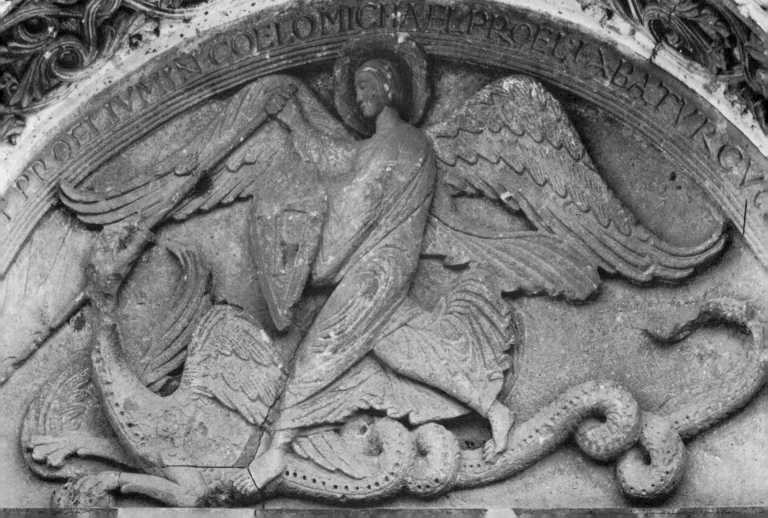

Sacred or Angelic geography and architecture: certain physical sites are 'doorways' through which higher realms may be glimpsed or attained, and this is enhanced by the construction of a temple. Mont-Saint-Michel, off the Brittany coast

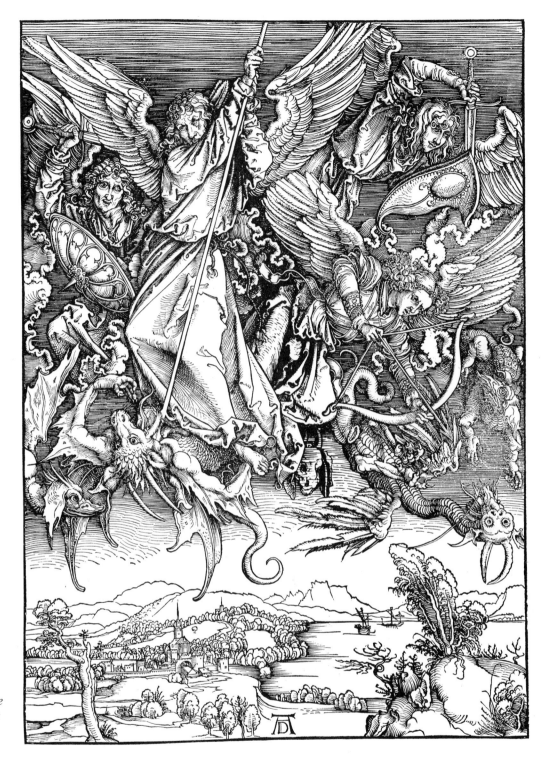

St Michael Conquering the Dragon; tympanum of the Church of Saint-Michel d'Etraignes, Angoulême, c.1140

Albrecht Dürer, St Michael and the Dragon; woodcut from the Apocalypse series, 1498

Since *The Book of Revelation* tells us that Michael battled with the dragon, he has been linked to many of the European, Celtic and Middle Eastern myths of mountains and dragons (unless the stories are told of his earthly 'avatar' St George). Just as in alchemy the volatile spirit of mercury must be 'killed' or fixed by the stable solar principle of sulphur, so the lithe and sinuous dragon, slippery as quicksilver, must be 'slain' by the Angel of the Sun, Michael. The symbolism is this: the vital spirit is by nature chaotic and chthonic, but the intellect cannot operate without its power. To 'kill' the dragon is not to eliminate it but to tame it, to leash it, to order it. to use its power towards spiritual ends.

The guardian Angel of Portugal also seems to have some connection with Michael. King Manoel I (1495–1521) petitioned the Pope to sanction the Feast of the Angel of Portugal on the third Sunday in July; no other country has such an observance. Alfonso Henriques founded a chivalric Order of the Wing in Honour of Michael (who is the Angel of chivalry) to commemorate his victory over the Saracens at Santarem, when his flagging forces were revived by the apparition of a hand grasping a sword, and a wing, emerging from thin air before their ranks.

The Angel of Portugal appeared as recently as 1916 to the three children of Fatima to prepare them for the apparitions of Mary in 1917. He took the form of a young man brilliant as crystal when it is lit by the sun, holding a chalice and a host dripping blood.

If the Angels 'penetrate' the earth to such an extent that one can call the Earth itself an Angel, they themselves are not in space in the same sense as men. As Aquinas says, 'Each of the spiritual entities . . . is the whole of the sphere of its heaven, yet at the same time has a particular place, different from that of its companions . . . for they are not bodies, nor is the heaven in question a body.'

In the same way, Angels penetrate Time. The message of the various Apocalyptic books is that history itself is directed, through the intermediation of the saints and Angels, towards a definite end. The significance of history lies outside any concept of 'profane time' – rather, events themselves possess an inner meaning which must be interpreted, just as Daniel and Joseph interpreted dreams.

Religion symbolizes this fact by recognizing that Time is presided over by Angels. The Zoroastrians know Yazatas (Angels) of the years, months, days, hours and even minutes; Enoch, too, gives a list of the

Even Time, which in the end reduces all matter to waste, has its Angel and hence its liberating power. Time, from Stephen Hawes's The Pastyme of Pleasure, *London 1509*

names of the Angels of Time. And if time falls under the government of the Angels, then 'profane time' is simply an illusion.

However, profane time certainly exists, at least on the psychological level. If the unawakened consciousness is 'trapped' in a space which constricts it, such consciousness is chained even more cruelly by its quantitative perception of time. Mystics speak of experiences 'outside time', and in the realms of the fairies three days can equal three hundred years in our world. St Bonaventure explains that profane time is like a river: its flow is constant, but one can never step twice in the same water. Angelic time is like a ray of light which (according to medieval physics) has duration but not sequence: it is everywhere the same light, instantaneous and yet extended. Angelic time, which Bonaventure calls the *Aevum*, undergoes no change, no history. It has all its being 'at the same time', but not all the continuation of its being at the same time: succession without innovation.

Only God knows eternity, only man knows the clock. The Angels live in a relative or 'created eternity', sacred time, the 'aeviternal substance'. Aquinas claims, 'We see a certain gradation of infinity in things . . . A spiritual substance [an Angel] is finite from above [i.e., from God's point of view] . . . but infinite from below [i.e., from man's point of view]. But the First Principle, God, is infinite in every way.'

Ultimately Time gives way to eternity: the four seasons in their roundelay are forever young and graceful, and the soul slips through their circle into Heaven. The 'Four Seasons Sarcophagus', c. AD 330; Dumbarton Oaks Collection, Washington, D.C.

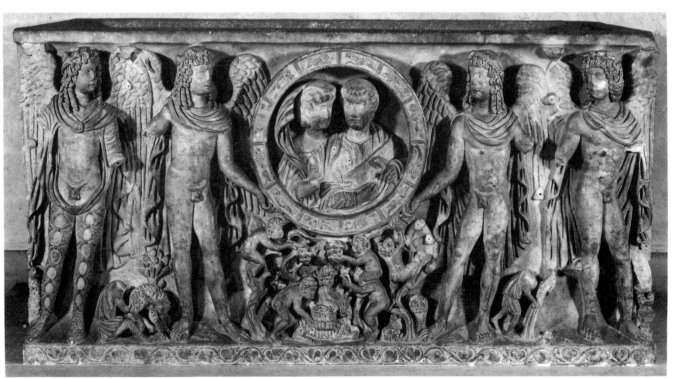

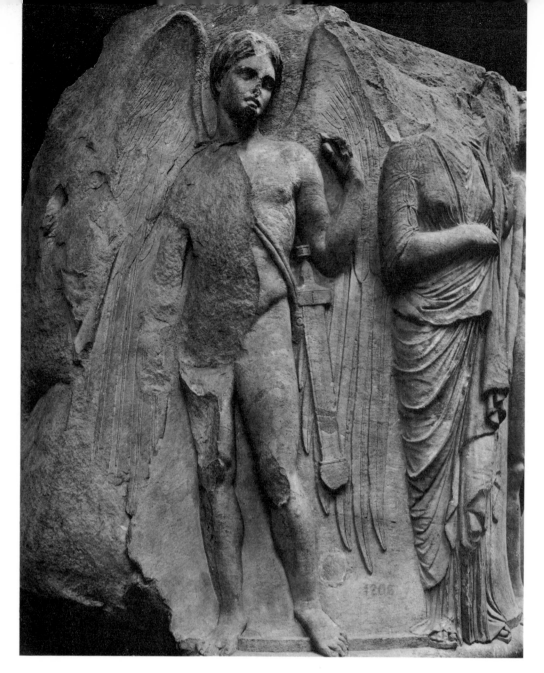

Death has its aspects of beauty just as Love is mortal: Thanatos and Eros are nearly twins. Detail of funerary column from the Temple of Artemis, Ephesus

Death and love

The eager longing of creation awaits the revelation of the sons of God.

(Romans, 8:19)

In Jewish folklore the Angel of Death stands between heaven and earth holding a poison-dripping sword. Identified with Satan, he is full of eyes, a diligent reaper, an old fugitive and wanderer like Cain, a beggar, a peddlar, an Arab nomad, a skeleton capering with sinners and misers in a juggler's dance. Before the Fall, man was immortal; death has come upon us as a punishment for sin.

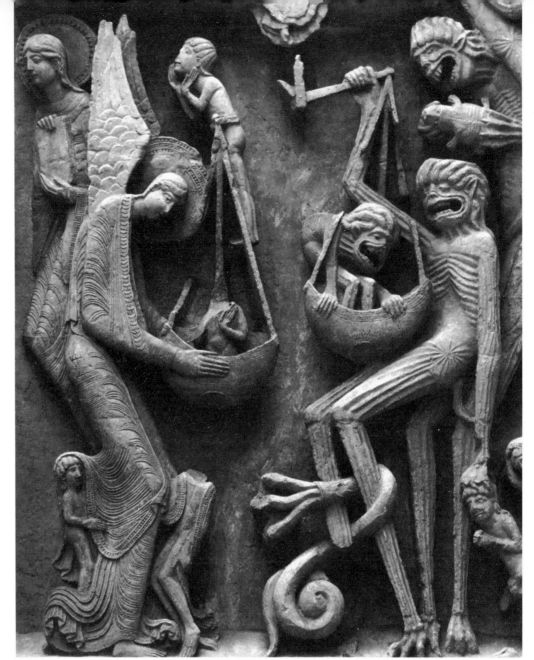

The soul which is 'cooked' through contemplation greets death as an Angel; the soul still 'raw' experiences only the freezing cold of terror. Detail of the Last Judgment, by Gislebertus, Autun Cathedral

But the nightmarish Angel presents a different face to one who has 'died before death' or who has attained some measure of the saint's *apatheia*. Jili tells us that Azrael, Death, appears to our spirit in a form determined by our beliefs, actions and dispositions during life. He may even manifest invisibly, 'so that a man may die of a rose in aromatic pain' – or of a rotting stench.

When the soul sees Azrael it 'falls in love', and its gaze is thus withdrawn from the body as if by a seduction. Great prophets and saints may even be politely invited by Death, who appears to them in corporeal form. Thus it was with Moses, and with Mohammed. When

85

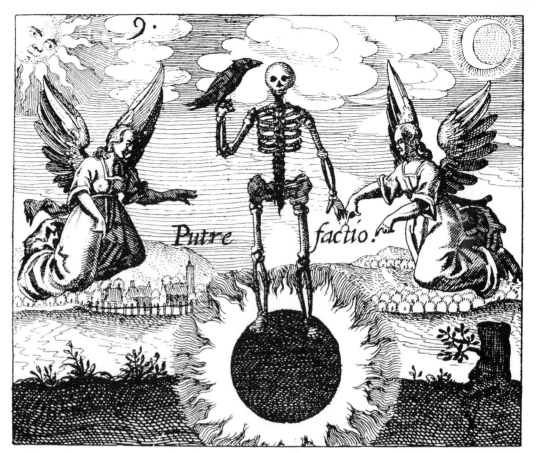

In alchemy, putrefaction must take place before the Elixir can be obtained: the ego must die before the heart can be turned into the Philosopher's Stone. This is the meaning of the 'Midnight Sun'. Woodcut from Rosarium philosophorum, *printed as a second part of* De Alchimia Opuscula, *1550*

Rumi lay on his deathbed Azrael appeared as a beautiful youth: 'I am come by divine command to enquire what commission the Master may have to entrust to me.' Rumi's human companions nearly fainted with fear, but the sufi replied, 'Come in, come in, thou messenger of my King. Do that which thou art bidden, and God willing thou shalt find me one of the patient.'

We begin to discern a strange connection between *Mors* and *Amor*, Death and Love. The moment of 'extinction' in the pleasure of love resembles that of death, and thus that of the mystic (a resemblance well-exploited by certain Tantriks and sufis). In mythic terms Eros and Thanatos are almost twins, for in some cases (as we have seen) Death appears as a lovely youth, and Eros as a withered starveling. Both Love and Death are gateways; hence their eternal adolescence, their fixation in the midst of the *rite de passage*. The tombs of Eleusinian initiates are often carved with the revels of Dionysius attended by his satyrs, nymphs, priapi and erotes (the plural of Eros).

Yama, the Lord of Death in Hinduism and Buddhism, rides an angry black water-buffalo. His flesh is green or black, his robes are

blood-red, he wears a crown and a flower in his hair and carries a lasso. But his horrific countenance softens towards the Seeker after Wisdom, such as the youth Nachiketas who braves the realm of Death to discover Truth. Yama teaches him the mantra, OM.

'This word is Brahman, the Supreme. He who comprehends this word, whatsoever he desires is his.

'For that Singer is not born, nor does he die. He came from No-where, nor is he any thing. Unborn, eternal, everlasting, ancient; unslain is he, though the body be slain.'

The monotheistic equivalent of this teaching is the dogma of the Resurrection of the body, which has shaped the funeral rites of Judaism, Christianity and Islam (as of the ancient Egyptians and others). 'Then the Lord will appear in the heavens like lightning with an unspeakable glory. The Angels and Archangels will go on before His Glory like flames of fire, like a mighty torrent. The Kerubim will turn their faces and the Seraphim will fly ahead crying out in fear, "Arise, you who sleep. Behold the Bridegroom is coming!"' (St Ephrem). 'The Angels will lead the Elect to their blessed end, when they will be lifted up, carried as was Elias on an angelic chariot amid rays of heavenly light' (Eusebius).

The popular image of the Resurrection depicts Gabriel or Israfil (his size is astounding: his feet beneath the seventh earth, his head brushing the pillars of the Throne; he has four wings, one in the West, one in the East, one with which he covers his body and one as a protection against the majesty of God) blowing a great trumpet, at which the graves tremble and the reawakened bodies surface like mushrooms of fire from beneath the mold.

In the end, even matter must be 'raised' to the level of Spirit, since in essence it already *is* Spirit. Angels preside over the Resurrection, symbolizing the truth that Low and High are joined by an act – the blast of Gabriel's horn – performed in the In-between. Because this occurs 'at the end of Time' (or, in some traditions, in cyclic time) the Resurrection happens *outside* time – in the 'Nowever'.

An image of Gabriel blowing his trumpet from Geffrey Whitney, A Choice of Emblemes . . ., *Leyden 1586*

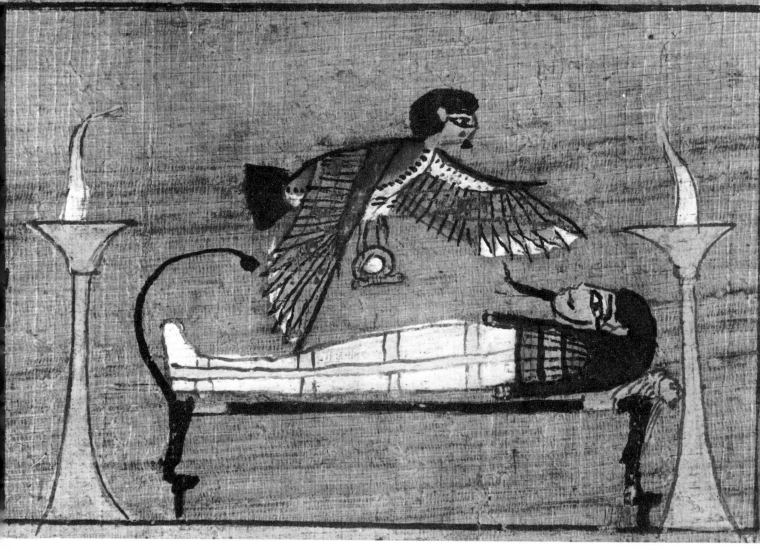

ANGELS AND DEATH

Ba-figure of Ani, a human-headed hawk bearing the ring of eternity, hovers over its mummy in the tomb. The ba travelled about at will, but returned periodically to the tomb to feed upon the funerary offerings. From the Papyrus of Ani, XIXth Dynasty

Sleep and Death carry a soul to their palaces beneath the earth. Detail from 5th-century BC red-figured vase, showing a dead warrior on the battle-field of Troy

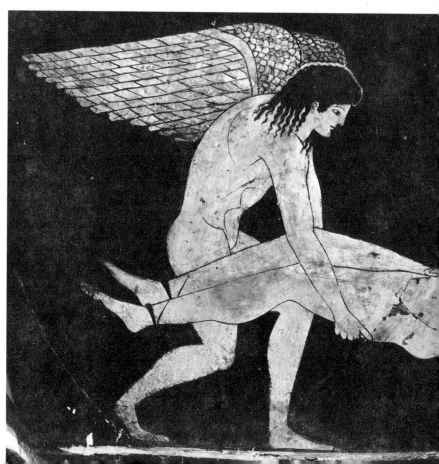

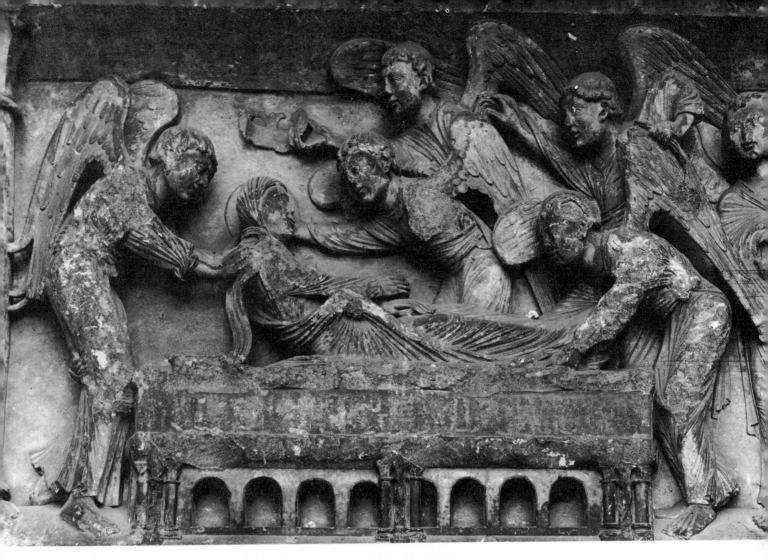

Resurrection of the Virgin; detail from the 'Virgin's Door' in Senlis Cathedral, late 12th century

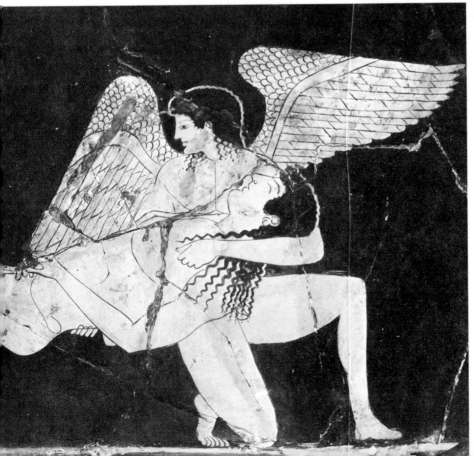

89

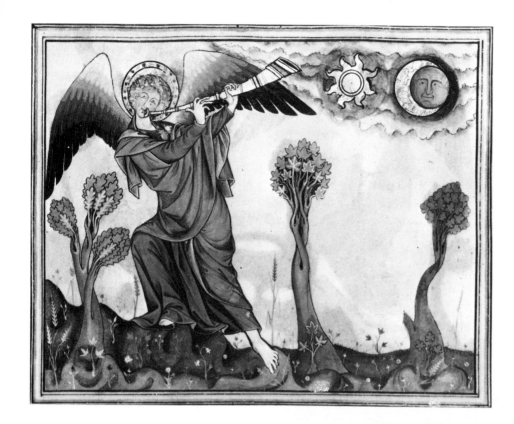

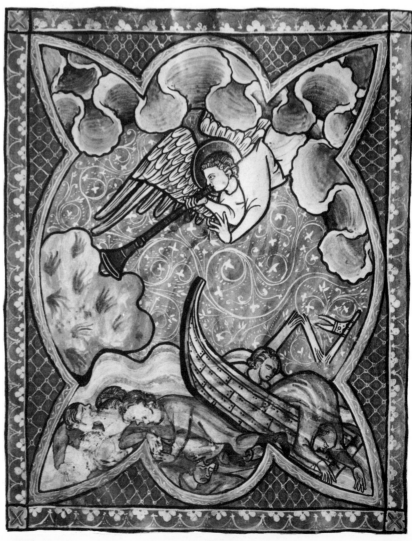

(Opposite) Resurrection. Dead souls dance, putting on their flesh again, rising from graves like mushrooms after rain: the image of the mystic, dead to the self, who gains a body of light and hears the Angelic music of bliss which causes time to cease. From the Pericopes of Henry II, 1002–14

Angel blowing the Fourth Trumpet; from the Douce Apocalypse, c. 1270, Bodleian Library

Blowing the Second Trumpet; from the Dublin Apocalypse, early 14th century, Trinity College

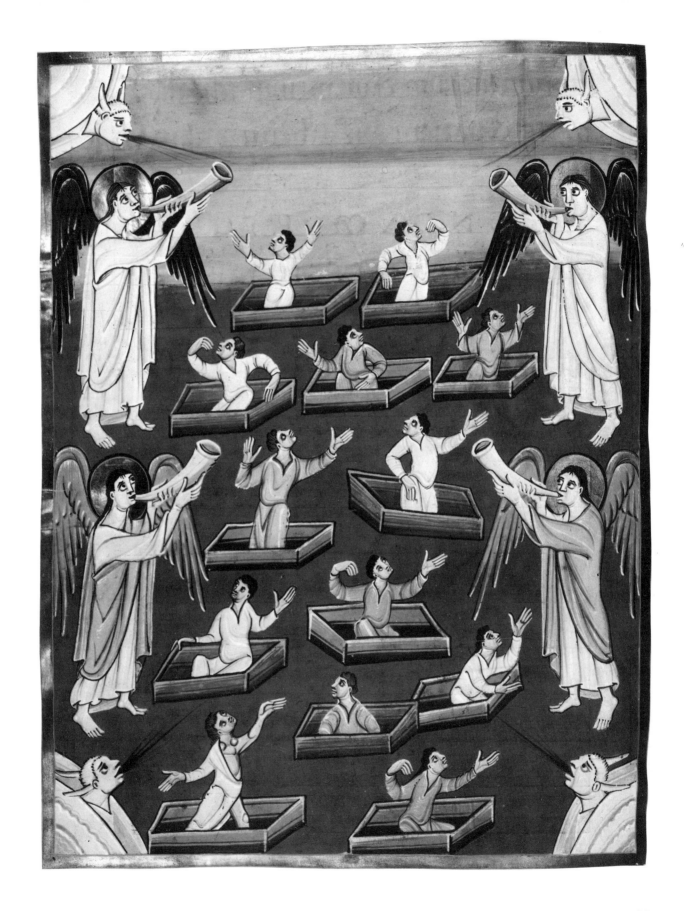

Angelic eroticism

Contact with the Intermediate World sometimes involves a certain sexual ambiguity, an exalted erotic state often interpreted by monotheistic puritans as diabolic. Archaic societies tolerated a balancing measure of chaos: the Saturnalia. Along with the sacred clown, such societies also recognized and even enjoyed the psychic necessity for manifestations of non-ordinary sexuality. Temple prostitution is one example, shamanic homosexuality another. Both occur among the Dyak of Borneo, who say that since the earth is feminine and the sky masculine, the shamans who intermediate between the two should act out this cosmic ambiguity in sexual terms, the men as hermaphrodites, the women as prostitutes. Similar ideas are found in ancient Japanese and contemporary Sioux cultures, among others.

Actual contact with spirits is often sexual: the shaman 'marries' his guardian spirit and must cohabit with it despite its terrifying appearance. In the Hermetic tract, *Isis the Prophetess to her Son Horus*, the prophetess relates how an Angel dwelling above the firmament came down, made love to her, and revealed to her the hidden mysteries of the preparation of gold and silver.

The *Book of Numbers* briefly relates that in the days before Noah the 'sons of God' came down to earth to teach the secrets of the arts to mankind, and that they fell in love with and married the beautiful daughters of men. Apparently no condemnation is intended, since the offspring of these unions are called 'the heroes of days gone by, the famous men'. The shamanic origins of this tale are hinted at in the Midrashim (traditional commentaries on scripture), which relate that these Angels revealed the Hidden Name of God to a girl named Istehar, who was thus able to ascend to heaven.

The Book of Enoch, however, interprets the incident as the origin of evil. Two hundred sons of God, under the leadership of one called Semjaza, descended without Divine permission, 'defiled' human women and 'taught them charms and enchantments, and the cutting of roots . . . and they became pregnant and bare great giants, whose height was three thousand ells [11,250 feet]! . . . The giants turned against men and devoured them.' Azazel taught men the arts of war and women the vanity of cosmetics. Fornication and lawlessness spread over the earth. Finally God ordered Michael to overcome these Angels, who are called 'Watchers', described by Enoch as 'stars whose privy

A Gnostic seal of Horus, and the Ourobouros or self-consuming snake of unity; bronze bas-relief, Geneva

The hermaphrodite, symbol of the union of opposites; woodcut from Rosarium Philosophorum, *printed as second part of* De Alchimia Opuscula, *1550*

members were like those of horses'. Enoch is rapt up in heaven to be told of God's displeasure, and of His intention to imprison the fallen Angels 'till the day of Judgment'.

At the centre of Angelic eroticism is the great Angel, Eros. In India he appears exactly as in Greece, a boy with bow and arrows (made of flowers and bees). According to the legend, Parvati, daughter of the god Himalaya, falls in love with Shiva. But the great god remains immersed in contemplation and refuses to notice her. Meanwhile the other gods interest themselves in Parvati's plight, because a terrible demon is ravaging the cosmos, and Brahma predicts that only a son of Shiva and Parvati can overcome this menace.

So Kama (Eros) is sent, with his wife Rati, to move Shiva's heart with desire for Parvati. But just as the boy is about to release his love-arrow, Shiva opens his third eye and with his terrible gaze burns Kama to ashes (hence his title, Ananga, the Bodiless). Rati (Passion) weeps, but hears a voice say, 'Thy lover is not lost forever; when Shiva weds Parvati he will restore Love's body to his soul.'

Finally Parvati wins Shiva's love by practising meditation and austerity. The wedding takes place, and all the prophecies are fulfilled.

The burning of Love's body signifies the predominance of contemplation over mere desire. But Parvati loves even when Love itself is destroyed, for she loves Wisdom. The restoration of Kama as a wedding gift from Shiva to his bride indicates that Love under the rule of Wisdom is true pleasure, *ananda*, Bliss. These motifs remind us of the great Western legend of Love, *Cupid and Psyche*, as told in the *Golden Ass* by the Neoplatonist and worshipper of Isis, Apuleius.

The story begins *before* the descent of the soul, Psyche, into the world. Beautiful and pure, she is potentially divine, 'a second Venus'. Aphrodite herself, however, portrayed in this tale as the illusory power of the world (Maya in Hinduism), cannot bear to think of a soul's remaining untouched by her wiles. She inspires an oracle to predict that Psyche will be married to a dreadful serpent, and then sends Cupid to make the girl fall in love with the ugliest creature he can find. All this symbolizes the 'fall' of the soul into the corrupt material world.

But Cupid himself falls in love with her, for Love without an object of love is incomplete, and the Soul is made for Love. Thus her marriage (i.e., birth) is not into a nightmare but into a dream of love. Psyche cannot see Cupid (he is 'bodiless') for she has not yet earned the right

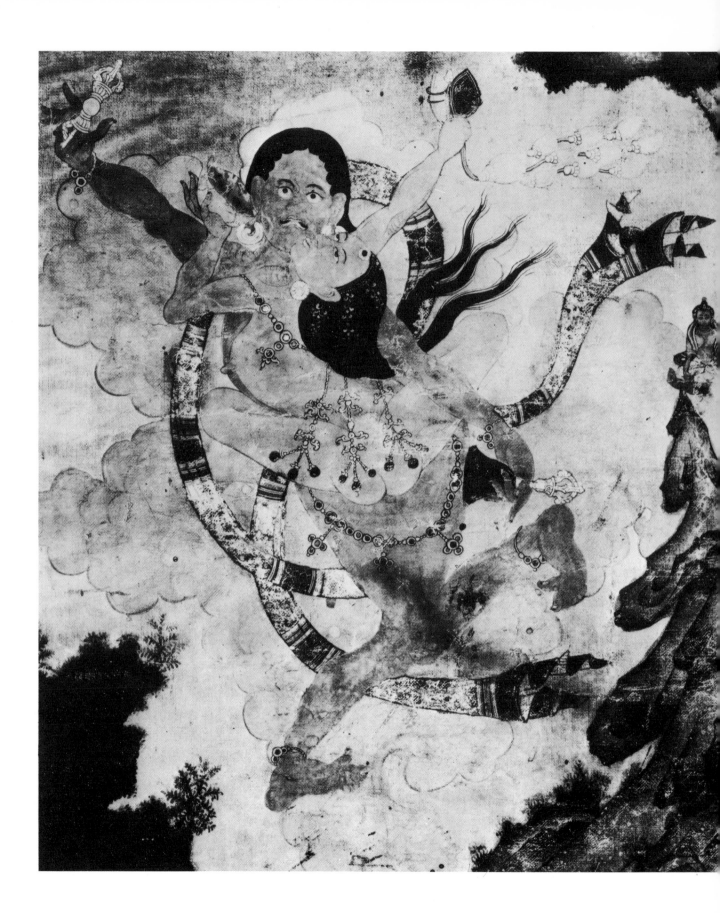

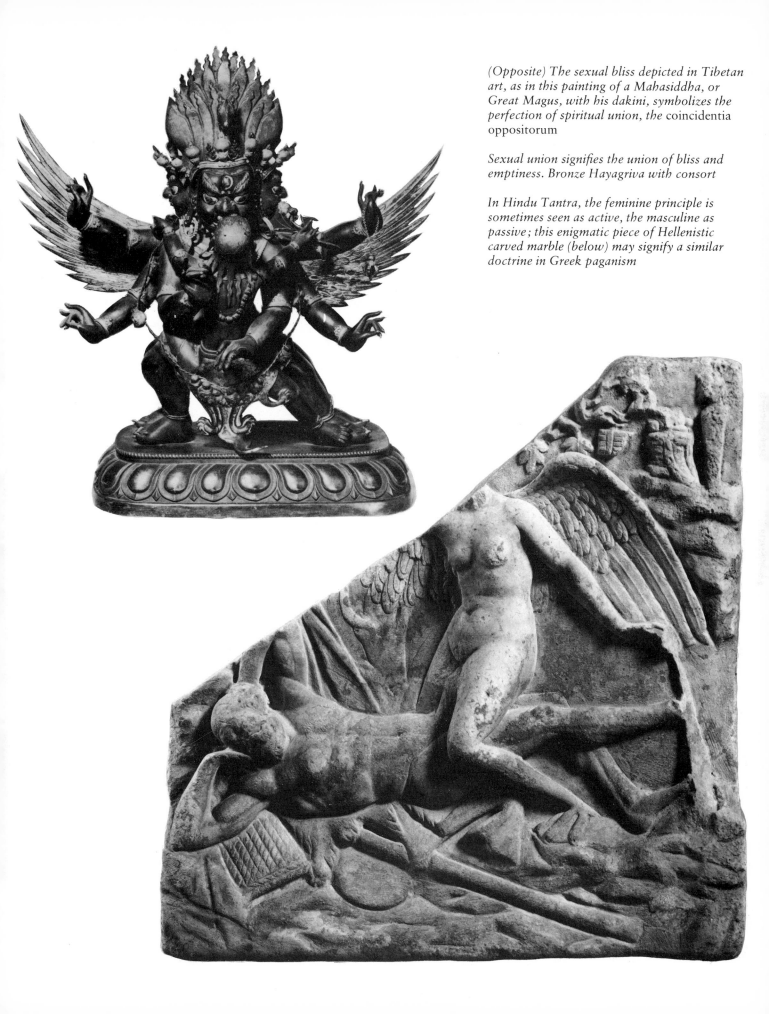

(Opposite) The sexual bliss depicted in Tibetan art, as in this painting of a Mahasiddha, or Great Magus, with his dakini, symbolizes the perfection of spiritual union, *the* coincidentia oppositorum

Sexual union signifies the union of bliss and emptiness. Bronze Hayagriva with consort

In Hindu Tantra, the feminine principle is sometimes seen as active, the masculine as passive; this enigmatic piece of Hellenistic carved marble (below) may signify a similar doctrine in Greek paganism

to true vision; nevertheless he visits her every night and her life is happy at first, as childhood is magically happy, because it is simple. Psyche's sisters (her bad inner faculties, her 'ego') are pictured as evil, but their action is not entirely so: they spur Psyche towards a new kind of maturity, a desire to know the object of her love. (As Mohammed said, 'He who knows himself, knows his Lord' – so he who knows his Lord, must know himself.)

Psyche tries to discover her lover's identity, an act of disobedience that results in her first true vision. Now she realizes how beautiful divinity really is, and also the extent of her own separation from it. She is now a seeker; she has entered on the spiritual path.

Interestingly, the only god who gives her good advice is Pan, spirit of wildness, who tells her not to weep or slay herself 'but rather adore and worship the great god Cupid and win him unto you, that is a delicate and wanton youth, by your gentle promise of service.'

Like a true aspirant, Psyche interprets this to mean 'worship *all* the gods'. Thus when Venus-as-Illusion sends her on her impossible tasks (all symbolizing the development of certain spiritual faculties), Psyche is aided by the gods themselves. Finally she descends into Hell ('Die before you die') – and the reward is a new vision of Cupid, who helps her to overcome her final test, and subdue her ego.

And Psyche gains immortality, is taken up to heaven like Elias and married to her love, who is Love himself, the beauty of the Divine. And their child is the god Pleasure – *ananda* – Bliss.

Winged erotes; relief from a shrine of Eros and Aphrodite, Greek, end 2nd century BC

*The Greek Eros; a
statuette from the 1st
century* BC

The Muse

The venerable Bede tells us that the poet Caedmon began his career unable to utter a word. When, in the evenings, the villagers would pass round the harp and sing, he would steal off to the hills in shame. One such night an Angel appeared to him and ordered him to sing; at once his lips were unlocked and he became a poet.

The function of the Muses for the poet Hesiod is that of the Angels for the Israelites: to reveal the cosmogony, the story of the origins of men and gods and the world. Indeed, Origen discourses on the tradition that Angels were involved in the very beginnings of language itself: not just Scripture, but all words are 'revealed'.

In primordial societies, shamans act as repositories of language, of rare, antique and special vocabularies often far more vast than those in ordinary usage. Their ecstasies are invariably preceded and accompanied by poetic recitals, and the epic and oral poetry of all peoples derives ultimately from the shaman's or hero's voyage to the Other World; or from possession, the descent of spirits into this world; or from the voices of the dead, the ancestors who have become spirits.

The Celts attained what might be called, in this respect, a high shamanic civilization. The functions of bard, seer and priest were related but highly specialized, and the techniques of ecstasy were attuned to the vast learning of bardic colleges in which the acquisition of a 'degree' could involve half a lifetime of study and preparation. The costume of the ancient Irish bard consisted largely of feathers: the poet as bird/man, the poet as Angel, or direct disciple of the Angel, Muse, White Goddess.

In Persia, lyric poetry revolves around the figure of the beloved. Poets like Rumi composed in a state of ecstasy (whirling round a pillar). Even today the Iranian musical modes correspond precisely to poetic metres, so that all traditional poetry can still be chanted. Some scholars believe in a connection between the twelve modes and the signs of the Zodiac and the twelve Angels of the months.

Nora Chadwick, who details the links between shamanism and oral literature in her *Poetry and Prophecy*, concludes: 'It would seem that poetry, that is, eloquence and music combined, is the language of prayer and spell, and of all communication between human beings and spirits.' In other words, poetry is an isthmus between ordinary consciousness and other-consciousness; it is a language of the Intermediate World. Mohammed had to deny explicitly that he was a

(Opposite) The Orders of Angels are also 'choirs', for they preside over all the arts – which depend on a 'breathing in' of divine vision – and especially over music, the most disembodied and hence spiritual of all the creative modes. Simon Marmion (c. 1425–89), Choir of Angels (detail); National Gallery, London

Fleshy putti-Angels of the early Renaissance making music. Detail from the Tempio Malatestiano, Rimini, end 15th century

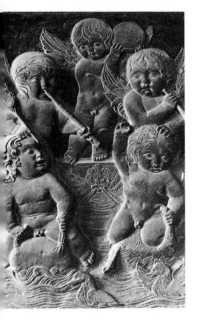

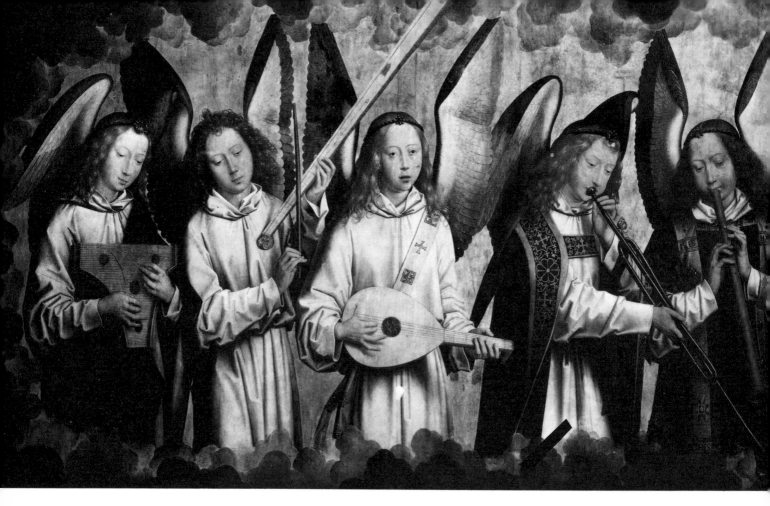

Angel Musicians; detail of panels for an organ gallery by Hans Memlinc (c. 1430–1494); Musée des Beaux-Arts, Antwerp

poet, since the way in which he received his Book reminded the Arabs of the trances of their tribal bards. And God provided him, through Gabriel, with one Verse of three lines, specifically to put to shame those poets who claimed they could achieve an eloquence equal to the Prophet's. On a lower level the *act* of the poet – in his true and traditional role – is the experience of the Angel. The inspired poet stands, like a prophet, between his people and the spiritual world, a Janus with one face turned to earth and the other to the celestial spheres.

Some might call music the Angelic art; and in the sense that it approaches 'pure' spirit, this is true. Indeed, music in itself must also derive from the Other World, and provide a link between men and those choirs of beings who are depicted in Buddhist, Christian and Islamic art as singing and playing the lute or harp. All primordial musical instruments were revealed to men by spirits; the lyre was invented by Hermes, the messenger of the gods. The drums of Siberian shamans are their divine horses, on which they ride the clouds; the drums of the Africans and Haitians are gods, carved out of pure spiri-

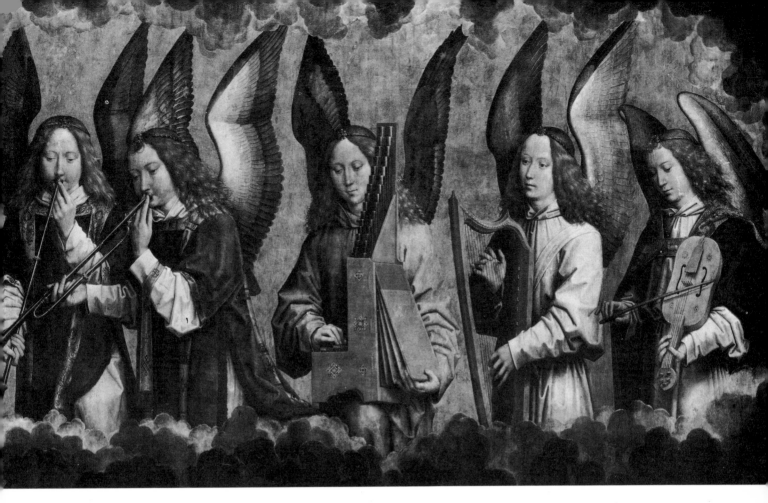

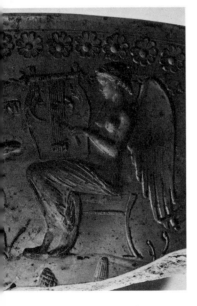

Angel with lyre; fragment of Samian ware bowl-moulds, Arezzo Museum

tual substances mysteriously manifest in certain sacred trees. The *Ave Maria*, the words of Gabriel to Mary, are set in plainsong modes which seem sliced out of eternity; and St John Chrysostom tells us that the *Sanctus* is the chant of the Seraphim, 'reserved for the initiates, the baptized.'

But music by itself lacks one particularly angelic function: the Logos. Thus it is in poetry, defined as rhythmic speech accompanied by music, that man reaches the language of the Angels, or as the sufis call it, the language of the birds, revealed by the djinn to Solomon. Rhythm lifts time out of the realm of the profane and transmutes it into the *Aevum*, the 'created eternity' of the Angels.

When speech is added to rhythm it evokes the imagery of the Other World and re-presents it to consciousness. This is poetry – and by its aid the shaman, the seer, the seeker prepares his escape from the crypt of sleep. By its aid he locks his vision in the treasury of memory (chief of the Muses) whence it can be paid out to posterity. The poem in this sense *is* the Angel, the ladder of silver and gold by which hierophant and bard mount the world of the Imagination.

The Guardian Angel

For He hath given His Angels charge over thee, to keep thee in all thy ways.

(Psalm 90)

I go to meet my image and my image comes to meet me: it caresses and embraces me as if I were returning from captivity.

(Mandaean Liturgy of the Dead)

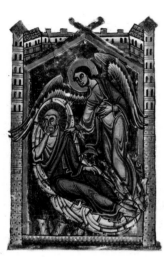

Joseph's Dream; from the Book of Pericopes of St Erentrud, Salzburg School, 1150–75

When man opens his heart, for even an instant, the figure he perceives (or the intuition he receives) is his Guardian Angel. When he hears the call to the spiritual life, when his psychic substance is protected from evil, when he meets certain mysterious figures in dreams, or even in waking day, who act out for him the drama of his own inner life – this is the Guardian Angel at work.

'It is a teaching of Moses that every believer has an Angel to guide him as a teacher and a shepherd' (St Basil); and Christ says of 'the little ones' that their 'Angels in heaven always behold the face of the Father.' In Zoroastrian belief, the soul after death meets a beautiful maiden who announces, 'I am none other than thine own personal conscience. Thou hast loved me in this form of sublimity, goodness and beauty in which I now appear unto thee.' At the time of his ordination a Taoist master is assigned a guardian spirit, called a *pen-ming*, which acts as a special liaison official to present the priest's documents and prayers to the lords of the cosmos. Some authors (including Philo) believe that each soul possesses a good and a bad Angel, who contend throughout life for its possession.

Gnosticism provides a useful definition of the guardian: the Angel and the soul form a *syzygy* or 'pair'. The Angel is the soul's twin, its spiritual counterpart which 'sees the Father in heaven'. When St Anthony was starving alone in the desert he saw someone who looked exactly like him, fishing in a brackish pool; it was Anthony's guardian, showing him how to obtain food. Great prophets or saints may have great Archangels for their guardians, since their earthly missions involve the spiritual welfare of whole segments of mankind. 'The prophet hastens to accomplish the action which the Angels contemplate spiritually' (St Hilary). Thus Mohammed's guardian is Gabriel, and Arjuna's in a sense is Krishna, who chooses the great hero as a vehicle for the teachings enshrined in the *Bhagavad Gita*.

On the mountain top, the point where earth meets Heaven, the alchemist meets his Angelic guide, who displays the wonders of creation. Woodcut from Musaeum Hermeticum Reformatum et Amplificatum . . ., 1678

Great mystics are sometimes initiated by Angels rather than human masters. St Francis was protected by one of the Seraphim, who gave him the Stigmata. King Solomon and Padmasambhava (founder of Tibetan Buddhism) were both served by hordes of Angels, djinn, converted demons and fairies.

If – as St Thomas Aquinas claims – each Angel is a separate species, how can we mere individuals attain such a one-to-one relationship with an Angel? One possibility is that the guardians are in fact multiple manifestations of a single 'Angel of Humanity' (Sandalphon, or Gabriel).

The guardian is also in a sense the Beloved. The Persian philosopher Avicenna, speaking of the Angel, explains that 'the soul must grasp the beauty of the object that it loves; the image of that beauty increases the ardour of love; this ardour makes the soul look upward . . . Thus imagination of beauty causes ardor of love, love causes desire, and desire causes motion' on the level both of the spheres (which are drawn in love toward their Archangel-Intellects) and of human souls (who are drawn in love toward their guardians).

Jacob wrestles not so much with the Angel as for the Angel: inner combat or spiritual warfare may be seen at first like a struggle against Heaven, but in the end the battle is revealed as a kind of love-play. Gauguin's famous painting places the event in a Breton context

Eugène Delacroix, Jacob Wrestling with the Angel, c. 1858, Church of Saint-Sulpice, Paris

And the earthly beloved can play the role of the Angel. As Plato says in the *Phaedrus*,

The newly initiated, who has had a full sight of the celestial vision, when he beholds a god-like face or a physical form which truly reflects ideal beauty, first of all shivers and experiences something of the dread which the vision itself inspired; next he gazes upon it and worships it as if it were a god, and if he were not afraid of being thought an utter madman, he would sacrifice to his beloved as to the image of a divinity.

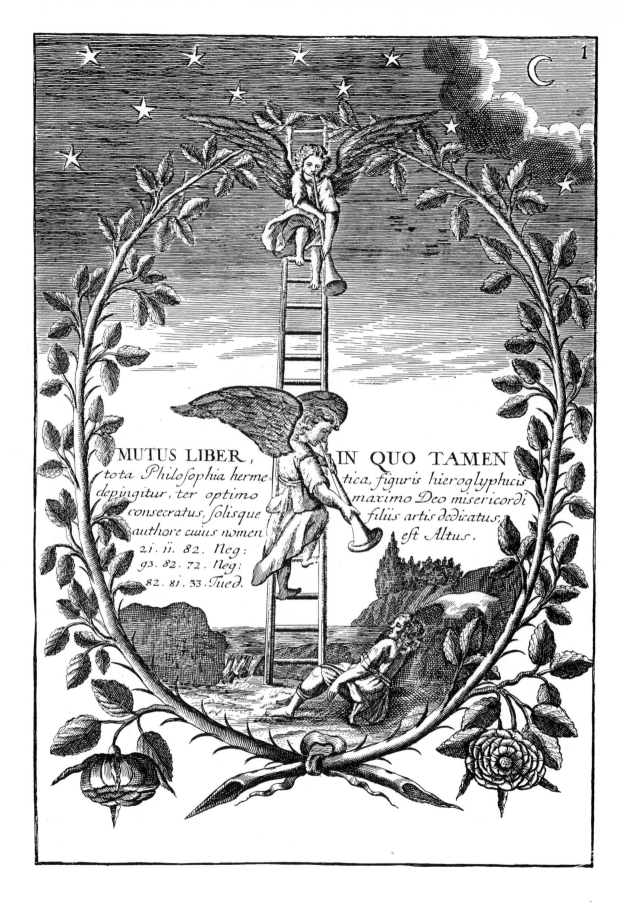

MUTUS LIBER, IN QUO TAMEN tota Philofophia herme- tica, figuris hieroglyphicis depingitur, ter optimo maximo Deo mifericordi confecratus, folisque filiis artis dedicatus, authore cuius nomen eft Altus.
21. 11. 82. Neg:
93. 82. 72. Neg:
82. 81. 33. Tued.

III Journeys

The ladder

> And he dreamed, and behold a ladder set up on the earth, and the top of it reached to heaven: and behold, the Angels of God ascending and descending.
>
> *(Genesis* 28)

(Opposite) The Angelic Ladder; woodcut from Muter Liber, *or 'Mute Book', published 1677*

Jacob, after his dream of the Angelic Ladder, 'was afraid, and said, How dreadful is this place! This is none other but the house of God, and this is the gate of heaven.'

'As above, so below', says the *Emerald Tablet of Hermes Trismegistus.* And Jacob's Ladder tells us that the way down is the way up. St John Chrysostom invites us to think of 'that spiritual ladder which the Patriarch Jacob saw stretching from earth to heaven. The Angels were coming down along it and the martyrs were going up.

St John Climbing the Ladder to Heaven; from Ms New College 65 fol. 12v.

Japanese monks climbing ladder of swords, April 1977

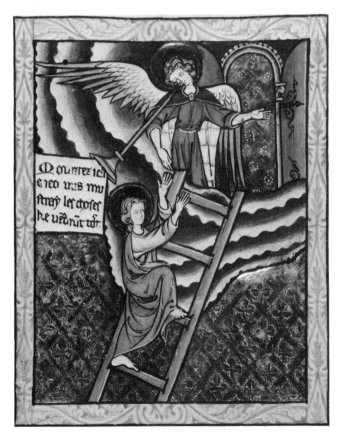

A winged monster; detail of a felt hanging found in a tomb at Pazyryk, Soviet Russia

A winged gold creature; part of the Scythian Oxus Treasure, 5th–4th century BC

(Opposite) This 'icon', an 18th-century Indian miniature, is said to represent Vishnu and Lakshmi on Garuda, but in fact the iconography is more appropriate to Kama, the Hindu Eros. Kama's mount is a parrot (Garuda is an eagle) and he carries a bow of sugar cane. The result is anyway the same: a delightful allegory of spiritual flight

You have often seen the sun rise in the morning, darting out purple-tinted rays in every direction. Such were the bodies of the martyrs: the crimson tide of their blood had flooded every part of them as with rays of purple and illuminated their bodies more than the sun lights up the heavens. The Angels gazed upon this blood with delight!'

The way of the mystic (who 'dies before death') is like the way of the martyr. Thus this ruby tint is the colour of the alchemic Stone, the crimson hue of Sophia or of the Archangel Gabriel.

The Ladder appears in every tradition. It is the tent-pole which the shaman climbs towards the smoke-hole of his hut: the Tree of Life. Mohammed's Ascent (*mir'aj*) is literally a ladder. In the Mithraic mysteries the initiate climbed a ladder (*klimax*) of seven rungs made of the seven planetary metals. In New Zealand, Indonesia, Melanesia, Japan and the southwest of the United States, the shaman climbs up a rainbow serpent whose seven colours represent the seven heavens. The Babylonian ziggurat was painted in these colours, and to climb it was to attain the summit of the cosmos. The Turk and Uighur shamans called their drums 'rainbows', and used them as magic mounts. Taoists in Taiwan and Yamabushi monks in Japan still perform the incredible feat of climbing in their bare feet a ladder built of razor-sharp swords, often as many as thirty-six.

Another obvious way of going up is to fly, and this explains the universal symbolism of birds and flight. Thus, as Mircea Eliade tells us, the Altaic, Minusinsk Tatar, Teleut, Soyot and Karaga shamans dress as owls. The Yakut shaman costume displays a complete bird skeleton of iron. Often the headgear is made of feathers. The Mongol shaman wears 'wings' on his shoulders and turns into a bird as soon as he dons his costume. 'One becomes what one displays,' as Eliade comments.

Garuda, the vulture god and mount of Vishnu, is evoked by mystics who wish to attain spiritual flight. In the *Rig Veda* the long-haired ascetic (*muni*) declares, 'Exhilarated by sanctity . . . we have mounted upon the wind; behold, mortals, our forms! . . . The steed of the wind, the friend of Vayu, the *muni* is instigated by the deity. . . . He repairs to both oceans, the Eastern and the Western . . . wandering in the track of the Apsaras and Ghandharvas.'

This flight sometimes occurs in the body. St Joseph of Cupertino (1603–63) rose into space, and from the middle of the church flew like a bird onto the high altar, where he embraced the tabernacle.

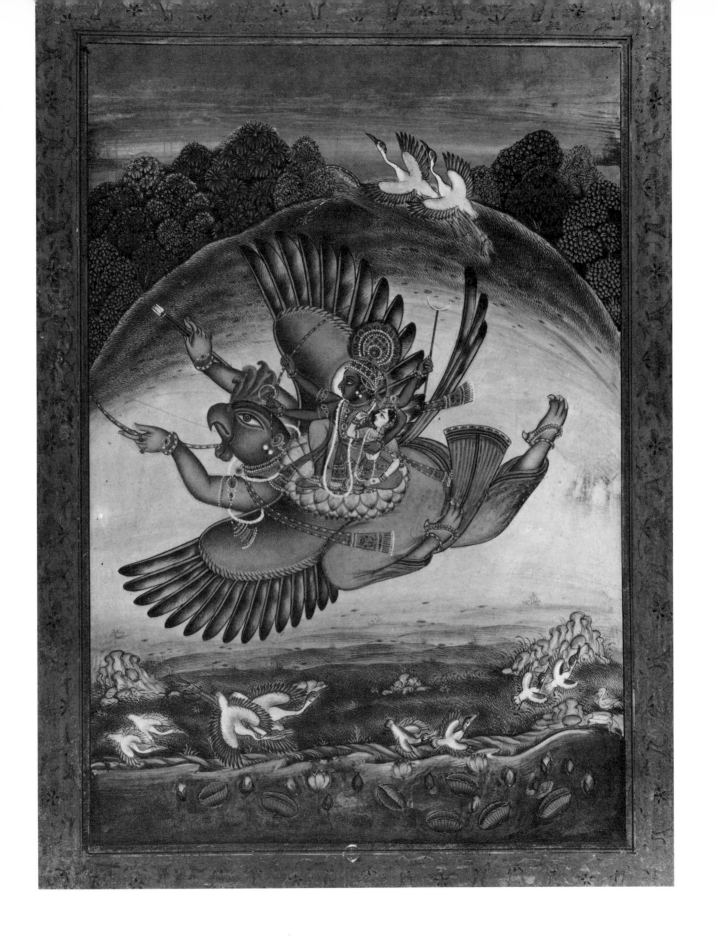

(Opposite) Bugaku dances; detail of painting by Hanabusa Itchō (1652–1724). It is uncertain whether Japan 'borrowed' the Angel figure from the ancient Middle East, or vice versa; but an archetype which is truly basic to human experience will appear spontaneously in all cultures

Carnival dancer in Bolivia

Mexican dancers; from the Codex Barbonicus, pre-Conquest or early 16th century

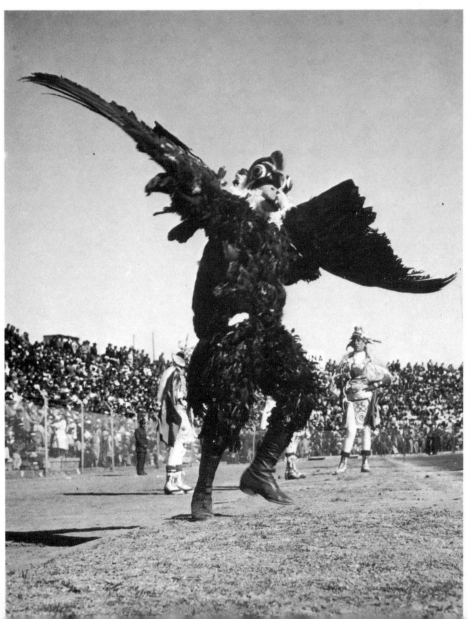

'One becomes what one displays': costumes and masks are means of attaining identity with spiritual forces, and of shaping the imagination to the archetypes

111

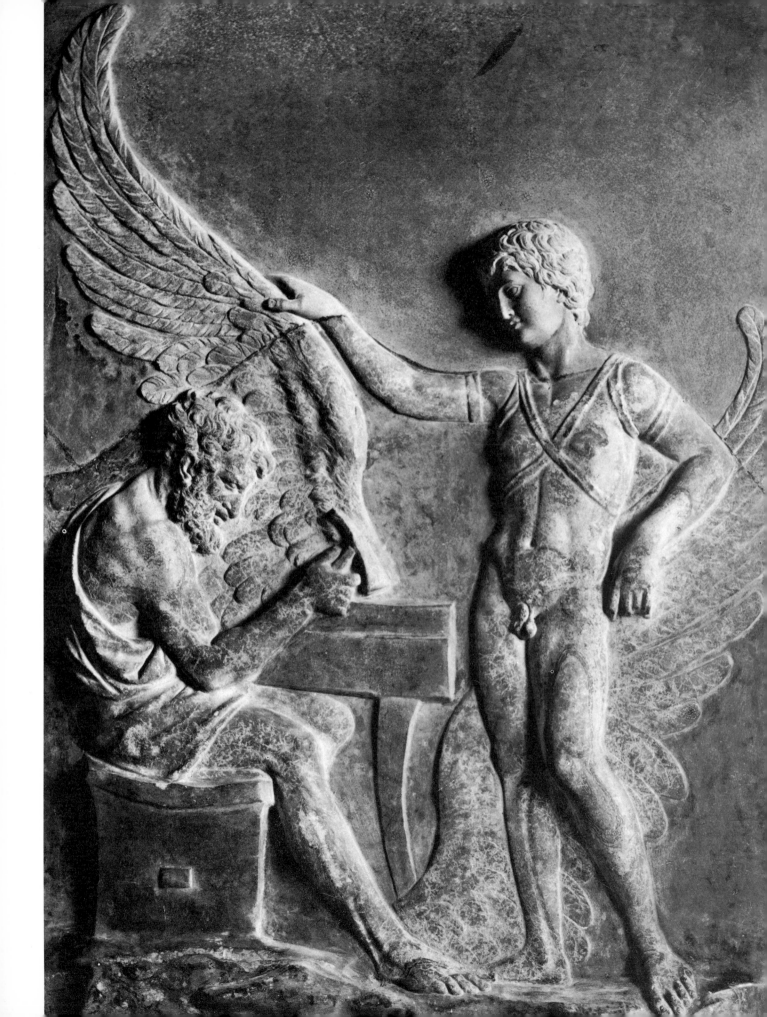

The tale of Icarus represents the dangers of flying unprepared for the marvels one may encounter in the Other World; the myth probably originates in ancient pre-Hellenic shamanism

(Opposite) Daedalus and Icarus; antique bas-relief in the Villa Albani, Rome

(Top) The Fall of Icarus, from Geffrey Whitney, A Choice of Emblemes . . ., Leyden 1586

(Above) Ganymede too is a figure from shamanism. Primordial themes survive in his myth: flight to Heaven, sexual ambiguity and intoxication. Woodcut from Andreas Libavius, Alchymia . . . recognita emendata et aucta, 1606

Sometimes, too, he was seen to fly to the altar of St Francis and of the Virgin of the Grotello. He once soared into an olive tree and remained kneeling for half an hour on a branch, which was seen to sway gently as if a bird had perched on it.

> I cannot wait
> > to start journeying;
> winged angels
> > on the Hill of Cinnabar
> are waiting to lead me
> > to the Homeland of the Deathless
> I wash my hair
> > in the valley of the sun
> at dusk dry out my body
> > by the Nine Orbs
> suck the fine liquid
> > of the Fountain of Flight. . . .
> Curbing my questioning mind
> > I rise into the haze
> embrace a floating cloud
> > fly upwards
> tell Celestial Watchman
> > to unlock the gate
> roll Heaven's portals clear
> > make way for me! . . .

(Yuan Yu, *The Far-off Journey*, attr. to Ch'u Yuan; trans. J. Peter Hobson)

Black Elk

I looked up at the clouds, and two men were coming there, headfirst like arrows slanting down; and as they came, they sang a sacred song and the thunder was like drumming. I will sing it for you. The song and the drumming were like this:
'Behold, a sacred voice is calling you;
All over the sky a sacred voice is calling.'

(*Black Elk Speaks*)

Black Elk was a cousin of Crazy Horse; he lived through the Wounded Knee massacre of 1890, became a holy man, and worked in Wild Bill Hickock's Wild West Show, among his other adventures. As an old

man in 1931 he told his story to a white friend, John G. Neihardt, fearing that otherwise his great vision would be lost. Black Elk believed he possessed a healing mission for all mankind, and especially his own people; after a life he interpreted as a failure, he doubted himself. But the document Neihardt produced, and later *The Sacred Pipe* composed by Black Elk with J. Epes Brown, constitute two of the most profound mystical and metaphysical records of this century; both have been a major force in the revival of native American religion.

Black Elk's teachings centre around a vision he experienced at the age of nine: an ascent to heaven. It begins with his falling ill, as is frequently the case with mystics still unaware of themselves, especially shamans.

The two figures described above (Black Elk later painted them with wings and spears, so that they look exactly like Native American Angels) come to fetch the spirit of the paralyzed boy. With them he soars into the clouds: 'We three were there alone in the middle of a great white plain with snowy hills and mountains staring at us; and it was very still; but there were whispers.'

The Angels then present the boy with a preliminary vision: a mandala composed in this cloudy space. A bay horse appears and speaks. In the West he points out twelve black horses whose manes are lightning and who snort thunder.

The two spirits coming for Black Elk

In the North appear twelve white horses, their manes flowing like a blizzard, and white geese soaring and circling around them. In the East twelve sorrel horses with necklaces of elk's teeth and eyes that glimmer like the daybreak star, and manes of morning light. In the South, twelve buckskins with horns on their heads and manes like trees and grasses.

The mandala grows with the addition of whole herds of horses dancing, which change into animals and birds of every kind. A huge procession follows Black Elk to a tepee made of clouds and a rainbow, where he finds the six 'Grandfathers' who have summoned him. 'They looked older than men can ever be – old like hills, like stars.'

The Grandfathers are the chiefs of the six directions (hence another mandala, representing the entire cosmos). Each of them presents the child with a gift. The West, the eldest, gives him a cup of water (the power to make life) and a bow (the power to destroy). Then he points to himself and says, 'Look close at him who is your spirit now, for you are his body and his name is Eagle Wing Stretches.' In other words, this is Black Elk's spiritual double or guardian, his spiritual 'name'.

The other grandfathers then present him with a healing herb, a peacepipe, a red stick symbolizing 'the centre of the nation's circle', and power over the birds ('All the Wings of the air shall come to you, and they and the winds and the stars shall be like relatives'). The sixth Grandfather, spirit of the Earth, appears to be the most decrepit of them all, but suddenly he begins to grow younger till Black Elk realizes 'he was myself with all the years that would be mine at last'. (Another form of the guardian – thus Black Elk is specially protected by two powerful Archangels.)

Again the horse-mandala forms; this time four beautiful maidens dressed in scarlet appear before each herd, holding the symbolic gifts. A black horse sings a song of renewal. 'His voice was not loud, but it went all over the universe and filled it. There was nothing that did not hear, and it was so beautiful that nothing anywhere could keep from dancing.' The whole universe dances to this song, so reminiscent of the harmony of the Spheres, or the Resurrection music of Israfil or Gabriel.

Then follows another vision. Black Elk stands on a mountain at the centre of the world (it was Harney Peak in the Black Hills – 'but any-where is the centre of the world'). He sees 'in a sacred manner the shapes of all shapes as they must live together like one being. And I

saw that the sacred hoop of my people was one of many hoops that made one circle, wide as daylight and as starlight, and in the centre grew one mighty flowering tree to shelter all the children of one mother and one father. And I say that it was holy.'

The two Angels now return to take the child back to his Grandfathers. 'He has triumphed!' cry the six together, making thunder. They again bestow their gifts, and as they do so they melt into the ground. At last the oldest dismisses him: 'Grandson, all over the universe you have seen. Now you shall go back with power to the place from whence you came, and it shall happen yonder that hundreds shall be sacred, hundreds shall be flames!' As Black Elk returns to earth he hears the Sun singing: '. . . with visible face I appear. My day, I have made it holy.' A spotted eagle conveys him home, and he sees his sick body waiting for him; as he enters it, he wakes. 'Then I was sitting up; and I was sad because my mother and father didn't seem to know I had been so far away.'

This extraordinary narrative is at once the most recent and the most primordial of Angelic recitals – and one of the most poetic and profound.

To ascend, to escape

There exist literally scores, perhaps hundreds, of accounts of heavenly ascensions. Obviously the symbolism, the archetype of the ascension, exercises a great fascination in every culture.

The Church Fathers who put together the New Testament, like those earlier and even more shadowy 'editors' of the Old Testament, evidently made both spiritual and literary judgments in sifting through the texts available to them. Thus the *Book of Revelation* is the only Apocalypse admitted to the orthodox New Testament. Perhaps the Fathers knew it was really written by John, perhaps not; ultimately, what does it matter? *Revelations* is a great poem and an authentic vision, whoever wrote it.

The late Zoroastrian text, *The Book of Arda Viraf*, seems to contain earlier and genuinely visionary material overlaid with a concern for ethics. Indeed, it begins by bemoaning the state to which the Faith has been reduced through the invasion of Persia by Alexander the Great. A group of pious priests, meeting in what is now Kabul,

Flight of the shaman;
Eskimo stonecut from
drawing by Oonark

decide that someone must visit the Other World to discover if the rituals on earth are being properly performed (a profound idea in itself, since it implies that ritual must be a direct reflection of actions perceived in the spiritual world).

Arda Viraf is chosen by lot to make the journey. After drinking a narcotic (apparently a potent mixture of cannabis and datura), he falls into a deep sleep, and his soul leaves his body. The Angel Saroush (the Messenger, a Gabriel-like figure) and Atar (Spiritual Fire) meet and escort him. He sees the souls of the departed leaving their bodies, drawn 'into the sweet scent of trees that comes from the South, the sacred direction.' They meet their guardian Angel in the form of a beautiful maiden who represents their good deeds and thoughts. Arda Viraf passes over the Chinvat Bridge (the narrow or perilous Way common to so many mythologies). Thence he visits a series of heavens; but the writer's imagination is flagging, and all he can say after each new level is that 'it seemed to him sublime'. The hells depicted appear to owe their highly moralistic punishments to Gnostic Jewish or Christian influences.

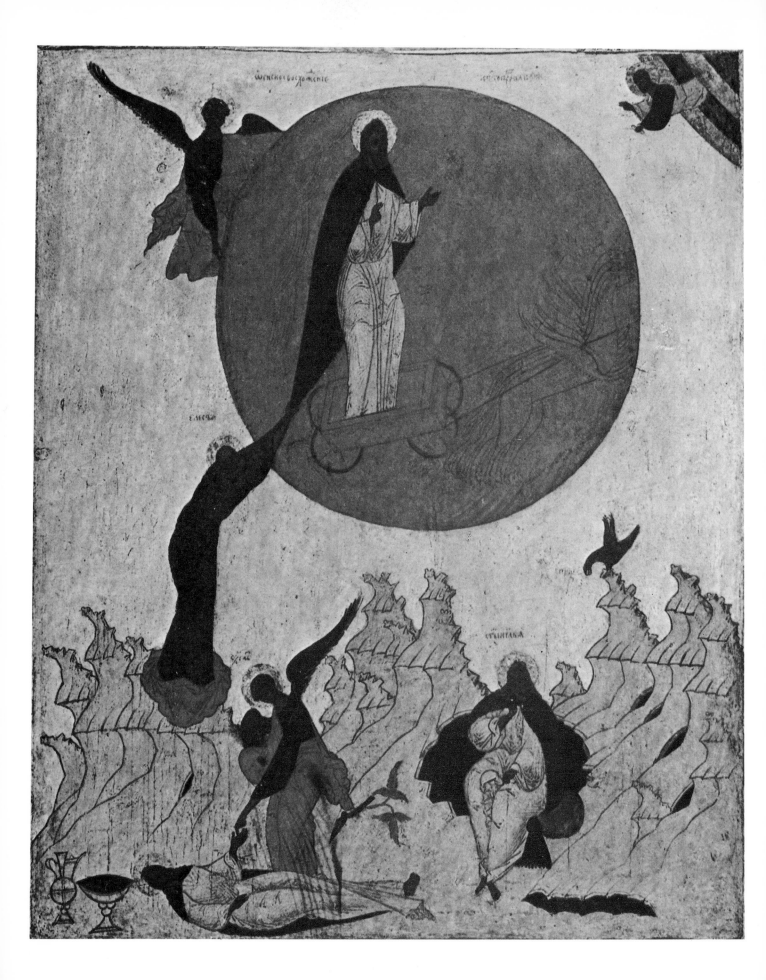

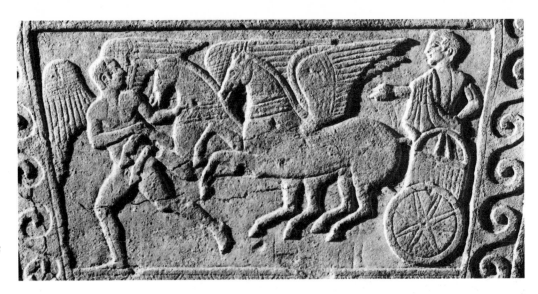

The Angelic journey; from an Etruscan stele of the 3rd century BC

The moralistic tone is matched and even exceeded by some of the Jewish and Christian Apocrypha, of which the genuinely interesting *Book of Enoch* serves as prototype. The *Apocalypse of Peter*, the *Apocalypse of Paul*, the *Ascension of Isaiah*, the *Shepherd of Hermas* and others are worth studying, perhaps, as possible sources for Dante. They have very little value in themselves.

As opposed to such works, however, we find others in which the visionary experience breaks through and transcends the bounds of a system. Such is the case, for example, with *The Hymn of the Pearl*, an exquisite little poem precariously embedded in the Apocryphal Acts of Thomas, where it apparently does not really belong. The dramatic anticosmology of the Gnostics, a system which scorns human life in every respect and tends towards a suicidal pessimism, has already been described. The *Hymn* belongs to this system – its mythos and vocabulary prove it. But nothing in it could give offence to even the purest life-affirming mystic. It exudes joy, and develops within a literary atmosphere of such subtle symbolism that any reader, whatever his religion or faith, can find in it reflections of his own soul-experience.

'When I was a little child': thus the tale begins, and the soul addresses us in the first person. It lives in the East, 'in the house of my father'. As with the tale of *Cupid and Psyche*, we begin before birth, in the heaven of souls not yet sent down into bodies. The narrator's parents provision him well with wealth for the trip, with gold and silver, 'chalcedonies of India and opals of the realm of Kushan. And they girded me with adamant, which crushes iron.' All this they give, but

(Opposite) Served in the wilderness by crows, Elijah himself attains the power of flight: the ravens of putrefaction give birth to the firebird of prophecy; a 16th-century Russian painting

they took off from me the splendid robe
which in their love they had wrought for me . . .
which was woven to the measure of my stature.

This robe represents the spiritual double, the Angel in heaven who sees the Father.

His parents make a covenant with him:

'If thou go down to Egypt
and bring the one pearl
which is in the midst of the sea
in the abode of the loud-breathing serpent,
thou shalt put on again thy spendid robe
and . . . be heir in our kingdom.'

Egypt is the West, the land of evil magic and the setting sun, the place of exile: the body. The serpent (Ourobouros, the world-encircling dragon) is the cosmos.

The soul descends into Egypt and takes up residence near the serpent, waiting for it to fall asleep so that he can rescue the Pearl. At the inn 'a nobleman of the Orient, a youth fair and lovable' warns him against the Egyptians, 'the unclean'. But 'I clothed myself in garments like theirs, that they might not suspect I was an alien.' When he eats the food of the Egyptians he forgets who he is and falls into a deep sleep.

The soul's parents observe and take pity. They write him a letter:

'Awake and rise up from thy sleep
and harken to the words of our letter.
Remember that thou art a son of kings . . .
Remember the Pearl.'

The letter takes on the form of an eagle. 'It flew and alighted beside me, and became all speech.' This is the Angel of the Call, the messenger from the Other World.

The soul now recalls its true mission. He begins to cast a spell on the serpent and puts it to sleep by repeating his father's name (i.e., *dhikr* or *mantra-yoga*, invocation of the Divine Name). He succeeds, and snatches away the Pearl. Now the Letter-eagle leads him back home:

As with its voice it had awakened me
so it led me further with its light
written on Chinese tissue with cinnabar
gleaming before me . . .
and drawing me with its love.

COLOUR PLATES

Isis the Protectress, Virgin and Mother, manifests herself as an Angel, her wings spread to enfold her worshipper in the sleep of unity. So powerful is this image that it long outlasted ancient Egypt; as late as The Golden Ass *of the Roman writer Apuleius, Isis is still a potent rival to Jesus Christ*

The seven-headed serpent of Revelation *swallows the waters of earth, sucking all the time and matter into the maw of chaos at world's end. But the Angel flies above, promise of safe harbour beyond time itself. From a medieval German manuscript*

Near the climax of his Night Ascension into Heaven, the Prophet Mohammed, his mount Buraq, and his guide Gabriel are nearly gulfed in golden clouds, symbolizing the gradual englobement of all multiplicity in the light of Oneness. The text of this Turkish manuscript is in Uighur, the language of Asian Manichaeans; it was probably circulated among them as an advertisement for the superior marvels of Islam

120

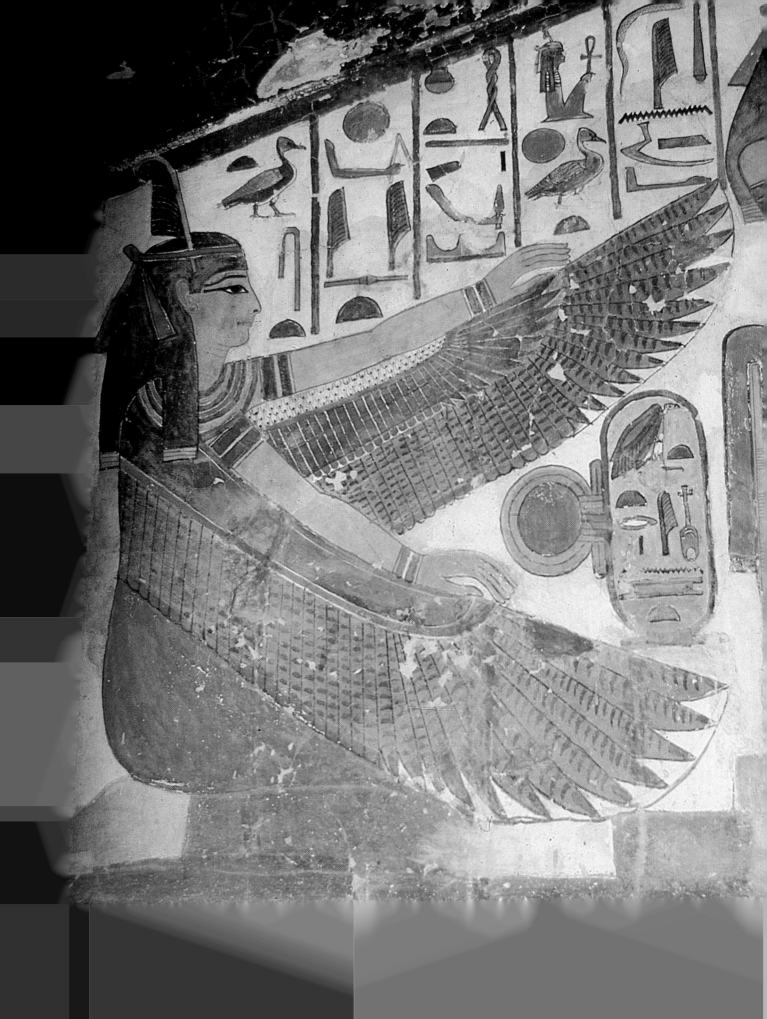

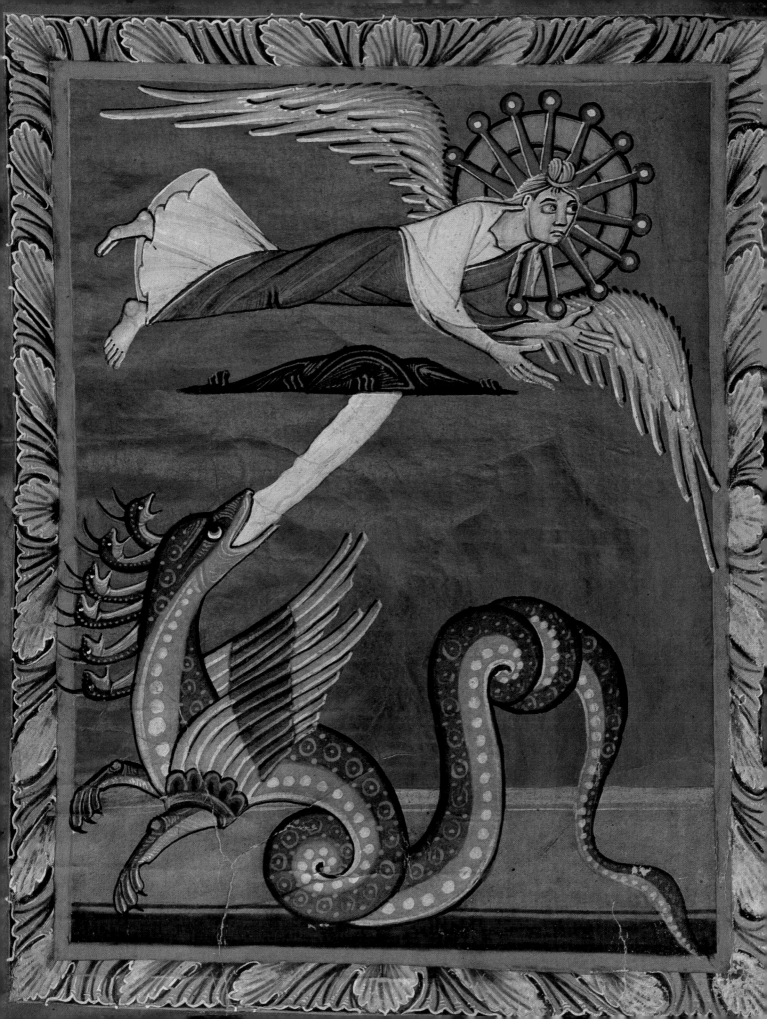

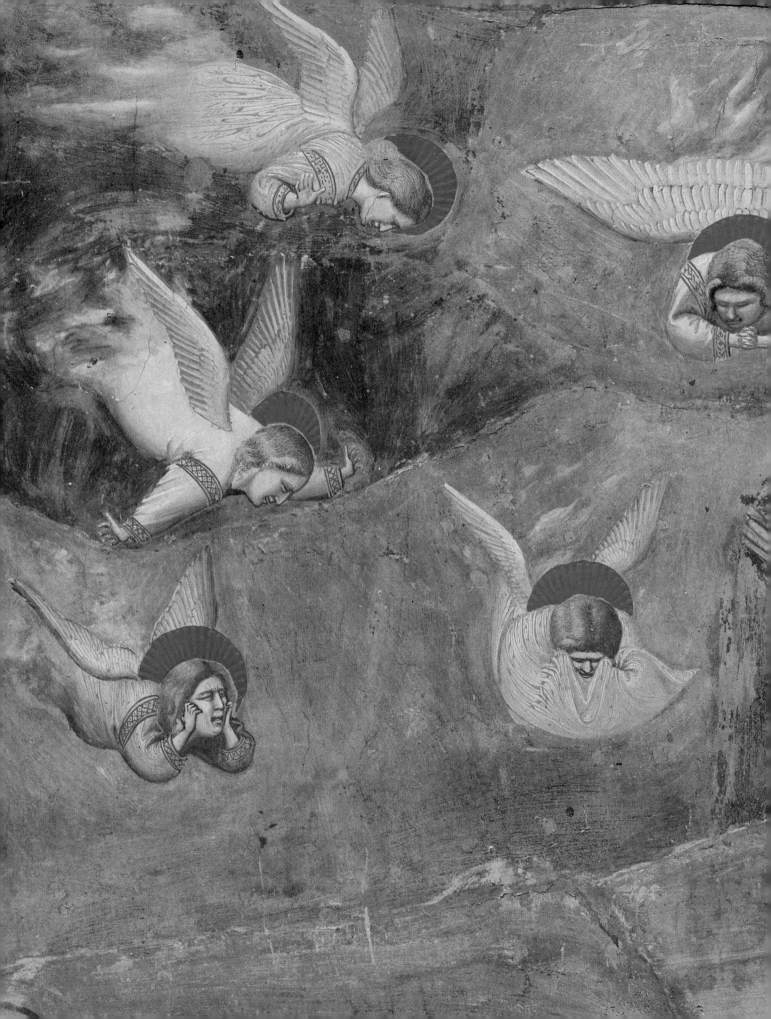

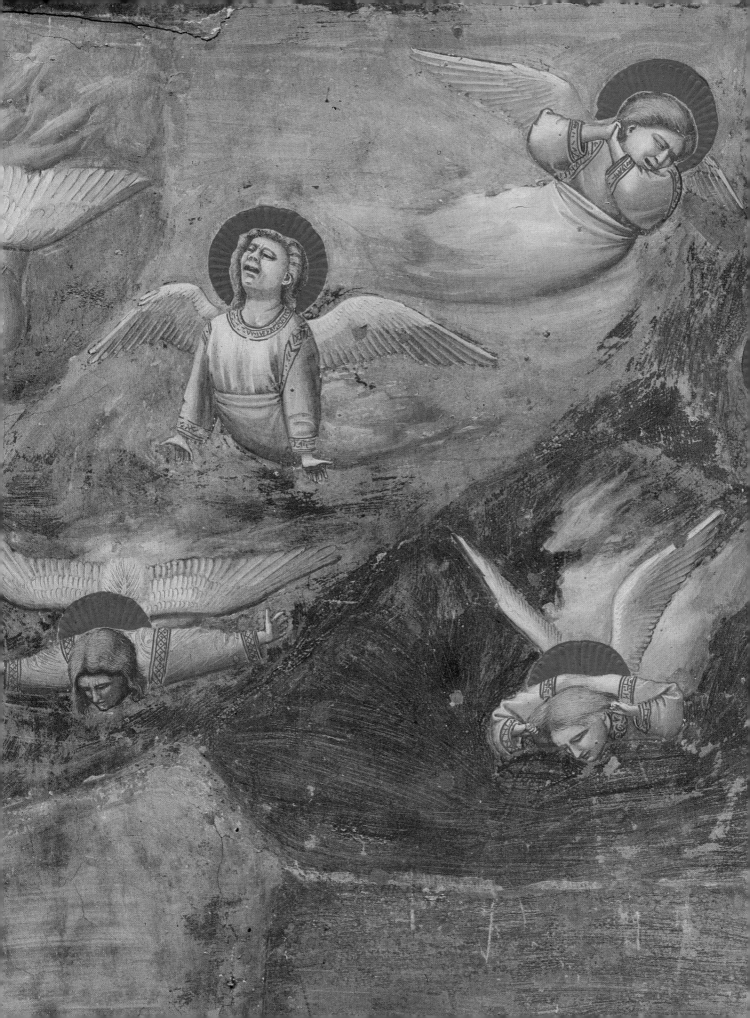

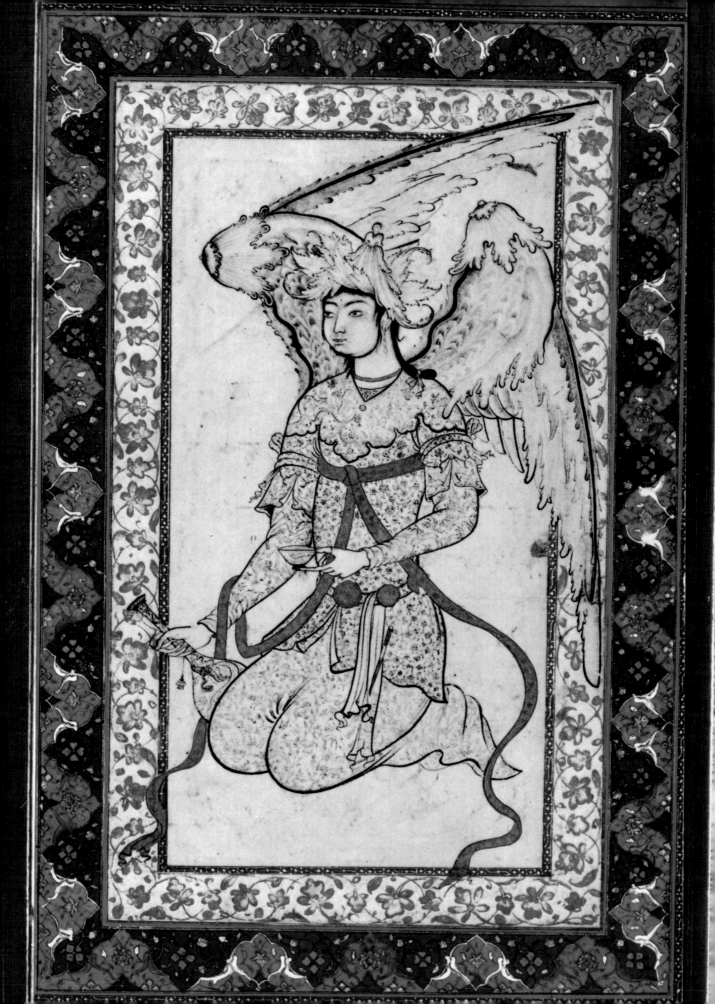

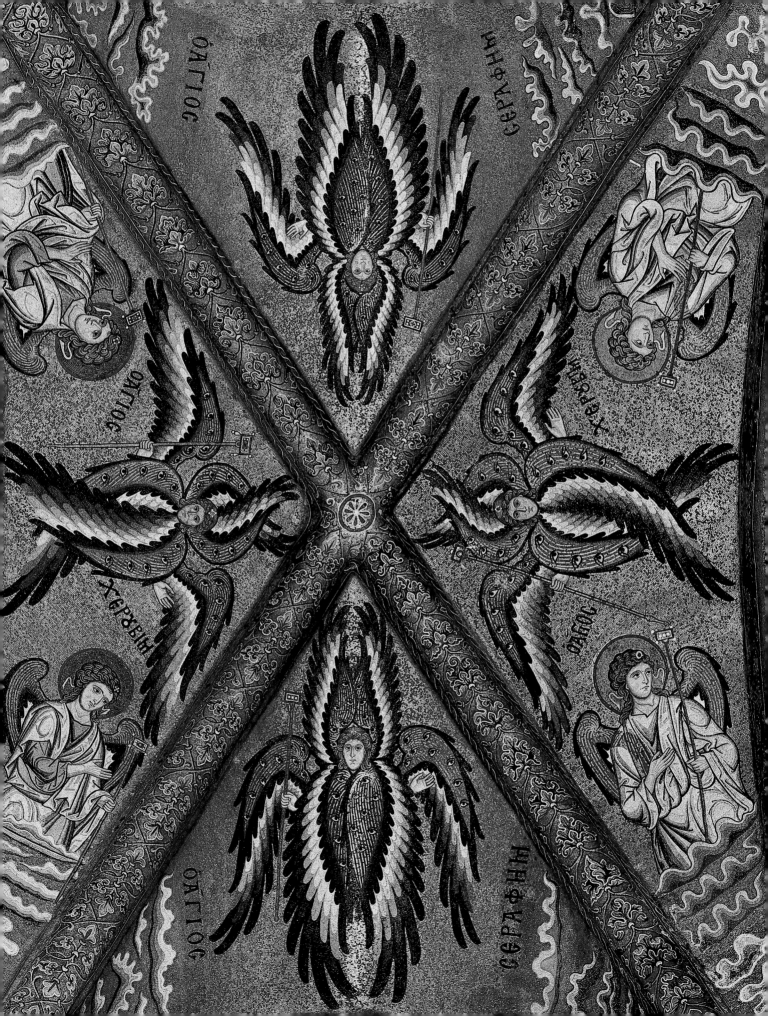

The soul now retraces its journey through a visionary landscape, towards the Orient. At the shore of a sea (the border between worlds), he is met by the Robe, which his parents have sent to him with two 'treasures' or Angels.

> . . . Suddenly, when I saw it over against me,
> the Robe became like me, as my reflection in a mirror;
> I saw it wholly in me
> and in it I saw myself apart from myself
> so that we were two in distinction
> and again one in form.

Thus is depicted the reunion of the human soul with its celestial counterpart. 'The likeness of the king of kings was embroidered all over it': the robe is in fact the divine Face of the individual soul. The Robe also speaks; 'and with its royal movements it poured itself entirely toward me . . . I drew it completely over myself . . . and mounted up to the gate of greeting and homage.' The soul is reunited with its heavenly family and enters into its kingdom.

What does the Pearl symbolize? If we interpret the poem in strictly Gnostic terms, it ought to represent the divine 'spark' lost in the hell of the material cosmos. In this case the soul – the narrator – would have to stand for the Redeemer, the Saviour (the Aeon Jesus), who is sent down to collect and redeem the 'sparks' imprisoned in human flesh.

In any case, there is no need to press such speculations too far, for the *Hymn* belongs to that body of pure symbolic literature which is too profound to be limited to a single interpretation. It is an authentic vision with universal applications.

Orient and Hyperborea

Not every journey is a journey *to* the Angel, and not every way leads *up* in the strict sense of the word. Some seekers travel *with* the Angel, and *across* the face of an earth transformed by symbolic insight into a horizontal mirror image of the celestial or vertical ascent. The sacred direction then might be any one of the four: in Zoroastrianism the way leads South, in Celtic and American Indian lore West. Most Semitic writers favour the symbolism of the East, and in Aryan-influenced myth the direction is sometimes North. In all these cases the purpose is the same: as the sufis put it, to make a 'journey to the Outer Horizons' which will correspond to the 'journey to the Inner Horizons'.

COLOUR PLATES

According to tradition, the Angels have no fore-knowledge of Christ's incarnation, passion or resurrection; each stage of the mystery is as marvellous to them as to mankind. But where our reactions are mixed with our imperfections, the Angels' response is pure: their grief is the very archetype of grief. From a fresco by Giotto in the Scrovegni Chapel, Padua

'Even Angels knock at the tavern door, seeking for the intoxicating wine of the mystics,' as the Persian poet Hafiz boasted. The saki, *or cupbearer, symbolizes the initiating guide. To be drunk on the wine of realization is to become an Angel*

'With a rushing motion', as Plato says, the Angels fly between earth and Heaven, going where God directs them as His emissaries and messengers. The crown and ribbons suggest a Chinese-Buddhist influence on the Persian imagination of this illumination of Shahnameh *by Firdowsi*

Kerubim and Seraphim divide all space between them in the universal four-sided formula of the mandala – an artistic device to trigger realization in the contemplative soul. From the Cathedral in Cefalù, Sicily

Thus one travels with the Angel, whose presence as guide or interpreter permits one to find in the landscape the 'signs', the symbols, of true selfhood.

The Book of Tobit, one of the Old Testament Apocrypha, contains such an itinerary. Tobit is a pious Jew of good family, an exile in Nineveh. He suffers persecution from the gentiles, and through an accident he goes blind. He decides to send his young son Tobias to Persia to collect a debt from a business acquaintance there, and directs the boy to find some older person to accompany him. Tobias goes out looking, and meets a man he immediately likes and trusts. 'Canst thou go with me to Rages [Rayy, near modern Tehran]? and knowest thou those places well?' The man introduces himself to old Tobit as Azarias, a Jew of good reputation, and the journey is arranged. 'So they went forth both, and the young man's dog with them.'

In the evening they come to the banks of the Tigris. A fish leaps out of the water as if to seize Tobias, but Azarias shows him how to catch it. (Apparently it is meant to be a sort of water-dragon, though later artists depict it as a little trout.) The man directs the boy to cut out the fish's heart, liver and gall, explaining that they possess magic properties.

Now the scene shifts to Persia, where we learn of the strange plight of a young girl called Sara, daughter of Raguel (a cousin of Tobit's living in Ecbatana, near modern Hamadan). She is bewitched: she has been married to seven men, but all of them have been killed on their wedding night by the demon Asmodeus 'before they had lain with her'.

Soon the boy and his companion arrive in Ecbatana, and Azarias suggests that a marriage be arranged between Sara and Tobias. Naturally everyone is rather reluctant (especially Tobias), but Azarias instructs the youth to make an incense of the fish's heart and liver. On the wedding night he burns it; 'the which smell when the evil spirit had smelled, he fled into the utmost part of Egypt.'

Tobias and Sara spend the night in bliss, and next morning emerge unharmed to great rejoicing. While they enjoy a honeymoon Azarias goes to Rayy to collect the debt. The three of them (and the dog) then return to Nineveh. Azarias directs Tobias to make a salve of the fish's gall and anoint the blind eyes of Tobit, whereupon he recovers his sight. Tobit offers Azarias half his wealth in return for all this kindness, but the man refuses. He now reveals his true identity: 'I am Raphael, one of the seven holy Angels, which present the prayers of the saints,

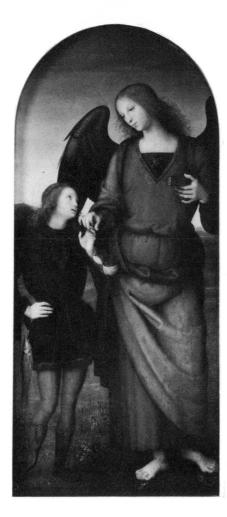

Tobias and the Angel;
*detail of Raphael's painting
of the Virgin and Child
with SS Raphael and
Michael, National Gallery,
London*

and which go in and out before the glory of the Holy One.' At first
the mortals are afraid, but Raphael calms them, and with an order
to write down all that has transpired, he vanishes. And they live
happily ever after.

In many mythologies the fish represents the life force, the sacrifice,
the food of wisdom. In the Koran we learn that the prophet Moses once
set out on a journey to discover the place where 'the two waters meet'
– which commentators interpret as the Gate between this world and
the World of Similitudes or the Angelic realm. He and his servant
wander, and reach the magic place without realizing it. The servant
takes a fish to wash it for the prophet's breakfast; the fish comes to life
in the water and swims away. The servant is afraid to mention the
incident, and soon they continue on their way. Moses grows hungry
and demands a meal; at last the story comes out. 'This is that which we
have been seeking!' Moses exclaims. They retrace their steps and
happen upon a slave. Moses begs to be allowed to accompany this

unnamed 'slave of God', but the man protests, 'Lo! thou canst not bear with me. How canst thou bear with that whereof thou canst not compass any knowledge?' But Moses insists, so the man accepts him – on condition that the prophet not question anything he sees, no matter how odd. Moses agrees. But when they arrive at the seashore the mysterious man finds a ship and breaks a hole in it. Moses is shocked, forgets his promise, and blurts out a protest. 'Did I not tell thee thou couldst not bear with me?' says the stranger.

Moses begs for another chance. So they journey on until they meet a lad, whom the stranger kills. Moses says: 'What! hast thou slain an innocent soul?' – he is horrified, and again forgets his promise.

The man offers Moses one more chance. They come to a town and ask for food, but are rudely refused. They find a wall there in ruins, and the man repairs it. Moses cannot help commenting, 'If thou hadst wished, thou couldst have taken payment for it.'

The stranger now tells Moses, 'This is the parting between thee and me! I will announce unto thee the interpretation of that thou couldst not bear with patience.' The ship, he explains, belonged to some 'poor people working on the sea, and I wished to mar it, for there was a king behind them who is taking every ship by force.' As for the boy, he was evil and wicked to his parents, who are 'believers', and God will send them a better child. The wall hides a treasure belonging to two orphan boys. If the stranger had not repaired it, the greedy townsfolk would have stolen the boys' inheritance.

The stranger, met like an Angel beside the fountain of Life, who thus instructs Moses in mysteries beyond the scope even of a great prophet, is traditionally identified as Khezr, the Green Man. Islamic folklore proposes many possible origins for this 'hidden prophet', who lives forever and appears suddenly to mystics who have been unable to find a human Master, to initiate them or rescue them from danger. All versions agree, however, that Khezr himself was once an ordinary man.

Once, when Khezr was still a mortal, he was hired as a cook to accompany the army of Alexander the Great on its march to the East. But he made fun of the great Macedonian's worldly ambitions, and was fired for insubordination. He hid himself in an empty trunk carried by one of the army's camels.

When Alexander reached India, he mourned because nothing remained for him to conquer. Just then the cook emerged from his

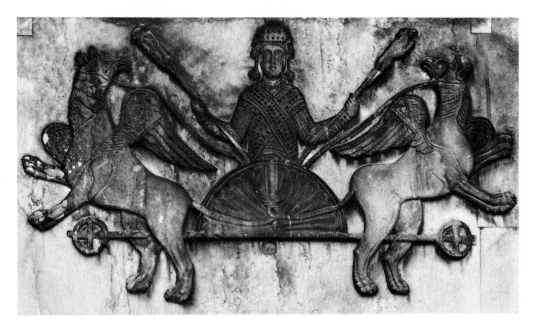

Alexander in the Orient is a figure of magic, almost a prophet; among other exploits introduced to Western tradition from Eastern sources was a flight to the heavens in a chariot drawn by gryphons. Relief from the Basilica of San Marco, Venice

trunk and addressed the General. 'I can tell you of a conquest worthy of your ambition,' he declared. 'Far to the North lies a land of permanent darkness. There is a spring there, a fountain of immortality, and whoever bathes in it lives forever.'

Alexander's imagination was ignited, and he ordered the army to set out. They passed through six mysterious lands, each of which was entirely of one colour. In the Blue Land, for example, the earth was strewn with turquoise and the streambeds with sapphire. In the Red Land the rivers seemed to run with blood and the sky burned with a perpetual sunset. In each land, battalions of the army deserted in fear, realizing that they marched no longer in the real world.

The sixth land was white, a frozen waste where the skeletons of trees were encased in ice, where the air rang with frost, so cold that even the flames of their campfires froze solid. Here the rest of the army decamped, and Alexander and the cook found themselves on the border of the Black Land, shrouded in perpetual mist. Courageously they determined to push on.

In a forest of ebony growing amid wild boulders of onyx they became separated in the darkness. Alexander took out his sword and hacked his way forward. The cook had resigned himself to death, when suddenly he found himself in a clearing, and in the midst of the clearing was an emerald pool. There are several different versions of what happened next. One says that the cook, not realizing where he was, took out a dried fish and tried to wash it in the pool, in order to

prepare a meal. When the fish came to life and wriggled through his fingers, he realized he had found the Water of Life. In another version the pool was guarded by two fiery Kerubim, who invited him to bathe. When he did, he became immortal. His skin turned green (or he was given a green robe by the Angels). From then on, wherever he walked, flowers sprang up in his tracks. He left the pool and met Alexander again at the border of the white land – for the soldier's hacking had simply led him in circles. One version says that Alexander was so angry when he realized the cook had succeeded where he himself failed, that he hurled Khezr into the sea, where he became a daemon of the waters (and thus a patron of islands, rivers and fishermen).

Many strands of literature and folklore have been woven into this story, from the Epic of Gilgamesh to the Koran, including Central Asian and Aryan shamanic ritual, Jewish legends about Elias (with whom some commentators identify Khezr) and certain Christian tales of St George. Versions appear in Ethiopic texts and in the *Alexander Romance* of the sufi poet Nezami. In the sequence of colours one feels the influence of Islamic alchemy; Ala ad-Dawlah Semnani, for example, uses a system of colours ending in white, black and green. Each colour corresponds to a metal, a heaven, a prophet and a spiritual state, and he who attains the seventh level reaches 'the Gabriel of his own inner being'. Jili, too, made use of the legend when he described the Hyperborean land where Khezr rules.

The presence of the fish, and of Raphael, is reminiscent of *The Book of Tobit*. The latter is a single work by a single author working within a well-defined symbolic and spiritual structure. The tale of Khezr, however, is a hodgepodge of mythic bits and pieces clustering around one figure like iron filings around a magnet. In fact, *Tobit* is a finished text, something to be read and appreciated for itself, while the Khezr cycle, in all its chaotic suggestiveness, has served as inspiration for countless mystics and poets.

Khezr is another manifestation of that mysterious figure met on the borderland of the World of the Imagination, the Angel who extends to us an invitation: '. . . I have heard of a land where . . .' He is old and wise, yet forever 'green', young and fresh. The soul parched with thirst, trapped in an arid wasteland where the mind has betrayed it, will revive at a touch from Khezr, who brings water, who causes the Imagination to blossom.

The miraculous night journey

It is the one mighty in Power hath taught him, the Vigorous One; he grew clear to view as he hovered in the loftiest sphere; then he drew nigh and hovered in the air till he was distant two bows' lengths or nearer ... And verily he saw him yet another time by the lote-tree of the utmost boundary nigh unto which is the Garden of Abode. When that which shroudeth did enshroud the lote-tree, the eye turned not.

(*Koran*, LI, 5–17)

According to the traditional interpretation of this text, Mohammed saw Gabriel in his cosmic form (as opposed to hearing him, or seeing him in the form of a man) only on the two occasions thus described. The vision of the lote-tree refers to the Prophet's *mir' aj* (his 'ladder' or Night Ascension). The Koran gives very few details, but the Prophet himself recounted more, and later folklore fleshed out the tale even further.

It takes place just after Mohammed has been chosen as a prophet. One night three Angels come to him while he sleeps, cut open his breast and tear out his heart. With water from the sacred well of Zam-Zam in Mecca, they wash the heart and lave away all that they find within him of doubt, idolatry, paganism and error. Then they fill the cavity with a liquid of wisdom poured from a golden vessel, replace the heart and sew up the breast again.

On the next night, 'I lay asleep in my house. It was a night in which there were thunder and lightning. No living beings could be heard, no bird journeyed. No one was awake, whereas I was not asleep; I dwelt between waking and sleeping.'

Suddenly Gabriel the Archangel descended in his own form, of such beauty, of such sacred glory, of such majesty, that all my dwelling was illuminated. He is of a whiteness brighter than snow, his face is gloriously beautiful, the waves of his hair fall in long tresses, his brow is encircled as with a diadem of light on which is written 'There is no god but God'. He has six hundred wings set with 70,000 grains of red chrysolite.

When he had approached me, he took me in his arms, kissed me between the eyes and said, 'O sleeper, how long wilt thou sleep? Arise! Tenderly will I guide thee. Fear not, for I am Gabriel thy brother.'

The Angel offers Mohammed a choice of three cups: one of wine, one of honey, one of milk. The Prophet starts to take the wine, but Gabriel corrects him and gives him the milk. According to the commentators, wine is the animal 'breath', honey the physical 'breath' and milk the mental 'breath'.

Gabriel now brings Mohammed a supernatural mount, the Buraq, a winged mule with a woman's face. The Buraq (like Garuda) represents the contemplative mind – it is restive, and the Angel must calm it before Mohammed can ride.

They soar into the sky, hover for an instant over the Kaaba, and whirl away towards the north. In an instant they have arrived in Jerusalem at the Farthest Mosque, the Dome of the Rock. Here the muezzin is giving the call to prayer. They enter and find an assembly of Angels and prophets, who welcome them.

Now, according to some versions, Mohammed abandons the Buraq, tying her to the Rock, and climbs a golden ladder which appears over the Mosque. In other versions he keeps her throughout the journey. In any case, they now rise to the first heaven.

We are already familiar with several schemes of seven heavens, corresponding to the planets. In the earliest versions of the *mir'aj* details are scanty: the travellers encounter prophets in each sphere (Adam in the first, John and Jesus in the second, then Joseph, Idris [Hermes], Aaron, Moses and Abraham), as well as presiding Angels. Later versions add more colourful details, such as Angels of mixed fire and ice, visions of the punishments of the damned, descriptions of various ranks or choirs of Angels mentioned in the Koran, etc.

In one treatment (ascribed to either Avicenna or Sohrawardi) two more heavens are added. In the eighth are found the glorifying Angels; from these beings, observing their mode of worship, Mohammed learns the words and movements of the ritual prayer which he will teach his followers. In the ninth the Lote or Lotus Tree of the Farthest Boundary marks the limit of the Imaginal World. Beyond this, Gabriel cannot go, and Mohammed sees only a vast sea of golden light. Around the Tree dwell a multitude of souls who have become Angels, and an Archangel who pours water from a vessel into a great river; this is the First Intelligence, the first created being, emanating the very stuff of the universe.

Mohammed proceeds alone into the golden sea, and finds himself in a valley.

(Opposite) For Moslems the cosmography of the Other World finds its ultimate expression in the Night Journey of Mohammed, who rode to Heaven on Buraq (part Angel, part mule), accompanied by Gabriel and escorted by attendant Angels. From a 16th-century Persian Ms, Haft Aurang ('Seven Thrones'), the seven Mathnawi poems of Jami.

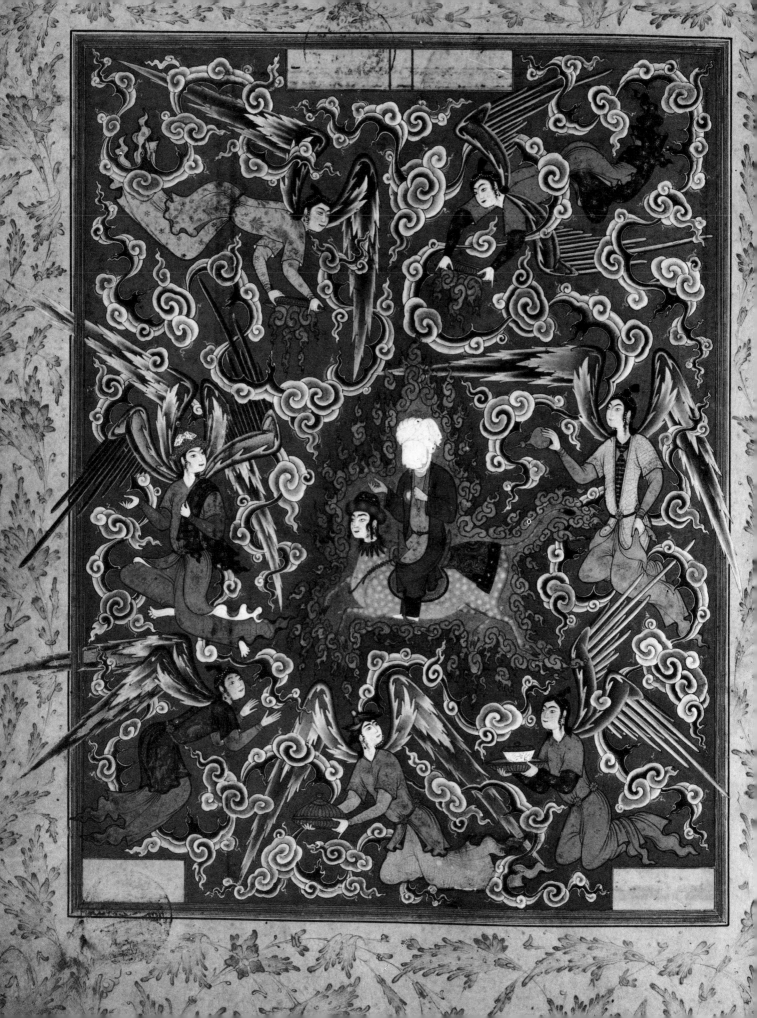

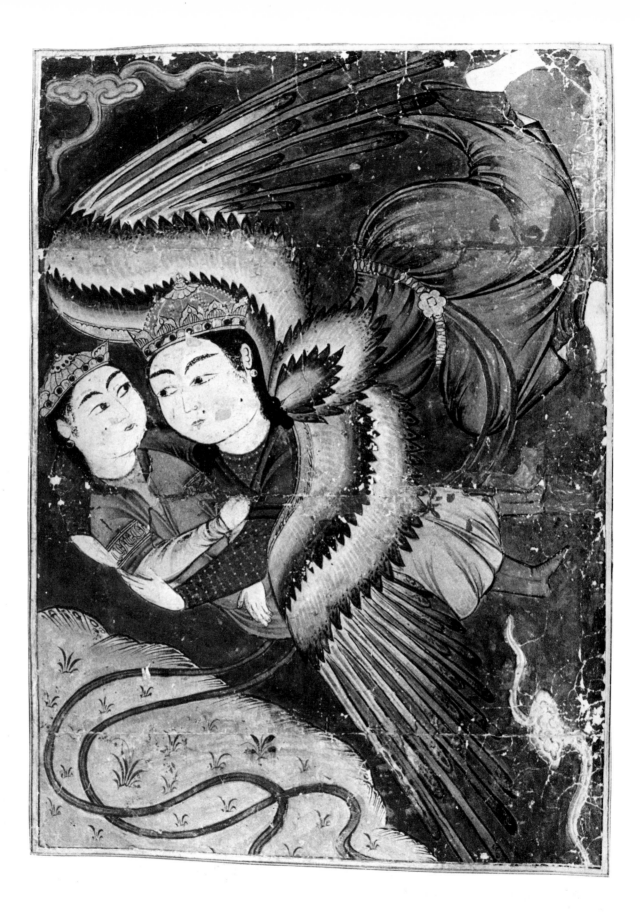

(Opposite) The 'Soul at Peace' is like a child, the puer aeternus *who represents all that is pure and sweet – yet also somewhat numinous and magical – in the human heart. Turkish miniature of an Angel carrying off a prince*

Over against the valley I saw an Angel in meditation, perfect in Majesty, Glory and Beauty. When he saw me he called me to him. When I had come close I asked, 'What is thy name?' He said, 'Michael. I am the greatest of the Angels. Whatever difficulty thou conceivest, question me; whatever thou desirest, ask of me.' I said to him, 'To come hither I have undergone many toils and sufferings. But my purpose was this: to attain to gnosis and the vision of Truth. Show me the direction that leads to Him, so that perhaps I may attain the goal of my desire, and receive a portion of His universal Grace.'

Then that Angel took me by the hand, he made me enter and led me through so many veils of light that the universe I saw had nothing in common with everything I had previously seen in these worlds.

He hears a voice summon him: 'Come yet nearer'. He experiences intoxication and fear of the divine *tremendum*, but the Voice says, 'Fear not, be quieted, come nearer yet.' Again it commands: 'Ask!'

Mohammed speaks: 'Permit me to ask concerning all that has been shown to me, so that all doubts may end.' Then the Voice instructs him 'without a voice', and bestows on the Prophet the highest mode of intellectual intuition, the perfection of gnosis.

Now Mohammed returns, descending through the heavens, to Mecca. As he wakes to himself in his room, he discovers that a water jug, which the Buraq knocked over with her hoof as they departed, is still pouring out upon the floor: the whole trip has taken place outside time, literally in a split second.

Visionary recitals

> As the Prophet said, 'He who knows himself, knows his Lord.' This is why the Master Avicenna says: 'He who crosses this clime and is shown the way to leave it, such a one comes to the clime of the Angels' – that is, when he has attained to knowledge of his soul, he can then know the Angels.
>
> (*Commentary on Hayy Ibn Yaqzan*)

Inspired by the *mir'aj*, many Moslem mystics lived intimately with the symbolism of the celestial journey. Moreover, in the first few centuries of Islam a vast amount of ancient literature was translated into Arabic, so that the learned grew familiar with Egyptian, Mesopotamian and Chaldaean mysteries, Hermetic and alchemical teachings,

Neoplatonic philosophy, Jewish, Christian and Zoroastrian scripture and Apocrypha, even Hindu, Buddhist and shamanic lore – an unprecedented mixture of cultures and faiths was tested with the touchstone of the Koran and Prophetic Traditions, and much of it was adapted and absorbed.

One result of this ferment was the crystallization of a literary genre which Henry Corbin called the Visionary Recital. These short treatises or 'fictions' are couched in a symbolic and poetic style, and deal with mythic or visionary material. A number of authors, for example, composed treatments of the soul's journey to God in terms of a fable about birds seeking their king; this subject reached its pinnacle with 'Attar's famous *Conference of the Birds*.

Avicenna, the Persian physician, statesman, philosopher and mystic (980–1037), was one of the earliest authors to develop this concept. One of his recitals deals with a version of the bird-journey; another, *Hayy ibn Yaqzan* ('Living son of Vigilant'), marks a major development of Islamic angelology.

Avicenna begins by describing his encounter with the Angel Hayy. 'He was beautiful; his person shone with a divine glory. Certainly he had tasted of years; long duration had passed over him. Yet there was seen in him only the freshness proper to young men; no weakness bowed his bearing, no fault injured the grace of his stature. In short, no sign of old age was to be found in him, save the imposing gravity of old Sages.'

Hayy reveals his identity to Avicenna and explains that his profession 'is to be forever journeying . . . about the universe.' He offers to teach Avicenna something of his wisdom, and urges the philosopher to abandon his evil companions (the lower faculties of his soul) so that he can one day accompany Hayy on his travels.

Hayy regales Avicenna with picturesque details of the spiritual cosmos, worlds of demons and djinn and Angels, the principles of matter and form, etc. Of greatest interest, however, is the detailed scheme of the Angelic hierarchy. It begins with the First Archangel/Intelligence or Kerub, the first thing created by God, from whom all the Archangels and Angels emanate in downward order. From him emanates the second Archangel/Intelligence, and from him in turn come forth two more figures: the first Angel/Soul, and the third Archangel/Intelligence. In Avicenna's scheme, the Angel/Souls are the rulers of the spheres: out of love and desire to reunite with their

'parent' Archangels, they cause the spheres to move and create the order of the cosmos.

Gabriel, the Active Intelligence, is the tenth Archangel; he rules the sphere of the Moon and all beneath it. He produces the multitude of souls which will become incarnate in human bodies.

Finally, each human being 'possesses' – or, to be more precise, 'is composed of' – two Angels. On his right stands the Angel spirit: guardian, guide and companion. On the left is the *guided* spirit, the receptive soul. Thus the total self is composed of a reunion of a celestial Angel with a 'fallen' Angel; they are the two wings of the soul.

The recital of *Hayy ibn Yaqzan* closes with a description of the end and goal of this hierarchy, God Himself. 'Sometimes certain solitaries among men emigrate towards Him . . . and when they return from His palace, they return laden with mystical gifts . . . Now, if thou wilt, follow me, come with me toward Him.' And here the text ends.

This invitation presupposes a specifically Angelic spiritual path. It will be taken up with fervour by many, the greatest of them a brilliant Persian named Sohrawardi, who was to be martyred for his beliefs in Aleppo in 1191 at the age of thirty-three.

Sohrawardi composed huge treatises in Arabic, developing his philosophy of 'Illumination' which was to shape the entire course of Islamic thought. But his Angelic teachings are couched in a series of graceful visionary recitals written in Persian.

In *The Rustling of Gabriel's Wing* he describes how one sleepless night he wanders forth and encounters ten Sages who are clearly Avicenna's ten Archangels. One of them teaches Sohrawardi various mystical sciences, such as Kabbalistic numerology and the invocation of Divine Names; and offers a mythic cosmology which exactly parallels that of *Hayy ibn Yaqzan*. Sohrawardi asks him to interpret the symbolism of Gabriel's wings, and the Angel (who in fact is Gabriel in human form) explains that the right wing is pure light, but the left is mixed and darkened 'like the moon at twilight' (i.e., it is red). Thus the first wing is turned toward Being, the other toward non-Being; from the first descends a ray of light from which emanate all human souls, from the second falls a shadow which is the world of mirage and illusion. The first gives spiritual realization, the second violence and the cry of misery. Now dawn comes and Sohrawardi is devastated at losing the company of the Sages. However, he meets Gabriel again: an encounter he describes in *The Crimson Archangel*.

These two narratives deal with preparations for the great journey. The third text, *The Recital of the Occidental Exile*, describes the journey itself. Sohrawardi begins by remarking that he has read Avicenna's *Hayy ibn Yaqzan*; despite its admirable and profound qualities, he finds it lacking in what the Koran calls 'The Great Shock', the complete revelation. Therefore he proposes a recital which will pick up where Avicenna left off, with the hint that 'sometimes certain solitaries among men emigrate towards Him . . .'

The hero starts out on a journey with his brother towards the Occident, to hunt for certain birds that live on the banks of the Green Sea. In the City of Qayrawan (actually in Tunisia, but used here as a symbol of the spiritual Far West) they are captured and thrown into prison by the evil inhabitants, who are enemies of their father Shaykh Hadi ibn al-Khayr ('Guide son of the Good') of Yemen (i.e., the Orient, the spiritual world).

They are chained and thrown into a deep well. During the night they are allowed to climb up into a high fortified tower, but during the day they must return to the pit. At night they gaze out of the windows onto the vastness of space, and doves visit them bringing news from Yemen. Lightning flashes in the Orient, and the Eastern breeze arouses in them an overwhelming nostalgia for their home.

One moonlit night a hoopoe brings them a letter from their father. The birds says he knows the way to save them, and adds that all is explained in the letter. Shaykh Hadi writes: 'We sigh after you . . . , we call you but you do not set out; we send you signs but you do not understand . . .'

The brothers escape and begin to make their way toward the East. The journey takes them through the spiritual world beyond the heaven of the Moon. Finally they reach the oratory of their father on Mount Sinai. The Shaykh tells the narrator that he is now 'saved', but must for the time being return to Qayrawan because he is not yet ready to live permanently in the Orient. But one day he can come back to Yemen and stay forever. The narrator is at first saddened by this news, but then heartened by a description of the Angelic hierarchy, beyond even the station of Shaykh Hadi, which he will one day come to know. Sohrawardi ends with a prayer: 'Save us, O my God, from the prison of Nature and the shackles of Matter.'

If we seem here to be back in the world of Valentinian Gnosticism, perhaps this can be ascribed to the influence of Persian (perhaps even

Manichaean) dualism on Sohrawardi. In effect, the 'plot' of *The Recital of the Occidental Exile* so resembles that of *The Hymn of the Pearl* that one imagines Sohrawardi must have read it. If anything, Sohrawardi's version is slightly more 'pessimistic'.

No one could accuse Sohrawardi of falling outside the Islamic insistence on Unity of Being (except the exoterists who condemned him to death); and yet the atmosphere of his recitals reminds us of the myth of the fallen Sophia and the gnostic sense of cosmic disgust.

The Grail cycle

> Then the Angel carried me and said to me, 'Hast thou seen great marvels?
>
> (Robert de Boron, *The History of the Holy Grail*)

The author of *The High History of the Holy Grail* (not the text quoted above) breaks off his narrative to relate that 'in those days' the forests and islands of Britain – or rather of Logres, the 'spiritual' Britain – possessed the strange property of never remaining the same. By some magic, each time Arthur's knights set out on an adventure, following one of the long, straight, emerald-shadowed lanes leading north, south, east, west away from the court of the Round Table, they would find themselves in a *different* forest. And this, the author believes, was so that each adventure would be fresh in every respect.

The author thus explains something that all lovers of romance must have noticed: how quickly and easily the knights lose themselves in strangeness, as if to ride a few twilit miles were to pass into another dimension.

An adventure must not be merely an event in time and space - for the man who remains embedded in history cannot attain the highest experiences of chivalry, transforming love and the wisdom of a death freely encountered; nor can he attain the vision of the Grail.

'Those days' are not quite *in time*, and those leafy roads are not quite *in place*. The world of the Grail Quest seems to be our world – but superimposed upon it, penetrating it at certain key points, the Other World is present. On certain key feasts, such as Christmas, the death-day birth-day of the Sun, a time which stands at a slant to Time, Arthur declares he will eat no meat nor hear any song till some adventure presents itself. Almost at once there bursts through the gate

a Loathly Maiden or a Green Ogre who invites us to cut off its head. These horrendous characters are not demons but Angels in disguise, who will test our will to 'adventure', to the attainment of truth, with their nightmarish fancies.

In the greatest quest of all, the Grail, many will hear the call but few will be chosen to achieve it. This challenge cannot be met communally – it is reserved for the elect. To treat it as a contest of strength will bring disaster on the Court, which responded to the challenge in the first place because of a subtle disease, a decline in 'glory', a weakening of the chivalric fire. Those who achieve the quest are destined never to return; those who fail will plunge the kingdom toward cataclysm in their confused resentment; Arthur will go into his Island of Glass, Lancelot will die.

The destined knights – Perceval, Bors, Galahad or Gawain – must already possess all the virtues. The key virtue, Chastity, is not necessarily a late Christian interpolation, although Christianity may have given it a specifically sexual meaning. In a broader sense, 'chastity' means 'purity of heart', a virtue prized as much in easier pagan moralities as in the Church. (Gawain, for example, is not sexually chaste, but is true to Love; he is a perfect exemplar of the spiritual caste called *kshatriya* in Vedic terms.)

In the *Vulgate Cycle* and certain other versions of the Grail, the knights from time to time come upon forest monks living alone in hermitages. To these old men the knights recount their adventures and the monks interpret these events, penetrating tales of battle and haunted cemeteries to the meaning behind the forms. The important aspect of the monks' interpretation is the direction, the 'map' supplied to those who seek the Grail Castle, which in itself symbolizes the soul. The monks know the story of the Fisher King, the Waste Land, the family of the Grail guardians and its genealogy; they are like bards or shamans who alone preserve the knowledge of the dead, the legend of the tribe. Outward events point to this knowledge; by measuring these events, the monks weigh the spiritual progress of the seekers after knowledge.

Argument still rages over the Grail: is it a Celtic horn of plenty or the cup that caught Christ's blood, the sacred *yoni* or the vessel of sacrifice? The answer must be that it is all these, because above all it is a symbol of symbolism itself. It represents the very potency by which a symbol symbolizes, the perfect gate between one reality and another.

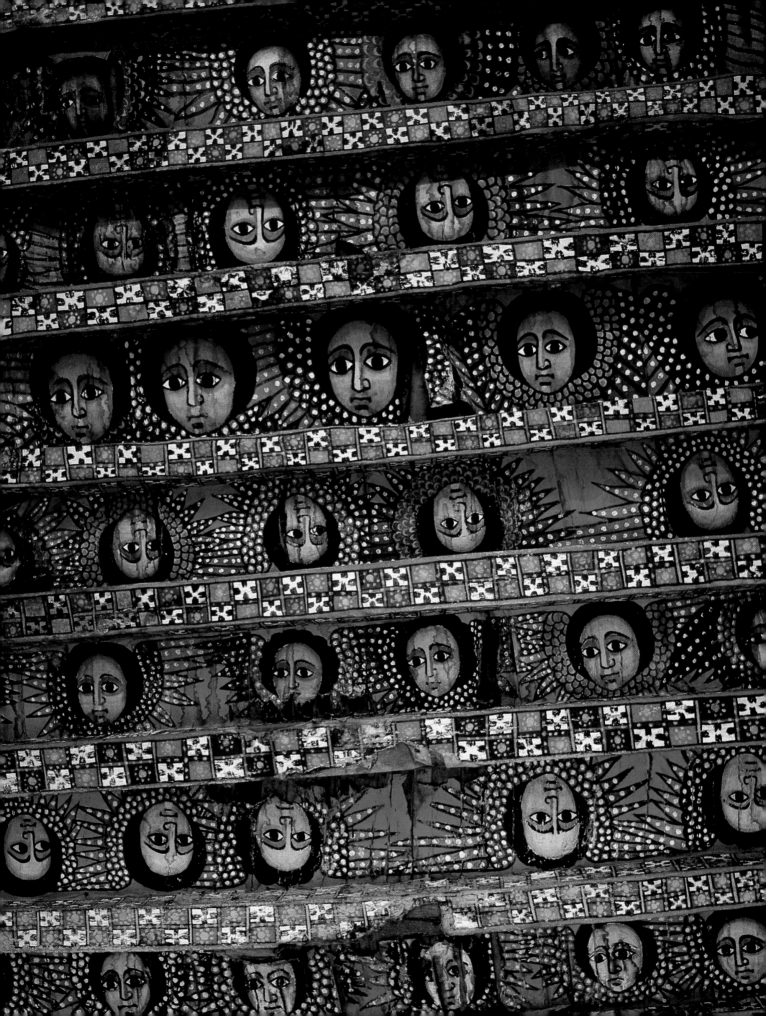

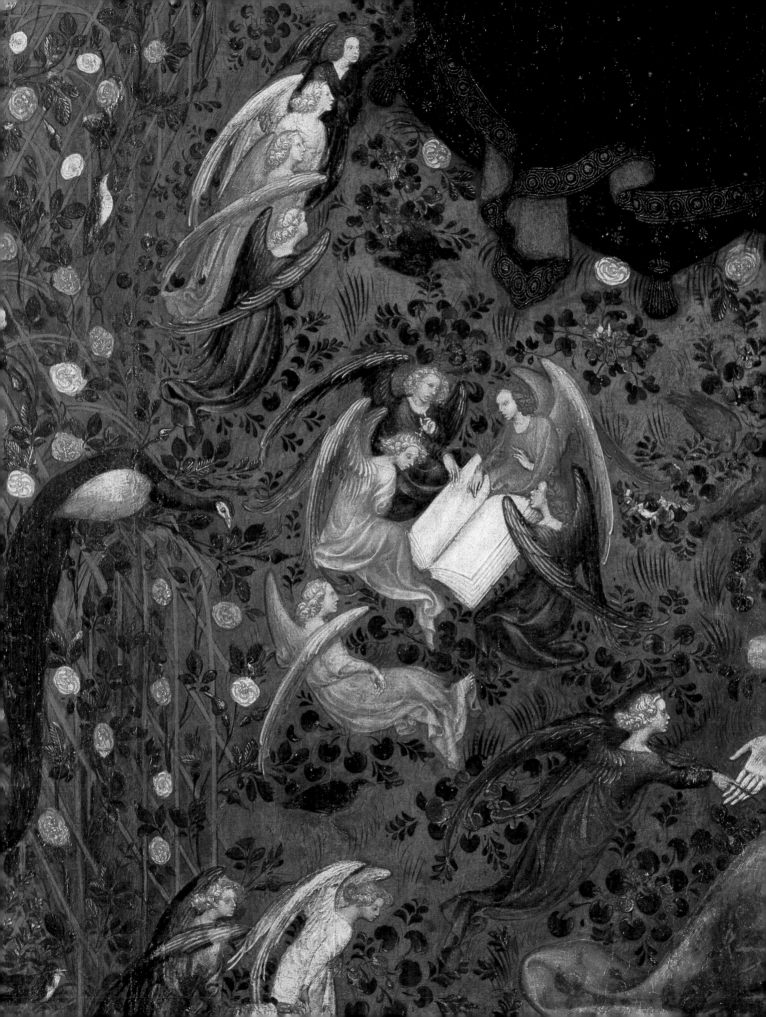

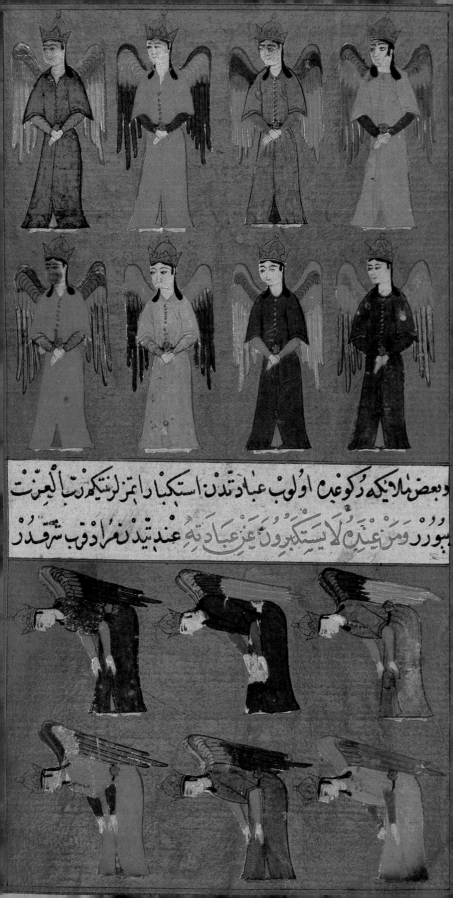

وبعض ملائكه دركوغيد اولوب عبادتدن استكبار ايتمزلرنتكه ربا العزت
بيورر ومن عنده لايستكبرون عن عبادته عندتيذنمرادقب شرقدز

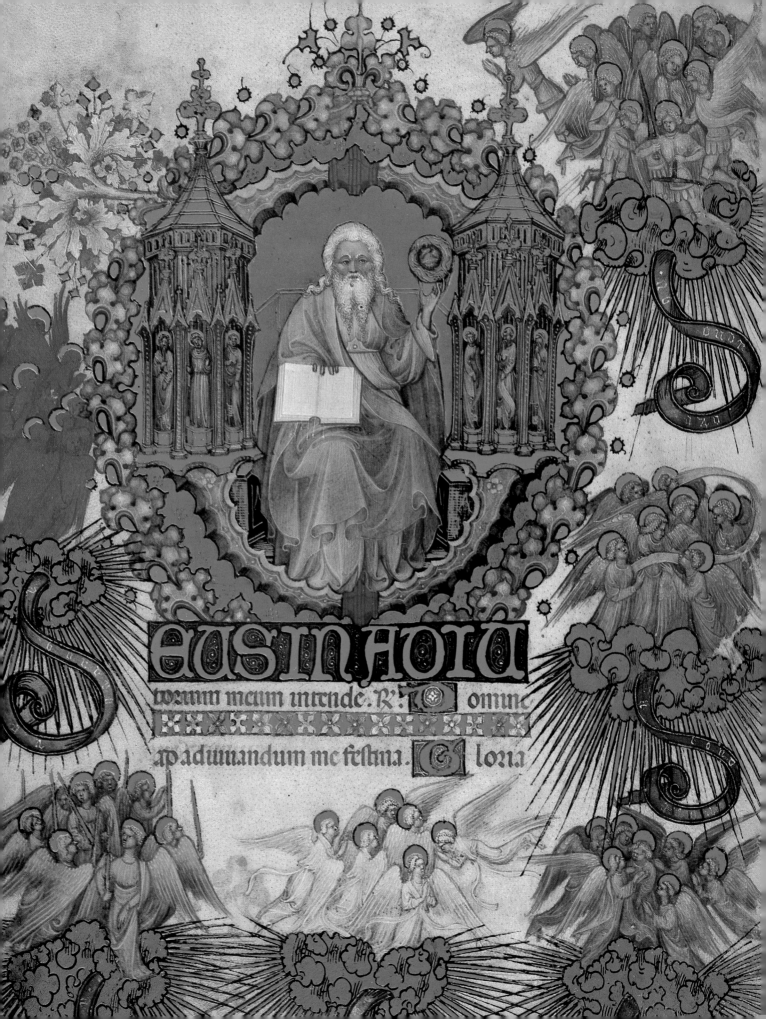

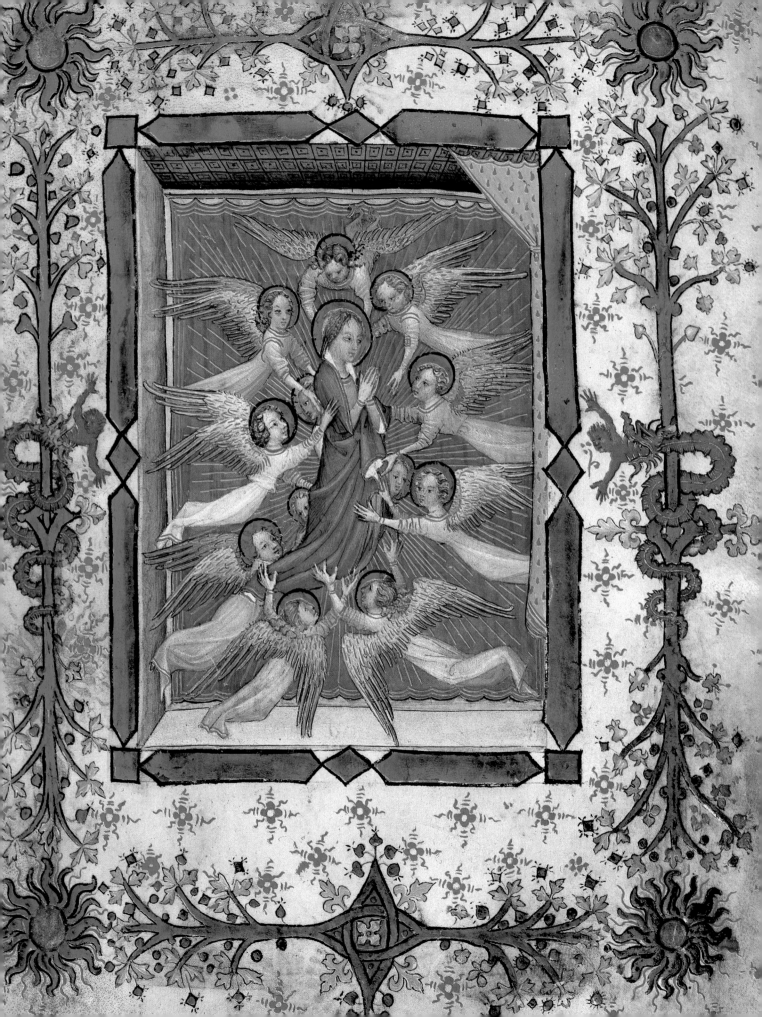

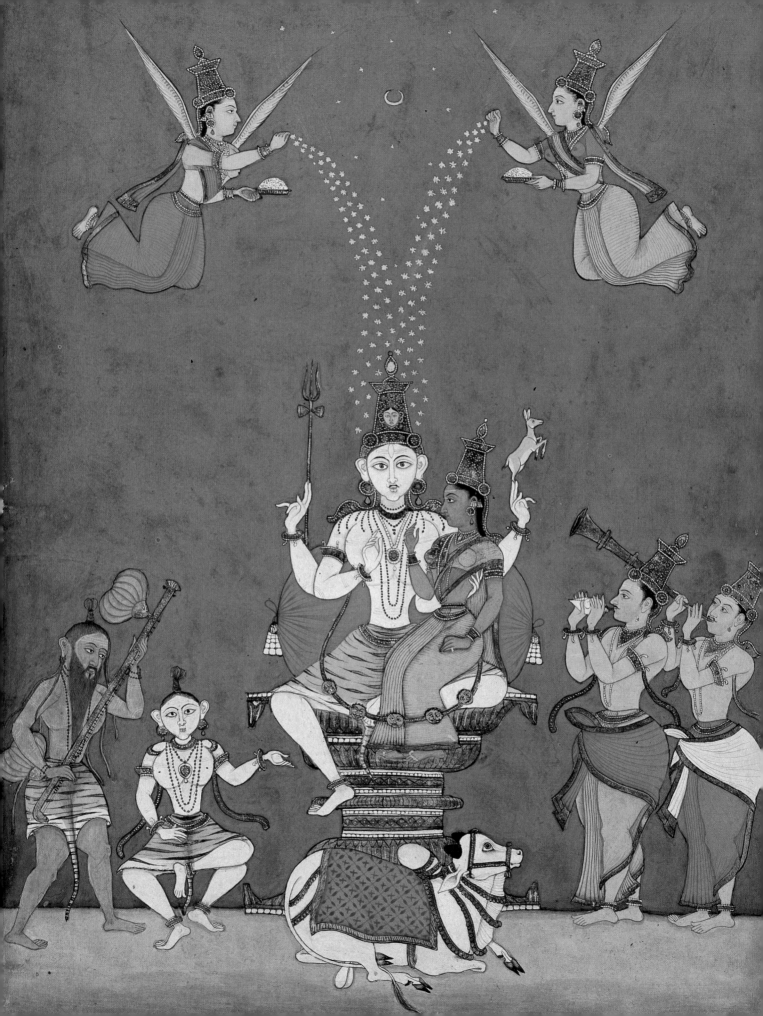

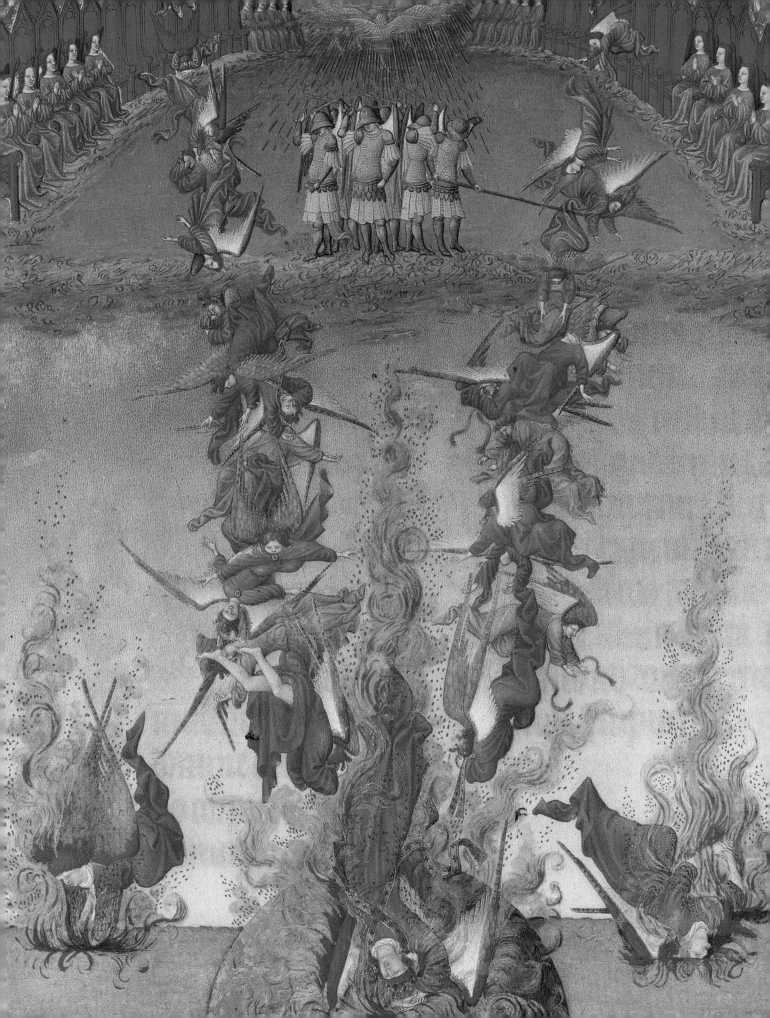

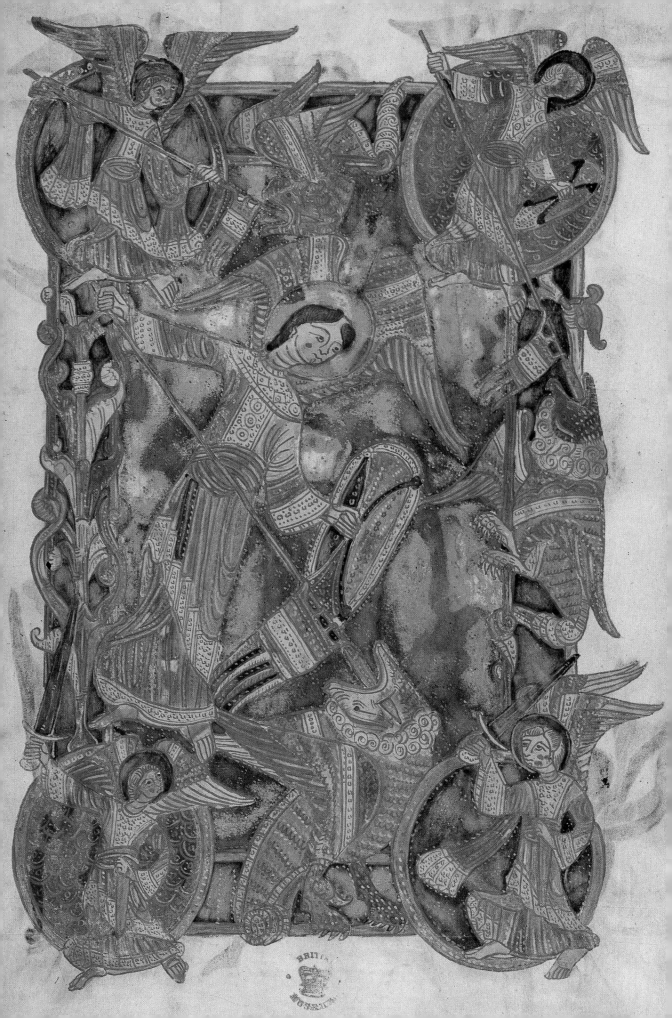

Whether the authors who treat it tend towards Celtic myth or Christian ritual, they invariably show the Grail served by spirits. The Grail maidens, in fact, are sometimes specifically referred to as Angels.

Robert de Boron, in the introduction to his Grail romance, claims that the romance itself in the form of a book was given to him by the Angel of the Lord. The book then vanished and he searched to find it again by journeying through the Angelic World, and by following the Questing Beast through a visionary landscape. Thus the Angelic origin of the legend is 'proved'.

In the end, however (at least in the consciously esoteric version of Wolfram von Eschenbach), the Grail of Britain is itself only a pro-longation of another more distant Grail. All this questing has only achieved yet another call. The Grail-as-Angel announces yet again, 'Follow me.' The Grail knights depart for the Orient. After many years the Grail-knight and the Grail itself will vanish even farther *upwards*, to the heaven of pure and divine intellect, never to be seen again on this imperfect earth.

Trickster invades Heaven

Blake accused Angels of having no sense of humour; and G. K. Chesterton said that laughter can get you to the Gate of Heaven – but not through it. Clearly neither of them had met Monkey.

Monkey is the hero of a romance by Wu Ch'eng En, a Chinese poet (d. 1580); but like certain other characters of fiction he has attained the status of a legend. Perhaps, in fact, he was already a legend when Wu decided to write his life, since he perfectly exemplifies the trickster figure – a Chinese version of Raven or Hermes.

Originally Monkey is a rock. After millions of years the rock breaks open and he emerges. By his exceeding cleverness he soon becomes king of the simians and spends several centuries enjoying a life of revelry and ease. One day, however, he hears about the Immortals, the sages who have attained everlasting life, and he resolves to achieve this status for himself. After much travel he finds a rather dubious Taoist hermit and apprentices himself – and in a very short time he has acquired amazing supernatural powers. He descends to the realm of the Dragon King in search of magic weapons, and so intimidates the scaly aristocrat that he manages to obtain a club which can grow at its owner's will huge as a tree or tiny as a needle.

The Dragon lays an official complaint against Monkey before the official gods of Taoism. After a bit of spying, they decide that the best way to deal with this bumptious character is to offer him a position in paradise.

Monkey is ecstatic: at last his true merit is being recognized. But when he discovers that the position is merely that of groom in the sacred stable, he grinds his teeth in rage and returns to his Mountain of Flowers and Fruit and his faithful followers. Here, at the instigation of two flattering demons, he proclaims himself 'Great Sage, Equal of Heaven'.

Next morning the Jade Emperor sends a Police-spirit to arrest the groom for dereliction of duty, but Monkey beats the stuffing out of him and sends him packing back to Heaven, where he reports on the stable-boy's newly assumed title. Greater spirits are sent to subdue him, but he defeats them all with the Dragon's club. At last the spirit of Venus proposes that Monkey be invited back to Heaven: 'He could be called by that title', says the planet, 'without having any special duties or salary . . . and the Universe would have a chance to settle down quietly.'

So Monkey acquires an office near the Peach Garden and a ration of two jars of imperial wine and ten sprays of gold-leaf flowers, 'and is begged not to allow himself to get in any way excited or start again on his pranks.'

Since Monkey has nothing to do, he loafs around Heaven, hobnobbing with Planets, Lunar Mansions, spirits of the Hours and Days. This disturbs the Emperor, who decides to keep him busy by putting him in charge of the Peach Garden. Monkey rushes off in wild delight to take up his new duties, tending the fruit of longevity – but soon he is unable to resist the delicious looking things, and gorges himself on them.

The Queen of Heaven wants to hold a Peach Banquet, and is outraged to find all the best fruit already consumed; Monkey, for his part, is insulted not to have been invited to the banquet. He disguises himself as a Red-legged Immortal and crashes the palace; but finding that none of the guests has yet arrived, he starts drinking all the wine. He sneaks out and stumbles off, much the worse for alcohol, and finds himself in the palace of Lao Tsu. There he steals a pan of Alchemical Elixir and eats up the contents 'for all the world as though it had been a dish of fried beans.' At last he sobers up, and realizing what a mess he's

gotten himself into, sneaks out of Heaven and flies back to his mountain to prepare for the inevitable war.

The Jade Emperor is livid with rage when Monkey's exploits are uncovered. 'Tell the Celestial Detective to get on his tracks at once!'

An enormous army of Spirits descends and lays siege to the mountain. Monkey is not worried:

> 'If today you have wine, get drunk today;
> pay no heed to what is at the door, be it good or ill.
> Poetry and wine are enough to make the day glad;
> high deeds must take their turn, glory can afford to wait.'

A scene from Monkey *or* Journey to the West

The war begins, and Monkey overcomes one after another of Heaven's champions. Meanwhile, up above, the Bodhisattva Kuan-Yin arrives from the Buddhist heaven to attend the Peach Banquet, but is 'astounded to find the halls in utter desolation and confusion. The couches were broken or pushed aside . . . and the Immortals were standing around in noisy groups, protesting and disputing.'

'It has always been such fun, year after year', complains the Jade Emperor to Kuan-Yin. 'It is terribly disappointing that this year everything has been upset by that terrible ape.'

Back on earth, Monkey goes on defeating hero after hero, until at last Lao Tsu himself takes a hand and manages to trap him with a Diamond Snare. An attempt is made to execute him, but he turns out to be 'inviolable' – nothing can pierce his hide. ('It's not surprising,' says Lao Tsu. 'After all, he ate the peaches of immortality, drank the wine of Heaven, and stole the Elixir of long life – five bowls full, some raw, some cooked.')

In their perplexity the Taoist deities send to the Buddhist heaven for advice. Buddha says to the Bodhisattvas who surround him, 'You stay quietly here in the Hall of Law, and don't relax your yoga postures. I've got to go deal with this creature who is making trouble at the Taoist Court.'

Buddha laughs when he hears Monkey's boast of being the 'equal of Heaven'. Monkey retorts: 'There is a proverb that says, "This year, the Jade Emperor's turn; next year, mine." Tell him to clear out and make room for me.'

'I'll have a wager with you,' says Buddha. 'If you are really so clever, jump off the palm of my right hand. If you succeed, I'll grant your wishes; if you fail, you shall go back to earth and do penance there for many a *kalpa*.'

'This Buddha', Monkey thinks to himself, 'is a perfect fool. I can jump a hundred and eight thousand leagues, while his palm cannot be as much as eight inches across.'

Buddha stretches out his hand, Monkey puts his cudgel behind his ear, and leaps with all his might. At last he comes to five pink pillars, sticking up into the air. 'This is the end of the world,' says Monkey to himself. 'I'd better just leave a record of some kind, in case I have trouble with Buddha.' So he writes his name on one of the pillars and relieves himself at the base of another. He somersaults back to where he started and announces his success.

'You stinking ape', says the Buddha, 'you've been on the palm of my hand all the time.' – and shows Monkey his fingers, from which arise an odour of monkey-urine. So Buddha seizes him and imprisons him under a huge mountain; and Monkey's invasion of Heaven comes to an inglorious end.

This is by no means the end of his career, however. After centuries of enforced penance he will be rescued by the mild-mannered sage, Tipitaka, who needs the help of someone so powerful to accompany him on a perilous journey to India in search of Buddhist scriptures. Monkey will have lost none of his boisterous courage and sense of fun, but this time he will put his talents at the service of true wisdom. After many adventures and battles with demons, he will be rewarded with a genuine promotion: he will become 'The Buddha Victorious in Strife'.

The Angelic World is undoubtedly a serious place. But there must always be room for 'dear Monkey' and therefore there must be laughter in Heaven.

Dionysius and the Paradiso

> Dionysius set himself so ardently
> to fix upon these orders his regard,
> he named them and distinguished them as I.
>
> (Dante, *Paradiso* VIII)

Dante constructed a towering spire upon the Church and culture of medieval Europe; even to discuss the angelology of the *Divine Comedy* would require a volume by itself. One cornice of the great cathedral is Dante's treatment of the Angelic Orders described by Dionysius the Areopagite.

The *Celestial Hierarchies* compares God to a ray of primal light which can never be deprived of its intrinsic unity; and yet it 'becomes a manyness' and proceeds into manifestation. This manifestation is in one sense the light itself, but in another sense a veil covering the divine unity.

The primal ray of light, as it descends towards the extremity of creation (a hypothetical 'brute matter'), must be graded or arranged in an order, a hierarchy, 'so that we might be led, each according to his capacity, from the most holy imagery to formless, unific, elevative

principles and assimilations.' It is for this reason that everything 'delivered in a supermundane manner to Celestial Natures [i.e., Angels] is given to us in symbols.' God has revealed to us the Celestial Hierarchies that we might attain 'our due measure of deification.'

In this theology the concept of *theophany* becomes all-important. A theophany is a 'beholding of God which shows the divine likeness, figured in itself as a likeness in form of that which is formless.' Through such a symbol 'a divine light is shed upon the seers . . . and they are initiated into some participation of divine things.'

The Angels are most potent theophanies; and the initiation referred to above is passed down, as it were in a chain, from the higher to the lower ranks, till mankind receives it from the Angels. Thus one might say that for man every theophany (appearance of God) is in fact an appearance of an Angel.

In Cantos XXVIII through XXX of the *Paradiso*, Dante expounds on Dionysius by actually creating images for the doctrines of the *Celestial Hierarchies*. Having reached the Primum Mobile, the outermost limit of the cosmos, Dante pauses and gazes into the eyes of his beloved guide, Beatrice. He sees reflected in them a point of light

> of so intense a beam
> that needs must every eye it blazes on
> be closed before its poignancy extreme.

This point is in fact the divine light itself, surrounded by nine circles of light which are the Angelic Orders. Thus Dante experiences Heaven *in* Beatrice, 'who hath imparadised my mind'. She is in effect Dante's personal theophany, his Guardian Angel; and this symbol of reflected light is one of the images which make up the basic imaginal structure of the poem.

Dante now turns and gazes upon the rings of light themselves, empowered to do so by the theurgic effect of his love for Beatrice. He beholds the system as a series of lustrous haloes or rainbows surrounding a central point.

Beatrice explains it to him; then as she falls silent, he sees innumerable Angels:

> thick as the sparks from molten iron sped
> so did the sparks about the circles chase. . . .
> From choir to choir I heard Hosanna rolled
> to that fixt point which holds them in their home,
> hath held them ever, and shall forever hold.

Beatrice tells him that the highest choirs derive their bliss from *seeing* God:

> . . . the celestial bliss
>> is founded on the act that seeth God,
>> not that which loves, which cometh after this.

In other words, gnosis or knowledge is higher than Love.

Beatrice points out each of the Orders in descending rank, and comments:

> Upward these Orders gaze; and so prevails
>> downward their power, that up toward God on high
>> all are impelled, and each in turn impels;

thus interpreting Dionysius's teachings on the initiation of the Angels.

She now goes on to comment in a special way on the Areopagite's teachings on the Creation:

> Not increase of His own good to proclaim
> (which is not possible) but that His own
> splendour might in resplendence say *I Am*;
> In His eternity, where time is none,
> nor aught of limitation else, He chose
> that in new loves the eternal Love be shown.

In Mohammed's words: 'God was a hidden treasure, and He desired or "loved" to be known; so He created the world that He might be known.'

The Angels have from the beginning kept their vision fixed on God's face. Each Angel is a separate species, since each possesses its own mode of absorbing and reflecting the primal light which irradiates it:

> And since on the mind's vision love ensues,
> that sweetness glows within them fiery-bright
> or warm, according to the mode they use.
> See now the Eternal Virtue's breadth and height,
> since it hath made itself so vast a store
> of mirrors upon which to break its light,
> Remaining in itself one, as before.

Now, as day breaks in the wake of the Angelic vision, Dante beholds Beatrice and finds her more beautiful than he had ever known her:

> The beauty I saw not only exceeds our wit
> to measure, past all reach, but I aver
> He only who made it fully enjoyeth it . . .
> As the sun doth to the eyes that tremble most
> so doth to me the thought of the sweet smile
> whereby, shorn of itself, my mind is lost.

Thus Beatrice herself mirrors forth the Beatific Vision, which extinguishes all reason as in a blazing fire. Beatrice is an Angel; Beatrice reveals the Angelic World; and Beatrice is the theophanic symbol in which love and knowledge are united.

Gustave Doré, illustration of Dante and Beatrice among the circles of Angels

IV Ritual and mysticism

Angelic rites

Mohammed learned the words and gestures of the Islamic ritual prayer by observing the Angels at worship. Ritual is what the Angels do in heaven. It is brought back by prophets who visit paradise, or it is revealed by Avatars or Angels who descend to earth. Ritual, by definition, must be Angelic because it belongs properly neither to 'this world' nor to the divine Essence beyond form, but plays an intermediary role between the two. Ritual is a Jacob's Ladder, and its celebrants climb, meeting the descending Angels halfway.

He who participates in ritual becomes an actor in a drama, the catharsis of which is guaranteed by tradition. On condition that the participant act in the correct spirit, he will get more out of the play than he puts into it.

Thus ritual has its beginnings in symbolic vision and its end in pure contemplation; for the purpose of the rite is to transcend itself, penetrate its own symbols and induce a state of intuition which illuminates the verities. It urges us to apprehend reality and offers us the means to do so by participating in a shadow play.

In dogmatic terms a priest is always a priest, even if he is a bad man; and the Mass is always valid, even if no one present experiences the 'real Presence' as actual transformation of consciousness. But the *purpose* of the Mass is precisely that realization. According to the late Cardinal Daniélou, 'The Mass is a sacramental participation in the liturgy of heaven, the cult officially rendered to the Trinity by the full host of the spiritual creation. The presence of the Angels at Mass introduces the Eucharist into heaven itself.'

'Behold the royal table. The Angels serve at it. The Lord Himself is present' (St John Chrysostom). 'The Angels surround and help the

(Opposite) The alchemist's oven is the altar of the heart, the secret place where meditation slowly cooks the soul. Neptune, the unconscious watery element, protects the children, boy and girl, sulphur and mercury, which make up the dual soul. In the heat of Nature, guided by Angelic inspiration, the transmutation is effected. Woodcut from Muter Liber, 1677

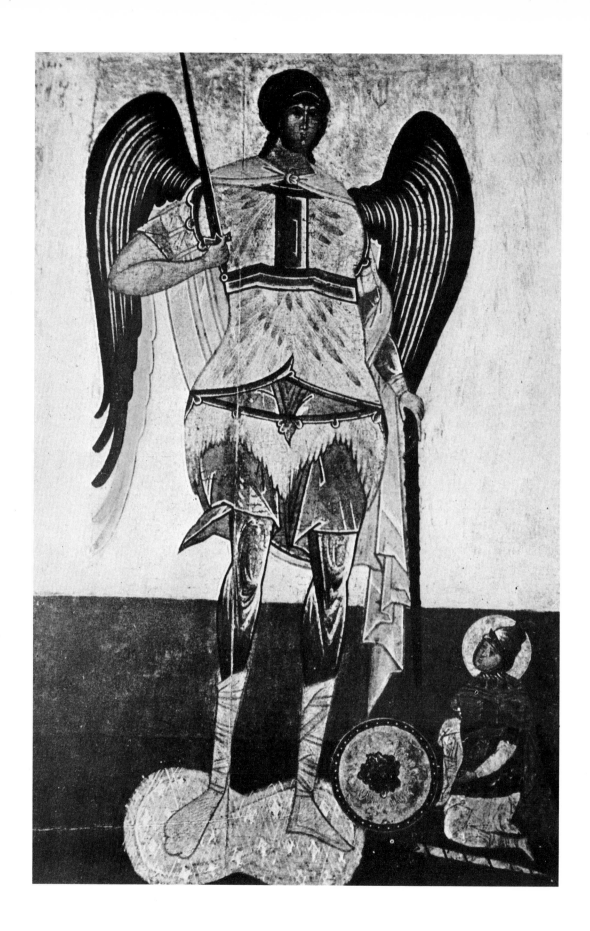

priest when he is celebrating the Mass' (St Augustine). St Bridget witnessed this herself: 'They sang heavenly canticles that ravished my heart. Heaven itself seemed to be contemplating the great sacrifice.' And Blessed Henry Suso was often attended while serving Mass by Angels in visible form, who came near to him in raptures of love.

Angels, in fact, preside over all the rituals of the Church – according to some writers, at any rate. Tertullian speaks of the Angel of Baptism: 'Cleansed in the water by the action of the Angel, we are prepared for the Holy Spirit.' Didymus of Alexandria explains that 'on the level of the visible, the baptismal pool gives birth to our visible body by the ministry of the priests; on the level of the invisible it is the invisible Spirit of God who plunges both our body and our soul into Himself and regenerates us with the aid of the Angels.'

Not only are the Angels thus the invisible priests of the religion, they are also due a kind of worship in themselves. Despite the hesitation expressed by some theologians, certain days are set aside as Angelic Feasts, notably the great Synaxis of Michael and All Angels in Orthodoxy (8 November), or the Feast of Uriel on 28 July, by which the Monophysite churches of Egypt and Abyssinia commemorate the revelation to Enoch of the revolutions of the celestial luminaries – though in Rome the image of Uriel in the Church in Piazza Esedra was painted over.

Zoroastrianism possesses a ritual by which lines of communication are opened to the Amesha-spentas by the offering of certain flowers. The ritual of the Mevlevi sufi Order culminates in a dance, performed to the music of a small orchestra of flutes, drums and stringed instruments, in which the dervishes seem to act out the parts of the Angels of the spheres, whirling around and around and turning in a great circle. As they dance they repeat over and over again the Name of God, for this is the most central and potent of all rituals, one that attracts the Angels themselves, who hover overhead like birds, and fly back to heaven to collect blessings for the dancers.

Calling down the Angel

Thus Angels provide the model for worship; they participate in human worship; and they are worshipped. But there is another sort of Angelic rite: one in which they are specifically evoked and called down, either to give and receive messages or to enter into the body of the ritualist.

In its simplest manifestation this results in the phenomenon of possession, a religious form found in cultures as far apart as Japan, Indonesia, Africa and South America. In some religions possession is the chief rite; the African scholar Wande Abimbola has said that the Yoruba cannot imagine a religion without possession. Whether the beings who indwell their human 'mounts' are called gods or spirits, we may certainly see them as Angels, since they come down from and return to heaven, and form the link between man's world and the realm of the high gods (or God), who never descend to earth.

One mysterious feature of possession is the fact that the human soul is completely displaced by the spirit; after the trance, the person possessed can never remember what has happened or what the god has said. Voodoo priests and priestesses are never possessed; they are expert in the occult means of inducing possession, but seem to remain aloof from the actual experience (although they may become possessed before their elevation to the priesthood). The same can be said of oracles in ancient Greece, in Tibet and in Japanese Shinto: they all serve the spirits as 'horses' to be ridden, and appear to derive no direct spiritual benefit from doing so.

However, this is not really the case. In the first place, possession is often part of a tribal or communal religion. The experience of direct confrontation and discourse with a spirit benefits the tribe, and thus all the individuals of the tribe. In the second place, the 'mounts' obtain great benefits from their patron spirits. These benefits may be 'worldly' – good health, good crops, etc. – but they also include a numinous sense of well-being which springs from the awareness of having been chosen by the Other World as a medium for its messages to mankind. In the third place, possession leads to an increased knowledge of spiritual realities. I have been told that among the Candomblé of Brazil there exist circles of high adepts who eschew all worldly benefit or magical power, and induce possession solely in order to advance spiritually through the acquisition of knowledge.

In the enigmatic *Elegies of Ch'u* we find the theme of possession developed in new ways, orchestrated with other themes we have learned to recognize as 'Angelic': spiritual flight, erotic spirituality and 'sacred nostalgia', among others. These nine songs are attributed to one of the earliest classical Chinese poets, Ch'u Yuan, who is supposed to have witnessed shamanic rituals in the southern kingdom of Ch'u and reworked the liturgy in poetic form. This is possible, but

it is also possible that the *Elegies* are in fact parts of a sophisticated shamanic cycle performed for the Ch'u court. These songs or dialogues lack the robust virility of primordial shamanism; rather they possess a fragrance of melancholy and ecstatic longing. One feels that shaggy animal skin coats hung with Siberian amulets of iron have been replaced by flowery embroidered robes, that the acrid smoke which rises like a hallucinatory bridge to the spirit world through the jagged roof-hole of a hut, has been replaced with sweet incense curling from an engraved pyx.

The archaic language of the *Elegies* (and the scarcity of pronouns in poetic Chinese) make it virtually impossible to identify in every case the personae dramatis of the poems. It seems that a shaman, male or female, prepares for a meeting with a spirit:

> I have bathed in lotus water
> rinsed my hair with perfumes
> put on brocaded garments
> sewn with leaves and flowers.

> (Poem II; all translations by J. Peter Hobson)

The place is variously a temple, a lonely lakeshore or mountain side, or a magic boat, or a bower under the waters of a lake:

> I build a bridal chamber
> under the waves
> thatched with a roof
> of lotus leaves
> walls hung with iris
> courtyard of purple shells . . .

The spirit appears, at first distant and unclear:

> long-limbed and sinuous
> now he is still
> his refulgence a glory without bound
> he stirs, he comes down
> to take his rest
> in the Abode of Life [the temple]. (II)

Or the spirit may refuse to manifest itself:

> The Princess does not come
> she waits, biding her time
> waiting for someone out there
> on that island. (III)

> I wait, my lovely lord
> but you do not come
> I howl into the wind
> my lovesick song. (VI)

The spirit must be enticed with offerings and with music. These are the words of the spirit himself, the 'Lord of the East':

> I sigh long and deep
> and prepare to ascend
> heart confused and sad
> look longingly back
> ah! voices and colours
> that bewitch a man
> the watchers, beguiled
> forget to turn homeward
> harps keenly tuned
> drums blending
> bells ringing
> bell-stand rocking
> flutes sounding
> pan-pipes shrilling
> I think of the shaman-maidens
> skilled and comely
> dipping and leaping
> like halcyons. (VII)

At last the spirit descends and takes possession of the shaman, who dances. But the tryst is short, the spirit is capricious. The 'wielding of yin and yang' (a reference to sexual union: 'The vulgar cannot understand what we do') is over too soon:

> Without a word the coming-in
> the going-out wordless
> riding off on a whirlwind
> with cloud-banners flying . . . (VI)

This relationship of shaman and spirit mirrors that of bard and muse, and of 'sons of God and the daughters of men' in *Enoch*, and of mortal maidens taken in love by Zeus or Apollo, and of St Teresa pierced by the flaming arrow of the Angel. To be penetrated by the Angel is to know the little death of ecstasy.

Arthur Waley compares the ambience of the *Elegies* with that of the Noh plays of Japan, and indeed within these fragments of song a drama can be felt, about to be born. Greek tragedy and comedy

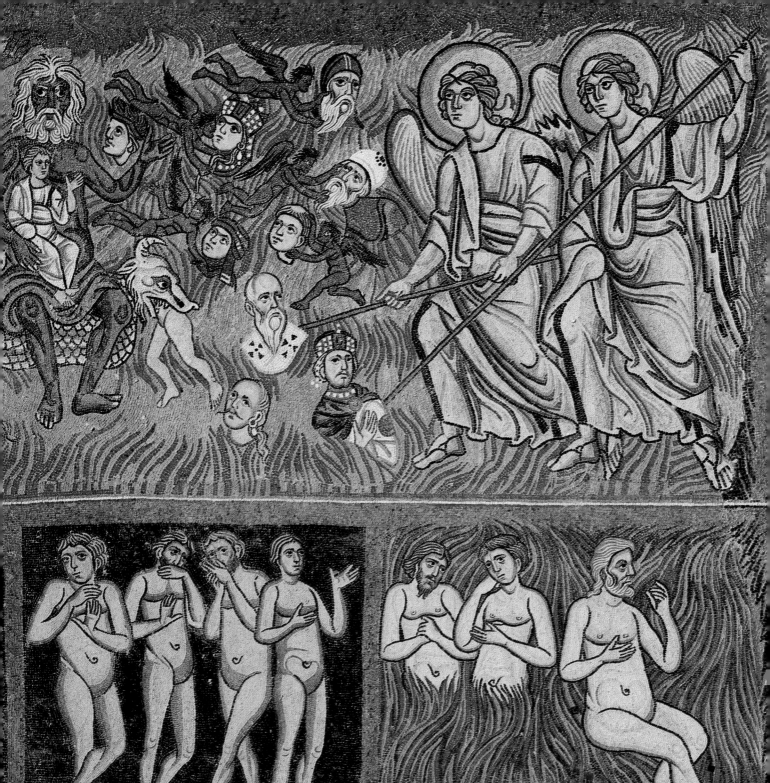

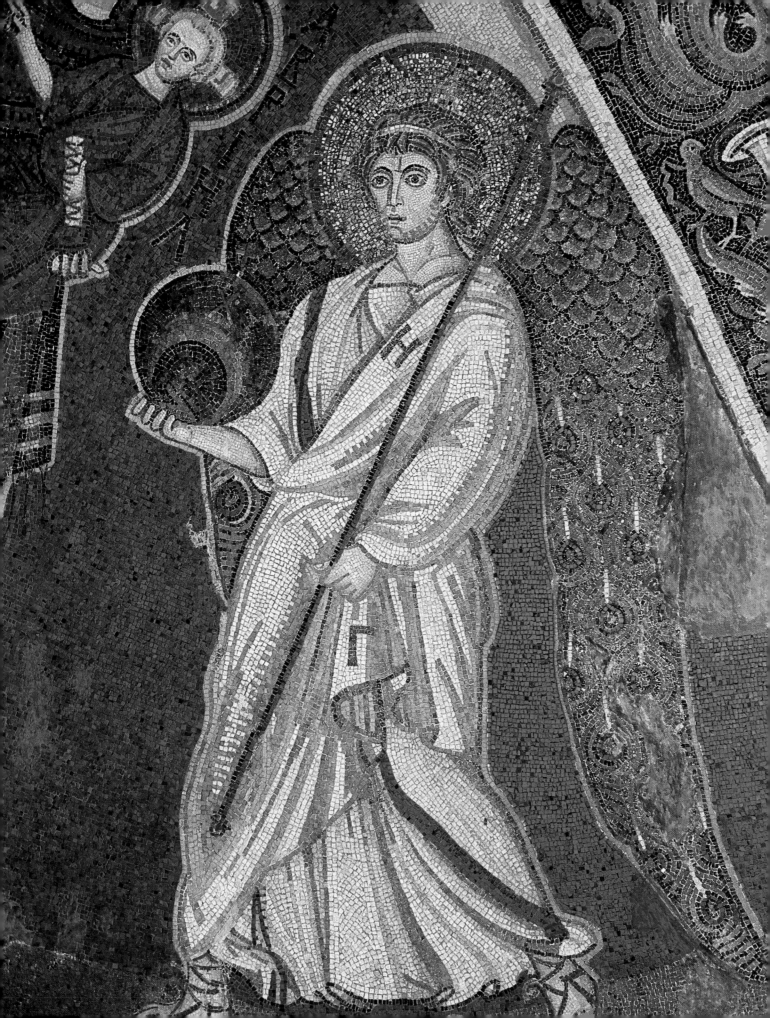

Illustration to Ts'ao Chih's poem, Nymph of the Lo River, *12th–13th century, Southern Sung*

COLOUR PLATE

An Angelic mandala, a round dance, a circle of paradise, an evocation of Spring, a ceiling to lie and gaze up at, intoxicated by the sky-whirling choreography of the Apsaras. Detail from the ceiling painting of an Indian palace

emerged (or descended) from similar Dionysian rituals of intoxication, possession and erotic power. If we wish to plunge backwards in time and try to visualize the shamanic rites of Ch'u, we might well begin at a performance of Zeami's *Hagoromo*, the Noh play of the Feathered Mantle, which (in Carmen Blacker's phrase) 'disguises' a much more ancient shamanic liturgy, overlaying and reconciling it with various forms of esoteric Buddhism, refining it through the aesthetic of Zen. (The following synopsis makes use of versions by Waley, Ezra Pound, and J. Peter Hobson.)

The play opens on the seashore, where a fisherman, Hakuryo, finds a strange feather mantle hanging on a pine tree bough. He decides to take the mantle with him, when suddenly an Angel (*tennin*) appears, who at first demands, then begs for the mantle.

ANGEL: O Pity: there is no climbing the air's wing-ways without this cloak, no return through the aether. I pray you give me back the mantle.

At first the fisherman refuses. But he sees that the Angel is dying:

CHORUS: Her coronet, jewelled as with the dew of tears, even the flowers that decorate her hair, drooping and fading. Sorrow, to see the five signs of Angelic disease before our eyes!

ANGEL: I look into the flat of heaven, the cloud-way is hid in mist, I have lost the road. O enviable clouds, wonder that fades along the sky, our accustomed dwelling. Now fades, fades the song of heaven's sacred bird . . .

The fisherman begins to relent, but demands that, in return for the cloak, the Angel perform for him and teach him one of the dances of heaven. She agrees, and having donned again her cloak, sings:

Now I have wings again and shall remount the sky. In thanksgiving I leave a dance of remembrance to the world: learn this dance that can turn the towers of the moon . . . an heirloom for the world's sorrows.

First she dances the 'Rainbow Skirt', then the dance of Suruga which recapitulates the Shinto Creation myth, and reflects the phases of the moon:

CHORUS: In white dress and black dress, thirty Angels divided in two ranks, thrice five for the waning, thrice five for the waxing; one heavenly lady on each night of the moon serves and fulfills her ritual task.

ANGEL: I am also heaven born, a moon-maiden . . .

The chorus, describing her dance, gives the key to the meaning of the play, of the intermediary role played by the Angel in linking heaven and earth:

The masks and costumes of Noh drama have a life of their own, and are often centuries old; to use them is to court a kind of artistic possession, to become a vehicle for the archetypes one portrays

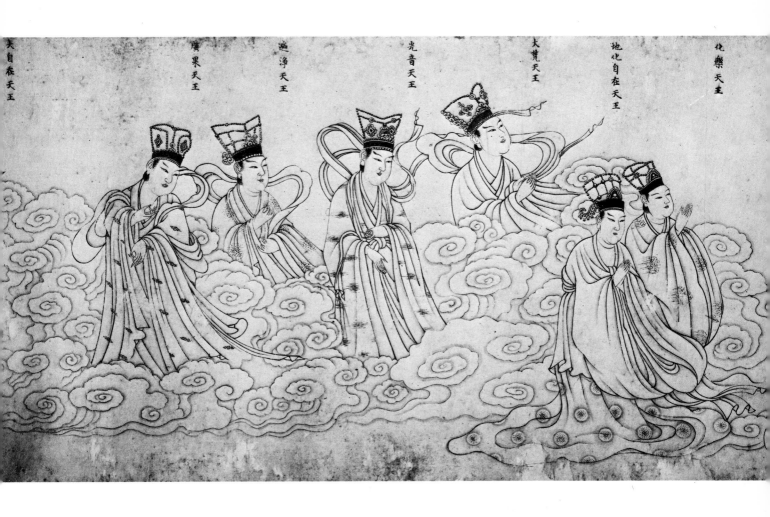

化樂天王

地化自在天王

大覺天王

光音天王

遍淨天王

廣果天王

天自在天王

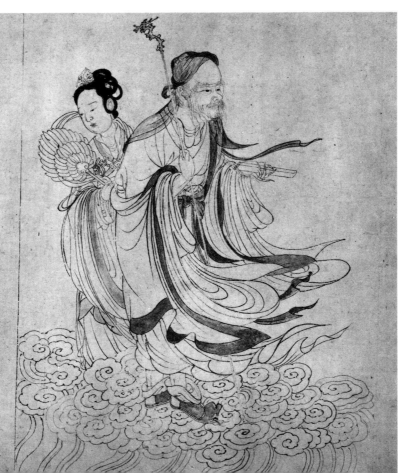

Detail from The Metamorphosis of Heavenly Beings *by Li Kung-Lin; British Museum*

Page from The Nine Songs *by Chang Wu, active 1335–65; Cleveland Museum of Art*

175

Not heaven is here, but beauty of wind and sky. Blow, wind, build cloud-walls across the sky, lest the vision of this divine maiden leave us! *What cause has Heaven to be estranged from Earth? Inside and outside the Jade Temple – are not both a prolongation of divinity?*

The Angel continues to dance, but little by little she grows indistinct, 'robed in sky, in empty blue, in mist, Spring mist'. As the chorus reveals her true identity (she is the Full Moon, the Splendour of Truth), she flies up into the sky, disappearing in the distance, melting into the mist, lost to sight.

The parallels with the scenario of the *Elegies* are striking: the same almost erotic nostalgia, the same setting in wild nature, the same beautiful robe shared by medium and spirit, the brief meeting, the dance, the vanishing of the spirit like a bird. But here the fruit of the meeting is more permanent. True, the chorus and the fisherman feel sorrow at the disappearance of the *tennin*, but something remains: ritual, sacred art, the child of Angel and priest, bard and muse, shaman and god. Through the Angel is given to earth a link which sanctifies man and nature.

In Taoism – a religion which grew out of the kind of shamanism discussed above – the purpose of trafficking with 'Angels' is threefold. According to Master Chuang of Taiwan (who died in 1976), the great ritual of the Tao of the Right obtains salvation and release from hell for the souls of the departed; blessing and renewal for the village or court in which it is performed; and, for the adept, union with the Tao and 'immortality'.

In order to obtain permission to perform this ritual, the adept must have received on his initiation a 'Register of Spirits', and a great part of his training consists in learning how to evoke these spirits.

The ritual begins with the entry of the adept and his assistants into a specially prepared space. Music is played and the assistants recite long passages describing what the adept is achieving or experiencing through his meditations.

The adept begins by 'voiding' his body of certain spirits, whom he places in various positions around the holy space, thus creating a mandala visible to him alone. He then begins to summon various 'secret liaison officials', messenger spirits who are needed to intermediate between the adept and the higher cosmic powers. One must know the features, mudras, mantras and names of these spirits. On their appearance, the adept burns certain documents (actually prayers

and summonses to the higher gods); the liaison spirits take these documents in the form of vapour and repair to the heavenly court.

The higher powers now appear at the adept's command. Chief among them are the Emperors of the five elements:

East – Green Emperor – wood – liver – Spring
South – Red Emperor – fire – heart – Summer
Centre – Yellow Emperor – earth – spleen
West – White Emperor – metal – lungs – Autumn
North – Black Emperor – water – kidneys – Winter

The adept then proceeds to a complex series of alchemical meditations in which these five elementals are reduced to three great spirits. These are: the Primordial Heavenly Worthy who resides in the head as breath and rules the highest heaven (blue-green mist); Ling-pao Heavenly Worthy, the liaison between heaven and earth, man's spirit which resides in the centre of the body (yellow light); and Tao-te Heavenly Worthy, the celestial form of Lao Tsu, the vital essence in the lower abdomen (white light).

According to the *Tao Te Ching*, 'The Tao gave birth to the One; the One gave birth to the Two; the Two gave birth to the Three; the Three gave birth to the myriad creatures.' The Heavenly Worthies present within the adept are the One, the Two and the Three. He now proceeds to 'void' himself of even these great powers, by offerings of wine and incense. Following the instructions of Chuang Tsu for the 'fast of the heart', he empties himself of all imagery and attains the state of Hun-Tun, Primordial Chaos. Thus he achieves union with the Tao – and if he cannot do this, *the ritual is rendered ineffective.*

Very similar 'Angelic' rites are practised in Tibetan and Japanese (Shingon) Buddhism, but the Taoist version (which may well be influenced by Buddhism) is interesting precisely because it is not a private form of Yoga, but rather a public rite in which the skill of the 'shaman-priest' in attaining high mystical states is demonstrated for the benefit of the souls of the dead and the living, and even for guaranteeing social order, good crops, etc.

In the *Corpus Hermeticum* the Angels (or planetary spirits) are called down not into living bodies but into statues; thus a truly and literally sacred art serves as the link between worshipper and deity. When the *Corpus* was rediscovered in the Renaissance, sages such as Pico della Mirandola and Giordano Bruno attempted to revive this sort of magic, in which planetary or other spirits were evoked with

corresponding scents, colours, flowers, emblems, poetry, music and meditations. Various objects such as talismans were then imbued with the Angelic *virtu* and used for magical and spiritual purposes. This sort of magic was further evolved by the English magus, Dr John Dee (Elizabeth I's astrologer), who communicated with Angels through his medium Edward Kelly. Dee devised a mysterious obsidian mirror or crystal to potentiate these seances, and learned the language of the Angels – Enochian. (An Angelic language was also written by St Pachomius, the founder of Egyptian desert monasticism, who received his *Rule* from an Angel.)

This kind of Angelic magic continued into the occult revival of the nineteenth century, with such groups as the Golden Dawn. It ran a parallel course among Jewish Kabbalists and in the Islamic world, where the Brethren of Purity celebrated a Hermetic Rite in honour of the planetary and astral spirits. Various sufis, such as Ala ad-Dawlah Semnani, with strong 'imaginal' and occult leanings, also developed meditations based on Angelic symbolism.

Becoming an Angel

> . . . and whatsoever you see of spiritual forms and of things
> visible whose countenance is goodly to behold
> and whatsoever you see of thought, imagination, intelligence, soul
> and the heart with its Secret
> and whatsoever you see of Angelic aspect, or things whereof
> Satan is the spirit . . .
> Lo, I, the *Perfect Man*, am that whole, and that whole is my
> theatre . . .
> The sensible world is mine, and the Angel-world is of my weaving
> and fashioning.

(Abdul Karim Jili, *The Perfect Man*)

If the cosmos is pictured as a tree, it is possible to understand how man is more central than the Angels, according to Jili. The Angels occupy branches to left and right of the trunk. They are higher than man, whose place is at the bottom. But being at the bottom places man on the axis, the trunk which rises to the crown of the Tree, the place of Metatron or the Angel called the Spirit. The Angels are fixed in their places – they are created with the special knowledge of the Divine appropriate to their stations ('None of us there is, but has a

known station', 'We know not save what Thou has taught us' – Koran).

But Adam, who is created in God's 'image' and is given knowledge of all the names, is capable of climbing the tree, of ascending through all the Angelic initiations and himself becoming an Angel.

'By philosophy man realizes the virtual characteristics of his race. He attains the form of humanity and progresses on the hierarchy of beings until in crossing the straight way (or "bridge") and the correct path, he becomes an Angel' (Brethren of Purity, *Risalat al-jami'ah*). 'Passing beyond the teaching of the Angels, the soul goes on to the knowledge and understanding of things, no longer merely betrothed but dwelling with the bridegroom' (Clement of Alexandria).

For Christians, the Ascension of Christ provides the unique symbol of this exaltation of human nature; it is through Him that other mortals participate in such perfection. According to a very interesting legend, the thrones left vacant by the fallen Angels are reserved for the elect among men; St Francis of Assisi is supposed to have been awarded the throne of Lucifer himself. 'The elect will be like the Angels in heaven' (Matt. 22: 30); 'The soul illuminated by the Word becomes a stranger to the slumber of illusion, a "Night Watchman". It is a type of Angelic life to which He thus introduces us' (Gregory of Nazianzen).

In Islam, however, not one man makes the perfect and total ascension, but all those humans who attain the state of perfection. The sufis say that every age must have its perfect man, its 'axis' – for if there lived no perfect lover (or knower) of God, the world would come to an end. The perfect man is he who repeats the Ascension of Christ or Mohammed, who realizes himself as the one who comprehends all the Divine Names, who actualizes man's central position in the cosmos.

This possibility is recognized by all systems of myth and mysticism. Ancient Greece, for instance, believed that certain mortals could be taken up into heaven and made demigods. We have already mentioned Psyche; the myth of Ganymede, the Trojan shepherd boy, also recapitulates the theme. Origen mentions that Melchisadek became an Angel, a belief shared by the gnostic sect of the Melchisadekians, who survived into the Middle Ages. St Vincent Ferrer of the Dominicans is often pictured with wings; and the widow of the sufi poet Rumi had a vision of him after his death 'winged as a Seraph'.

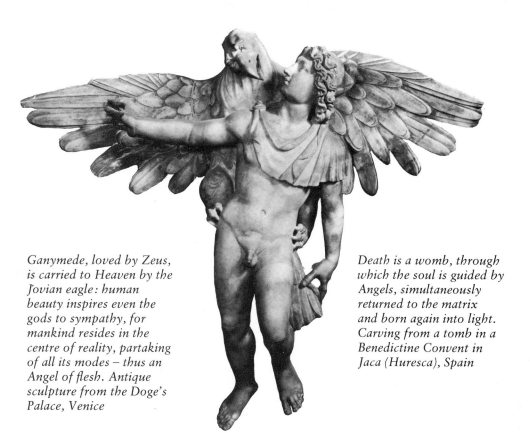

Ganymede, loved by Zeus, is carried to Heaven by the Jovian eagle: human beauty inspires even the gods to sympathy, for mankind resides in the centre of reality, partaking of all its modes – thus an Angel of flesh. Antique sculpture from the Doge's Palace, Venice

Death is a womb, through which the soul is guided by Angels, simultaneously returned to the matrix and born again into light. Carving from a tomb in a Benedictine Convent in Jaca (Huresca), Spain

The Tibetan sage-poet Milarepa is challenged by a wicked Bon-Po shaman-priest to a contest in levitation. The shaman is still spiralling upwards on his magic drum when he sees Milarepa, already on the peak, deep in meditation. The Bon-Po spell is broken, the magician tumbles with his drum into the valley below

Angels at childish sport. The putti, or so-called cherubini, began as companions of Eros and Dionysius. Their nudity is pagan, but as no more than infants they proved convertible to Christianity. Detail of mosaic in the Bardo Museum, Tunis

Chinese immortals became Angels, usually by drinking the elixir of immortality (the sceptics claimed they were victims of metallic poisoning). Their ecstatic flight has its historical origins in primordial Chinese shamanism, its spiritual interpretation in the elegant humour of Chuang Tsu, the sage who dreamed he was a butterfly. From a 19th-century Japanese screen

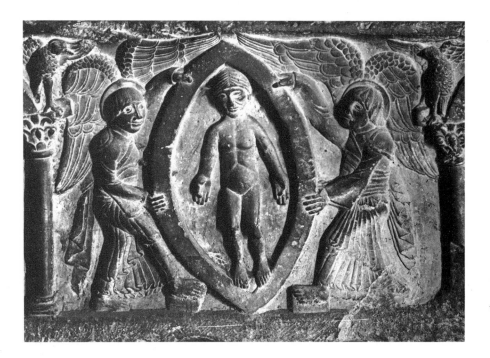

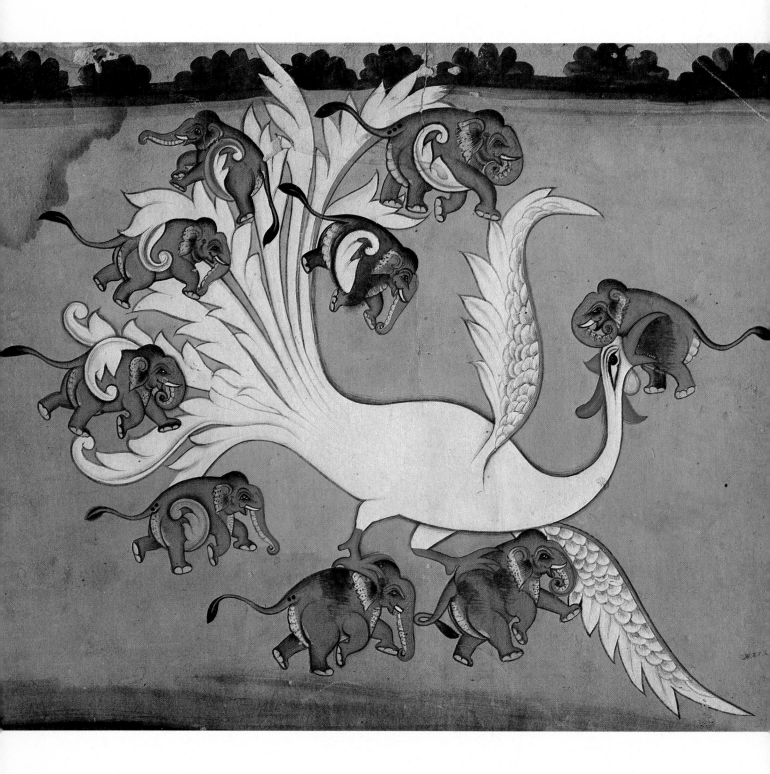

BECOMING AN ANGEL

Through the ritual use of symbolic masks or garments, one transforms oneself into what one worships; this is the mysticism of the tribe

(Left) Initiation mask of the Basuku, Africa.
(Below) Buckskin ghost dance shirt, Arapho tribe, Oklahoma
(Bottom) Ceremonial bird mask, Eskimo

COLOUR PLATE

The Simorgh, king of all mythical birds, has the strength of a herd of elephants. In The Conference of the Birds *by the Persian poet 'Attar, thirty birds in search of their king eventually discover the Simorgh – but 'he' is the very birds themselves, for in Persian si-morgh means 'thirty birds'. From an Indian painting*

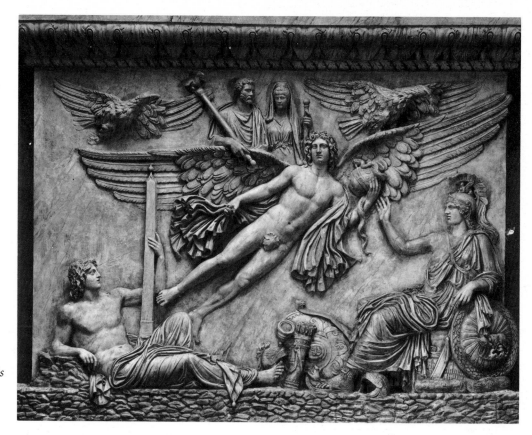

(Opposite) Becoming an Angel: Love, the power which moves the spheres, liberates the soul from that web of psychic worldliness which keeps it from realizing its true nature. Statue by Francesco Queirolo in the Church of St Severus in Naples

Apotheosis of the Emperor Antoninus and his wife Faustina. Relief at the base of the Antonine column, Vatican, Rome

Enoch is transformed into Metatron; from the Caedmon Manuscript, Bodleian Library, Oxford

The Perfect Men, like Jacob, have 'wrestled with the Angel' and won – or rather, they have *striven for* the Angel. They have reached the Gabriel of their own inner being. In them man realizes his full potential for transcendence, and finally escapes the cosmic – only to discover that he himself is the cosmos.

But transcendence, escape, cosmic grandeur are not enough. What about *immanence*, what of the *return*? According to the sufis, the 'two bows' lengths' referred to in connection with Mohammed's vision of Gabriel stand for two journeys: the journey *to* the Angel, and the journey *from* the Angel, the Return. The Persian poet 'Azizi chides those who limit religion only to the transcendent:

> It is no more than two steps
> to the Friend's door –
> you have stopped
> at the first step.

Those who are capable of making that second step will find themselves back in the world – but a world now transformed in the light of their Angelic experience.

ANTONIO SANGRIO
DUCIS TURRIS MAIORIS
PAULI SANSEVERI
PRINCIPIS FILIO
ELOQUENTIA INGENIO
VARIAQ. FORTUNA ADMIRABILI
QUI QUUM UXORE
IN ADOLESCENTIA AMISSA
CÆLEBS DEIN
JUVENILIBUS CUPIDITATIBUS
SATIS SUPERQ. PARUISSET
PROPTEREAQUE
PATRIA PROCUL EUROPAM OMNEM
PERAGRASSET
IDEMQ. COGNITIS
TANDEM ERRORIBUS
REDUX SACERDOS
HUIUS TEMPLI ABBAS
SANCTITATE ACTA MANSIONE
VIXDUM SEPTEN. MDCCLVII
AETATIS LXVII OBIISSET DOCUIT
NON SATIS ESSE
HUMANÆ IMBECILLITATI
UT MAGNÆ SINT ETSI VIRTUTE
EXSTANT
RAYMUNDUS SANSEVERI
PRINCEPS FILIUS
NE QUID IN HAC RE QUIT VERITATI
DENEGARET
HUIUSMODI ELOGIUM
INSCRIBENDUM CURAVIT
CURAVIT

Plato in the *Symposium* again:

This is the right way of approaching or being intiated into the mysteries of love, to begin with examples of beauty in this world, and using them as steps to ascend continually with that absolute beauty as one's aim, from one instance of physical beauty to two and from two to all, then from physical beauty to moral beauty, and. from moral beauty to the beauty of knowledge, until from knowledge of various kinds one arrives at the supreme knowledge whose sole object is that absolute beauty, and knows at last what absolute beauty is.

With these words Plato takes a powerful stand against all 'cosmic pessimism' and dualistic asceticism. For him the beauty of the cosmos is reflected in all beautiful things, and the soul climbs a ladder of love to the realization of the absolute.

Nevertheless, the Platonic tradition seems to possess a hint of dualism (more developed in later philosophers, especially Christian platonists like Augustine). The physical world, for all its importance as a symbol, and despite its ultimate oneness with the Supreme Principle, still remains something to be escaped. Even in the quotation above, the lover climbs beyond his first appreciation of the loveliness of nature or of the beloved, and reaches the realm of pure Ideas – but does not return.

For Plato the sensible world serves as an 'excitation', provoking the Intellect towards remembrance of knowledge caused in the soul by the Ideas. By transforming the Ideas into Angels, however, a greater role is given to the sensible world. To journey with the Angel means to transmute the sensible into symbols, such that to turn towards the sensible is to turn towards the Angel.

This concept appears to complete the Platonic scheme by allowing a return from the contemplation of the archetypes to a contemplation of the world – a world now purified of all 'worldliness.' Above all things, the human form serves as an object of such contemplation, since man is made in God's 'image' and is thus most worthy of love. One might say from this point of view that to love a beautiful beloved is not the beginning but the end of the Angelic path – on condition that one understands who loves and who is loved.

The great twelfth-century Andalusian sufi, Ibn 'Arabi, visited Mecca and there met a Persian shaykh from Isfahan. This shaykh had a fourteen-year-old daughter named Nizam Ayn al-Shams ('Harmony Eye of the Sun'), who was both beautiful and mystically gifted. In honour of his love for her, Ibn 'Arabi composed a volume of

poems, *The Interpreter of Desires*. So erotic were these poems that the public authorities attempted to persecute Ibn 'Arabi, who thereupon wrote a commentary explaining the mystical allegory he had intended.

In the *Interpreter*, the young girl Ayn al-Shams is precisely the theophanic form, the 'veil' assumed by God for Ibn 'Arabi. She is his Angel.

> Long have I yearned for a tender maiden, endowed with prose
> and verse, having a pulpit, eloquent,
> one of the princesses from the land of Persia . . .
> Had you seen us proferring each other cups of passion
> without fingers
> while passion caused sweet and joyous words to be
> uttered between us without a tongue
> you would have seen a state in which the understanding
> disappears.

In commenting on this poem, Ibn 'Arabi explains 'pulpit' as 'the ladder of the Most Beautiful Divine Names. To climb this ladder is to be invested with the qualities of these Names . . . I allude enigmatically to the various kinds of mystical knowledge which are under the veil of Nizam, the maiden daughter of our shaykh.'

> . . . A maid of fourteen rose to my sight like a full moon.
> She was exalted in majesty above Time and transcended it
> in pride and glory . . .
> Thou art a pyx containing blended odours and perfume,
> thou art a meadow producing spring-herbs and flowers.
> Beauty reached in thee her utmost limit: another like thee
> is impossible.

Love of Nizam has made the poet a companion of the 'Watchers', the Angels who gaze upon the face of reality while the rest of creation slumbers as if drugged, or already dead. 'She is unattainable, yet through her manifestation to thee all that thou hast is baptized for thee, and thy whole kingdom is displayed to thee by that essential form . . .'

This form of the Beloved can appear to the mystic in dreams or visions. Thus, for example, Mohammed related, 'I saw my Lord in a form of the greatest beauty, as a youth with abundant hair, seated on the throne of grace; he was clad in a garment of gold (or a green robe); on his hair a golden mitre; on his feet golden sandals.' This vision, so reminiscent of the figure of *Christus Angelus*, the Eternal Youth, has

been much meditated upon by certain sufis, who find in it a justification for their mysticism of forms.

Ibn 'Arabi recounts such an experience in his *Meccan Revelations*: 'The power of Active Imagination attains in me such a degree that it has visually represented to me my mystic Beloved in a corporeal, objective and extramental form, just as the Angel Gabriel appeared to the eyes of the Prophet.' But the Prophet not only saw 'the Lord', and Gabriel, in Angelic guise; he also saw the Angel in the form of a specific and particular human being, a beautiful youth named Dihya Kalbi, one of his Companions. Some of the sufis say that this occurred in a vision; but others maintain that in the spiritual sight of Mohammed, the youth Dihya was the locus of manifestation of Gabriel. (This role is attributed by other mystics to another Companion, the Persian Salman.)

Out of these traditions grew a special mystical technique among certain sufis, who actually trained their active imagination to transmute, through the power of Love, a living human being into a Guardian Angel. Such a beloved was called 'the Witness', not only because his or her human beauty might 'bear witness' or testify to the Divine Beauty, but also because through the Beloved the lover might witness all of reality.

Becoming an Angel: In the depths of the soul dwells our double, the Angel who is the self transfigured by life. Painting by George Frederick Watts (1817–1901)

(Opposite) The Beloved as Angel, the Angel as apotheosis of beauty. Detail of a painting by Filippino Lippi

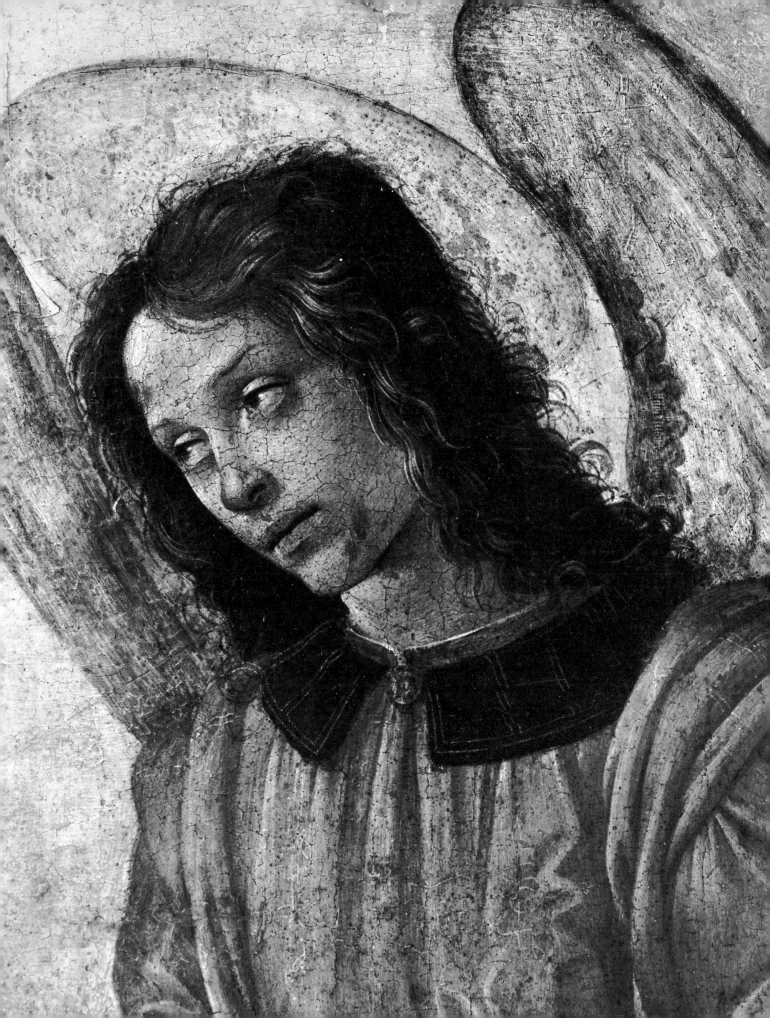

Thus Ibn 'Arabi's companion, Awhaduddin Kermani (who was also accused of heresy), argued with those moralists who condemned this spiritual practice:

> I want
> to testify about
> the heart's witness
> to be safe
> from worldly
> grief.
> For one
> forbidden glance, you need
> your pious ablutions
> but I with one look
> at the Witness himself
> wash clean the whole world.

And he assures his Beloved:

> Lord you know it was never
> now and again
> I gaped
> at the beauty
> of your face.
> Each child
> of this world
> is a mirror
> of your beauty
> a glass to gaze
> forever on the
> king's face.

And again:

> In the circle
> of Being, only
> you are.
> I shall not confess
> to my motive for bowing
> to you alone.
> In the poem
> I quote the name
> of curl and musky down
> but that's a pretext –
> you alone the object
> of desire.

One might give hundreds of further examples from Persian poetry, in which it can never be said for certain if the 'beloved' being addressed is human or divine – precisely because he or she is *both* at one and the same time. Surely such a figure, which thus mediates for the lover between this world and heaven, deserves above all others to be called an Angel.

In the Christian West, with its emphasis on one single and supreme manifestation of the Divine in human form, we may miss this sense of the Angelic possibilities of human love. In the poetry of Dante and his fellow troubadours of the sect known as the 'Fedeli d'Amore', however, there appears a powerful echo – perhaps even influenced by sufi teaching – of this Path. For Dante, Beatrice was indeed the witness: she was both a living woman and an Angel in heaven. In the *Vita Nuova*, he remembers how, in his youth, he saw her in the streets of Florence. Returning to his room, he fell into

a pleasant slumber, wherein a marvellous vision was presented to me: for there appeared to be in my room a mist of the colour of fire, within the which I discerned the figure of a lord of terrible aspect to such as should gaze upon him [Eros], but who seemed therewithal to rejoice inwardly that it was a marvel to see. Speaking he said many things, among the which I could understand but few; and of these, this: 'I am thy master.' In his arms it seemed to me that a person was sleeping, naked but for a blood-coloured cloth; upon whom looking very attentively, I knew that it was [Beatrice]. And he who held her held also in his hand a thing that was burning in flames; and he said to me, 'Behold thy heart.' But when he had remained with me a little while, I thought that he set himself to awaken her that slept; after the which he made her eat that thing which flamed in his hand; and she ate it as one fearing.

Here we are once again in the presence of that greatest of all messengers between heaven and earth, Love himself. In a crimson flow the Archangel presides over the moment of the poet's encounter with his destiny, his love, his soul, his Angel. At the very moment of the encounter, with the eating of the flaming heart, the final consummation is foreshadowed: the union of the soul with God through the Angelic beloved.

A partial bibliography

ANON., *The Book of Arda Viraf*; text edited by D. D. Jamaspji Asa; trans. by Martin Haug and E. W. West (Bombay and London, 1872)

ANON., *The Book of Enoch*, trans. by R. H. Charles (London, 1917)

ANON., *The Shepherd of Hermas*, trans. by J. M.-F. Marique; in *The Fathers of the Church*, Vol. I: *The Apostolic Fathers*, ed. by R. J. Deferrari, *et al.* (Washington, D.C., 1948)

AQUINAS, ST THOMAS, *Treatise on Separate Substances*, trans. by F. J. Lescoe (West Hartford, 1959)

BARBEAU, L., *Totem Poles* (National Museum of Canada, n.d.)

BEREFELT, GUNNAR, *A Study on the Winged Angel* (Stockholm, 1968)

BLACKER, CARMEN, *The Catalpa Bow* (London, 1975)

CHADWICK, NORA, *Poetry and Prophecy* (Cambridge, 1942)

CHARLES, ROBERT HENRY, ed., *The Apocrypha and the Pseudepigraphica of the Old Testament in English*, 2 volumes (Oxford, 1913)

COOMARASWAMY, ANANDA K., 'Who is "Satan" and Where is "Hell"?', in *Coomaraswamy*, Vol. II, ed. by R. Lipsey (Princeton, 1977)

COOMARASWAMY, A. K. and the SISTER NIVEDITA (M. E. NOBLE), *Myths of the Hindus and Buddhists* (New York, 1913)

CORBIN, HENRY, *Avicenna and the Visionary Recital*, trans. by W. R. Trask (London, 1960)

——, *Creative Imagination in the Sufism of Ibn 'Arabi*, trans. by Ralph Manheim (Princeton, 1969)

——, *Mundus Imaginalis, or the Imaginary and the Imaginal* (Ipswich, 1976)

DANIÉLOU, JEAN, *The Angels and Their Mission*, trans. by D. Heimann (Westminster, Md., 1976)

DANTE, *The Comedy of Dante Alighieri*, Cantica III: *Paradise*, trans. by Dorothy Sayers and Barbara Reynolds (Harmondsworth, 1962)

———, *The Portable Dante* (*The Divine Comedy*, trans. by Laurence Binyon; *La Vita Nuova*, trans. by D. G. Rossetti); ed. by Paolo Milano (New York, 1947)

EFLAKI, SHEMSU-'D-DIN AHMED, *Legends of the Sufis* (*Selections from the Menaqibu' l 'arifin*), trans. by J. W. Redhouse (London, 1881)

ELIADE, MIRCEA, *Shamanism: Archaic Techniques of Ecstasy*, trans. by W. R. Trask (London, 1964)

FENOLLOSA, ERNEST and EZRA POUND, *'Noh' or Accomplishment* (London, 1916)

GILSON, E., *The Philosophy of St Bonaventure*, trans. by D. I. Trethowan and F. J. Sheed (Paterson, N.J., 1965)

GRAVES, ROBERT and RAPHAEL PATAI, *Hebrew Myths: The Book of Genesis* (London, 1964)

HALEVI, Z'EV BEN SHIMON, *A Kabbalistic Universe* (London, 1977)

HALLAJ, MANSUR, *The Tawasin*, trans. by A. A. at-Tarjumana (Berkeley and London, 1974)

HARNER, MICHAEL J., *Hallucinogens and Shamanism* (Oxford, 1973)

HAWKES, DAVID (trans.), *Ch'u Tz'u, the Songs of the South* (Oxford, 1959)

HENNECKE, E., *New Testament Apocrypha*, Vol. II, trans. by R. McL. Wilson (London, 1964)

IBN 'ARABI, The Interpreter of Desires (*Tarjuman al-ashwaq*), trans. by Reynold A. Nicholson (London, 1911)

KERÉNYI, CARL, *The Gods of the Greeks* (Harmondsworth, 1958)

MEAD, G. R. S., *Thrice-Greatest Hermes* (London, 1906)

MILIK, J. T. and M. BLACK, ed. and trans., *The Books of Enoch: Aramaic Fragments of Qumran Cave Four* (Oxford, 1976)

MODI, J. JAMSHEDJI, *Dante Papers: Viraf, Adamnan and Dante* (Bombay, 1914)

NASR, SEYYED HOSSEIN, *An Introduction to Islamic Cosmological Doctrines* (Cambridge, Mass., 1964)

NEIHARDT, JOHN G., *Black Elk Speaks* (Lincoln, Neb., 1961)

NICHOLSON, REYNOLD A., *Studies in Islamic Mysticism* (Cambridge, 1921)

O'SULLIVAN, PAUL, *All About the Angels* (Lisbon, 1965)

PLATO, *Phaedrus and Letters VII and VIII*, trans. by W. Hamilton (Harmondsworth, 1978)

———, *The Symposium*, trans. by W. Hamilton (Harmondsworth, 1951)

RUMI, MAULANA JALALU'DDIN, *The Mathnawi*, trans. by Reynold A. Nicholson (London, 1934)

SASO, MICHAEL, *The Teachings of Taoist Master Chuang* (New Haven and London, 1978)

SCHAYA, LEO, *The Universal Meaning of the Kabbalah* (London, 1971)

SCHUON, FRITHJOF, *Dimensions of Islam*, trans. by P. N. Townsend (London, 1970)

WALEY, ARTHUR, *The Nine Songs* (London, 1955)

——, trans., *The No Plays of Japan* (London, 1921)

WOLFSON, H. A., *Philo*, Vol. I (Cambridge, Mass., 1948)

WU CH'ENG-EN, *Monkey*, trans. by A. Waley (London, 1942)

Index

Page numbers given in italics refer to colour and black-and-white illustrations

ACKNOWLEDGMENTS AND PHOTOGRAPHIC CREDITS:
Abbreviations: t=top, c=centre, b=bottom, l=left, r=right.

A.C.L., 60, 64 r, 100–1; Alinari, 24, 27, 35, 133, 177, 186 t, 187; Antwerp, Musée des Beaux-Arts, 100–1; Archives Photographiques, 7, 80 t, 80 b, 89; Arezzo Museum, 101 b; Athens, National Archaeological Museum, 96; Bamberg Staatsbibliothek, 45, 122; Roloff Beny, 145, 172, 181; Brian Beresford, 180; Berlin DDR, Staatliche Museen, 159; Carmen Blacker, 107 r; Bologna, Museo Civico Archeologico, 119; Boston, Museum of Fine Arts, 47, 95 b; Bulloz, 37, 191; Calcutta, Indian Museum, 39 c; Cambridge, St John's College, 51 br; Canadian Eskimo Arts Council, 117; Chantilly, Musée Conde, 37, 151; Chicago, Field Museum of Natural History, 17; Chicago, Oriental Institute, 65; Josip Ciganovic-Omcikus, 99 b; Cleveland Museum of Art, 175 b; Cologne, Rheinisches Bildarchiv, 78 t; Courtauld Institute of Art, 46 tl; F. H. Crossley, 38 l; Yolande Crowe, 34; Dresden, Staatliche Kunstsammlung, 46 bl; Dublin, Trinity College, 90 b; Edinburgh, National Gallery of Scotland, 104; Edinburgh, University Library, 38 r, 61 t; Erlangen, Graphische Sammlung der Universität, 12; Florence, Biblioteca Nazionale Centrale, 148, 149; Olga Ford, 32; Mr and Mrs John Gilmore Ford, 94; Werner Forman Archive, 17, 20; Geneva, Musée d'Art et d'Histoire, 92; Giraudon, 88–9, 105, 151; Sonia Halliday, 43, 51 t, 56, 170; Arthur A. Houghton Jr., 126; Istanbul, Topkapi Saray Museum, 78 b, 138; Japanese Foundation, 174; Alfredo Linares, 111 b; London, British Library, 22, 33 t, 41, 42, 50, 147, 152; London, British Museum, 14 b, 16, 21, 36 l, 36 r, 49, 64 l, 81, 84, 88, 97, 108 b, 175 t; London, National Gallery, 25, 98, 131; London, Tate Gallery, 30, 190; London, Victoria and Albert Museum, 2–3, 48, 72, 73 b, 79, 109, 150; Los Angeles County Museum of Art, 182; William MacQuitty International Collection, 121; Mansell-Alinari, 39 t, 39 b, 112, 184 t; MAS, 184 b; Georgina Masson, 57; Leonard von Matt 14 tl; Ajit Mookerjee, 183; Moscow, History Museum, 118; Otto Muller Verlag, 31; Munich, Bayerische Staatsbibliothek, 62, 91, 102; Munster, Westfalisches Landesmuseum für Kunst und Kulturgeschichte, 61 b; John G. Neihardt Trust, 114; New York, Metropolitan Museum of Art, 110, 126; New York, Museum of the American Indian, Heye Foundation, 145 tr; Nicosia, National Museum of Antiquities, 99 t; Novosti Press Agency, 53, 164; Oxford, Bodleian Library, 10 b, 90 t, 200 bl; Oxford, New College, 107 l; Paris, Bibliothèque de l'Assemblée Nationale, 111 t; Paris, Bibliothèque Nationale, 40 b, 44, 51 bl, 59, 68, 123; Paris, Louvre, 64 r, 88–9; Paris, Musée Guimet, 73 t; Portland Art Museum, 20, 145 br; Rome, D.A.I., 14 tr, 26; Jean Roubier, 85; San Marino, Henry E. Huntington Library and Art Gallery, 40 t; Scala, 54, 55, 124–5, 127, 146, 169, 171; Edwin Smith, 13; Vienna, Staatsbibliothek, 46 r; Washington D.C., Dumbarton Oaks Collection, 83; Washington, Freer Gallery of Art, Smithsonian Institution 128, 137, 173; Yale University Art Gallery, 69; Zurich, Rietberg Museum, 145 tl.

Title-page by William Blake